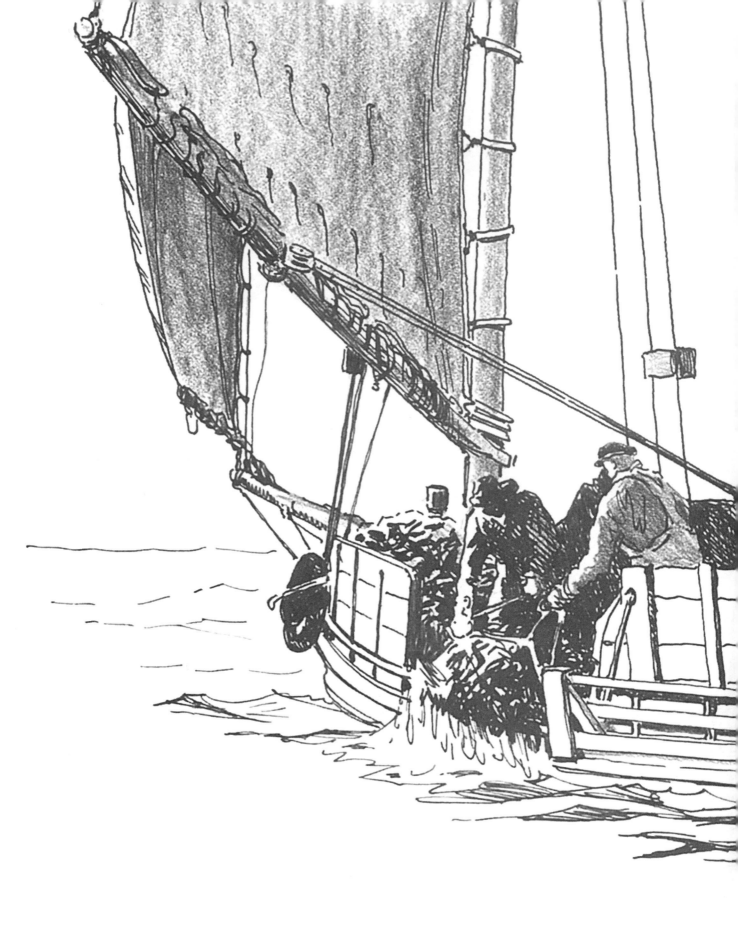

Marine
Painter's Guide

Jack Coggins

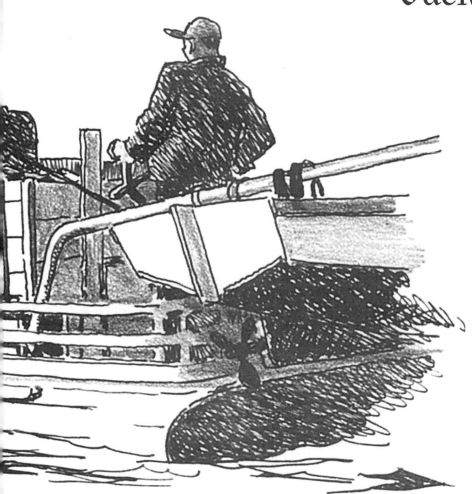

Dover Publications, Inc., Mineola, New York

Dedication

My thanks and gratitude to my wife (she works under the name of Alma Woods), who over the years has helped immeasurably with each of my books, from planning, layout, and typing of manuscript and captions to preparation for finished drawings and indexing.

To ready this last book for publication, she has given up months of her precious painting time. It was only with the knowledge that her help would once more be forthcoming that I undertook this book, and it is due to her efforts that it has reached completion.

Photographs for *Marine Painter's Guide* were taken by Dr. Richard Heller, Associate Professor of Biology, Albright College, Reading, Pennsylvania.

Bibliographical Note

This Dover edition, first published in 2005, is an unabridged republication of the work originally published by Van Nostrand Reinhold Company, Inc., New York, in 1983.

International Standard Book Number: 0-486-44974-2

Manufactured in the United States of America
Dover Publications, Inc., 31 East 2nd Street, Mineola, N.Y. 11501

Contents

Marine
Painter's Guide

Introduction

Ships and the sea have been an inspiration to artists and craftsmen since ancient times, as paintings from ancient Egypt and ceramics from Crete and Greece testify. Much of our knowledge of Roman and medieval shipping comes from contemporary coins, reliefs, and manuscripts. Marine painting as we know it may be said, I suppose, to have begun with the Dutch painters of the early seventeenth century. Worthy sons of a seafaring nation, they portrayed the vessels and rigs of their day with a rare combination of artistry and technical knowledge. Unlike monkish illustrators whose creations were beautiful but somewhat fanciful, the Dutchmen painted their craft as they actually saw them, true in perspective and detail.

The artists who have followed in their footsteps have, in most cases, maintained a realistic approach. The degree of realism varies. We all know the stiff, monochromatic, every-line-ruled-in picture of the mid-Victorian clipper, with waves advancing in rigid, evenly spaced ranks, canvas and house flags hard as hammered iron. Contrasting with these, we have the more colorful and painterly works of later artists like Gordon Grant and Montague Dawson.

Personally, I like to let the mood and subject matter dictate the style in which I work, always taking into consideration the requirements of the client if the painting is a commission. Usually the owner of a multimillion-dollar tanker will prefer that the painting of his ship contain at least some recognizable detail. And the yacht portraitist will often find that his client will be as fussy about certain features of his dream boat as a fond mother about the likeness of her debutante daughter. I have done a good deal of this sort of painting but, apart from the satisfaction any craftsman enjoys in the pursuit of his craft, they come under the heading of work, not fun. Fun painting to me is a rough (often very rough) sketch, a set of painting knives, and lots of paint.

No one loves the fine points of a hull or rigging more than I do, but increasingly I find that detail bores me. I get impatient, and halfway through one painting I find myself thinking more about the next. I am always fascinated to read about artists who spend months—some claim years—working on a canvas. Given a clear picture in my mind of what I want to do, I usually like to spend no more than a day and a half on a painting, and often considerably less than that. Of course, this presupposes that the subject matter is to be handled in a direct manner.

But everyone to his own style, or styles, of painting. The important thing, whether the tool is a "one-hair" brush or a painting knife like a small trowel, is that the handling of the subject matter be knowledgeable and workmanlike. To do this it is not necessary to be able to identify all the running and standing rigging of a clipper (although if you plan to set up as a painter of such vessels, you might well learn to do so). What you *should* be able to do is convey the feeling that your hulls, sail or power, even if painted in the broadest and most impressionistic manner, are sitting *in* the water, not resting precariously *on* it, and that they are sparred, canvased, funneled, or whatever in a logical manner.

Ships as such may not interest you—in which case there is a host of marine subjects to hand: old docks with a dory or two, beaches, fishing villages, surf, rocks, or the open ocean. These lend themselves well to the splashy techniques of watercolor or to a broad oil treatment with brush or knife.

Whether you prefer to work direct or from quick sketches, photographs, and memory, or from combinations of the three, you will find that a knowledge of your subject and all the bits and pieces that add authenticity to a painting will be a great help. A stretch of dock can look bare indeed, but add some of the clutter that one would normally find in such a spot—an upturned boat (being repaired or painted, perhaps), a pile of nets, some fish boxes or lobster traps—and your painting will begin to come to life. A few figures help. A dock or harbor scene, or a vessel for that matter, without any sign of life looks as if the plague had struck. There's a chapter on figures and what they might logically be doing. And don't forget the gulls. They are not always present, but a busy fishing port usually hosts them by the hundreds. There's a chapter on them, too—the different kinds seen on the American coasts and their shapes and sizes.

Water and the fascinating way it tumbles and surges around the rocks is almost a separate branch of marine painting. Some artists paint little else. It calls for experience born of much observation to capture the movement—always different but following the same general pattern—of waves and foam pouring over and around masses of rock of infinitely different sizes and shapes. What better way, though, to spend a few hours than in a sheltered spot out of the wind and spray watching the big ones race in? White laced and smoking, they explode against the glistening rocks, then retreat in fantastic spouts and whirlpools of foam.

My own love affair with the sea began early, as a small boy sailing model yachts on a pond and later small boats on Long Island Sound. It was only natural, when the urge to become an artist led me to art school, that one of my first paintings was of a ship. I have been at it ever since, and while a career as a commercial artist and illustrator often called for the portrayal of a host of different subjects, marine painting has always remained my main interest. Students of mine who tried their hands at boats and the sea, however, ran into unusual problems, which made me realize that a sort of marine painter's guide might be of value not only to the beginner but to the more advanced as well. So here is something for everybody, some technical details, some ideas, some do's and don't's. Remember, we all see things differently and we certainly don't all paint alike, so the suggestions and examples in this book are just my particular ways of handling certain problems and not a set of rules.

Whatever you choose to paint—ships, dockside scenes, rock and sea—I hope this book will help you on the way to better, more authentic marine painting.

1

Materials

There is no special equipment for marine painting—only what is necessary for any other subject matter. As in any form of art or craft, it pays to use the best materials. Unlike most manufactured articles, the cost of paint and canvas compared to the value of the finished product is minuscule. Time, skill, and knowledge are the big factors. So don't waste effort by using poor supplies. The quick sketch done in haste on a piece of cardboard may turn out to be a little gem—and afterwards you may wish you had used better stuff to work on. Workers in wood and metal and other craftsmen insist on good tools and materials, and so should you.

These days oil paints are almost all of a good grade and meet the requirements of the Artist Oil Color Standard issued by the National Bureau of Standards of the U.S. government. Where they differ most is in the percentage, if any, of fillers mixed in with the pure pigment. The fillers are neutral substances that are mixed in (coprecipitated) with the pigment to give more bulk. There is nothing wrong with such paints; they just are not as strong—they don't have as much tinting power when mixed with white as paints composed of pure pigment. They are also not as expensive. Labels on tubes of paint must tell you the composition. The vehicle—the liquid mixed with the dry pigment—is usually linseed oil and probably varies little in quality from one maker to another. What often does vary is the amount of vehicle. Some paints are definitely mushier than others. Usually the more expensive brands are firmer.

Some pigments are more permanent, are less likely to fade or blacken, than others, and these gradations of permanency are shown in the color charts of most recognized color makers. Colors differ slightly from one manufacturer to another. Find the ones you like and stick with them.

So much for the colors themselves. Now for what you put them on. Let's get a couple of terms straight first. The canvas, board, panel, or whatever, is the support; the coating of white lead or gesso is the ground. Commercially primed canvas is usually tacked on wooden frames, or stretchers, so called because the interlocking ends provide room for little wooden wedges or keys. When tapped in place, they can, if desired, stretch a canvas drum tight.

Most artists seem to prefer the bounce that they get when painting on a stretched canvas. As it happens, I don't, so I glue my canvas on Masonite or smooth quarter-inch mahogany plywood. Prepared canvas boards, mostly cotton covered, I avoid, because the cardboard on which they are mounted is not made with permanence in mind. They are fine for students, though, who often wipe off a painting at the end of the day's session and reuse the board several times.

I usually buy unprimed linen, which has a more varied and interesting texture than cotton, and size it after it is glued to the board. If you want to try this, roughen the surface of the Masonite (don't use the tempered variety) with sandpaper, then give it a generous coat of rabbit-skin glue dissolved in hot (not boiling) water. A cheap egg beater does a good job of stirring it up so that there are no lumps. While working with rabbit-skin glue,

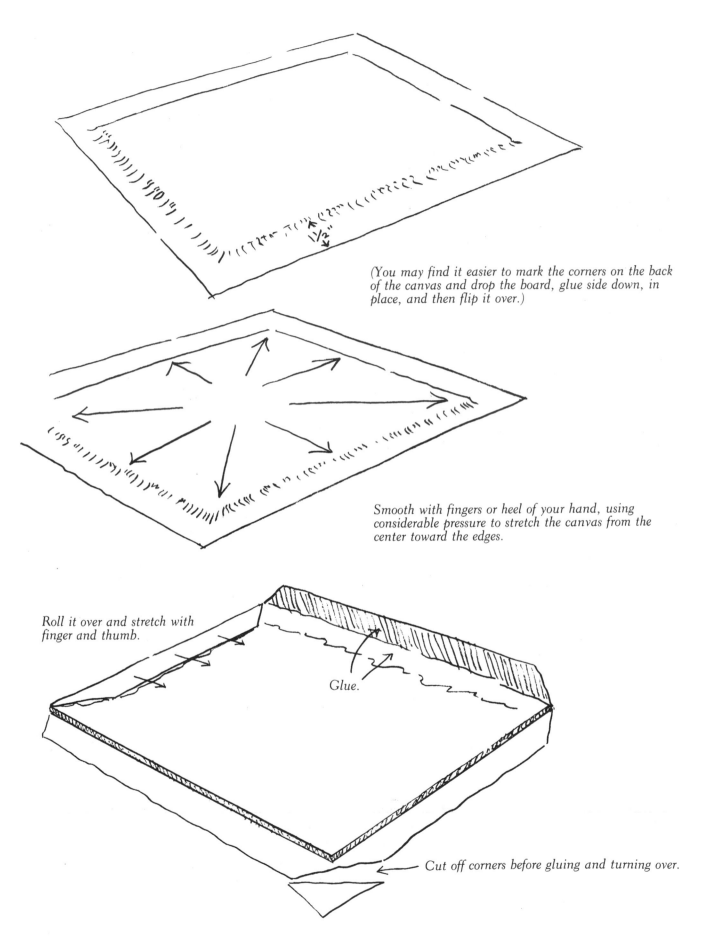

(You may find it easier to mark the corners on the back of the canvas and drop the board, glue side down, in place, and then flip it over.)

Smooth with fingers or heel of your hand, using considerable pressure to stretch the canvas from the center toward the edges.

Roll it over and stretch with finger and thumb.

Glue.

Cut off corners before gluing and turning over.

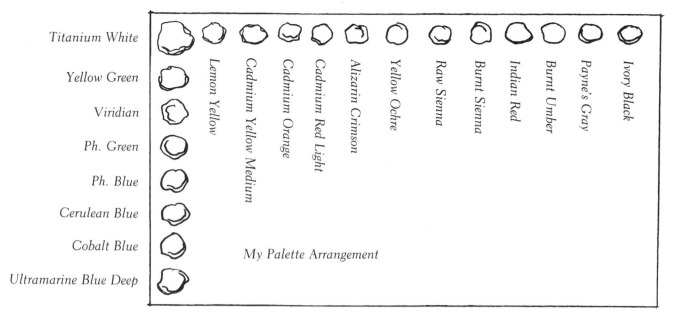

Titanium White

Yellow Green

Viridian

Ph. Green

Ph. Blue

Cerulean Blue

Cobalt Blue

Ultramarine Blue Deep

Lemon Yellow

Cadmium Yellow Medium

Cadmium Orange

Cadmium Red Light

Alizarin Crimson

Yellow Ochre

Raw Sienna

Burnt Sienna

Indian Red

Burnt Umber

Payne's Gray

Ivory Black

My Palette Arrangement

keep it warm in a double boiler. After the first coat is dry, cut the canvas an inch and a half larger than the board on all sides, give the board another good coating of glue, then lay the canvas in place in the center and smooth it out, starting from the middle and working toward the edges. Turn the canvas face down, make a diagonal cut across each corner, apply glue liberally to the edges, and fold over. Put a weight in the middle to hold the board flat while the glue is drying.

The priming is a matter of choice. White lead, thinned a bit with turpentine, can be used, or a prepared gesso. I use acrylic gesso (it isn't really gesso, but it's pretty thick). Thin the first coat a bit (follow the directions on the can) and paint the back of the board as well as the canvas. Work it into the weave of the canvas with a stiffish brush. When it's dry, sand the canvas side very lightly with fine sandpaper and apply a second coat without thinning. If you like a tinted canvas, mix some acrylic paint—maybe burnt umber and a little black—with the second coat.

Sometimes I prefer a smooth surface and paint directly on a Masonite panel, priming it with at least two coats of acrylic gesso sanded slightly after each coat.

The choice of colors is up to the individual artist. I use ultramarine blue, cobalt blue, cerulean blue, phthalocyanine blue, phthalocyanine green—these last two are sometimes sold under a maker's brand name—viridian and a yellow green such as Grumbacher's Thalo Yellow Green, lemon yellow, cadmium yellow medium, cadmium orange, cadmium scarlet or cadmium red light, alizarin crimson, yellow ochre, raw sienna, burnt sienna, Indian red, burnt umber, Payne's gray, and ivory black. To these I may add other colors, depending on the painting. I always arrange my colors on the palette in the order given above, starting in the lower left-hand corner. White goes in between the yellowish green and the greenish yellow. Whatever order you use, stick to it so that you automatically reach for the same spot when you want a color.

When painting outside, which I seldom do, use the palette which fits in your sketch box. In the studio I use a sizeable piece of heavy glass painted light gray on the underside. If I forget to clean it after a day's painting, a very sharp putty knife or a razor blade in a holder will do a good job. If some small bits of dried paint remain, I scrub it with a little steel wool dipped in turpentine.

For sketching outside there are some very fancy (and expensive) collapsible easels on the market. Sliding a canvas board, though, into the slots provided in the lid of the sketch box and sitting on the ground with the box between the knees works quite well. As I never do more than sketch outdoors, this method works for me, but those who prefer to work on a stretched canvas or on a prepared board larger than the box will need something more elaborate.

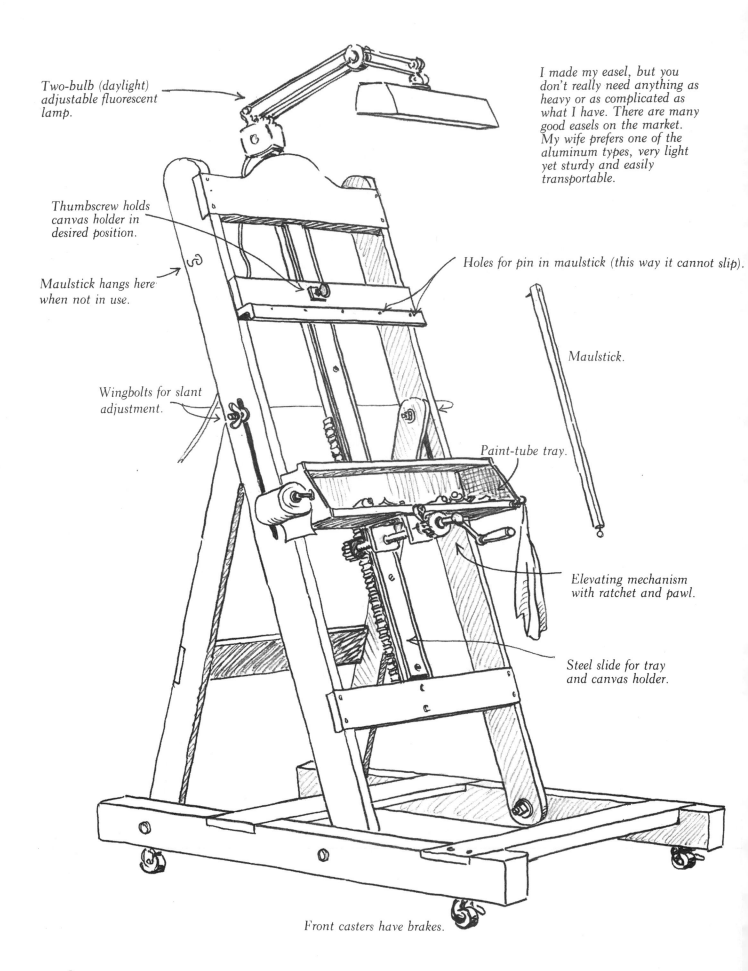

Two-bulb (daylight) adjustable fluorescent lamp.

Thumbscrew holds canvas holder in desired position.

Maulstick hangs here when not in use.

Wingbolts for slant adjustment.

I made my easel, but you don't really need anything as heavy or as complicated as what I have. There are many good easels on the market. My wife prefers one of the aluminum types, very light yet sturdy and easily transportable.

Holes for pin in maulstick (this way it cannot slip).

Maulstick.

Paint-tube tray.

Elevating mechanism with ratchet and pawl.

Steel slide for tray and canvas holder.

Front casters have brakes.

My studio easel is of the crank-up variety, with a shelf for tubes of paint, a hook or two for rag or paper cleaners—I like the heavy-duty type used in garages and machine shops—and on one side a holder for a roll of toilet paper (very useful for wiping knives and small but messy cleanup jobs).

Paints may be thinned with a medium. Depending on the nature of the support I am working on and the effect I am trying to get, I often do not use any medium at all. Most paints are mushy enough without adding medium. Usually when working with a painting knife, I use the paint as it comes out of the tube. When I do want to thin paints, I use a mixture of five parts turpentine and one part copal varnish or stand oil. There are many mediums on the market, as well as the old standby,

half linseed oil, half turpentine. The main thing to remember is to work fat over lean—that is, to use medium with less oil in proportion to turpentine in the underpainting. When that is thoroughly dry, you can safely overpaint with a fatter mixture. Of course, this doesn't apply when painting alla prima (wet into wet).

Keep a separate container for your cleaning turpentine and use it often. Dirty brushes produce dirty colors. There are several brush cleaning gadgets on the market, but one of the most efficient and certainly the most inexpensive is a wide-mouthed jar—a large-size peanut butter container is a natural—and either an open-mesh strainer with the handle removed or a piece of quarter inch mesh wire in the bottom. Keep enough turpentine—not

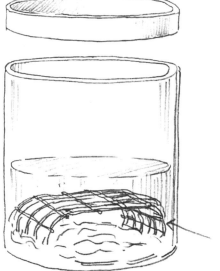

Better rest the jar top, upside down, on the jar. If you screw it on, the turpentine (which will inevitably collect on the edge of the jar) will make it stick and you will have difficulty removing it.

Cover mesh at one inch with commercial-grade turpentine.

Wire mesh.

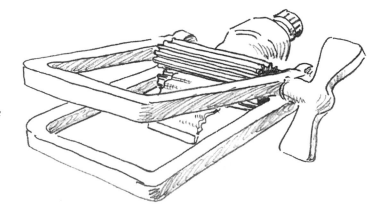

Paint-tube squeezer: a very handy gadget, but be sure you screw the top on tight before you put the "heave-ho" on it.

9

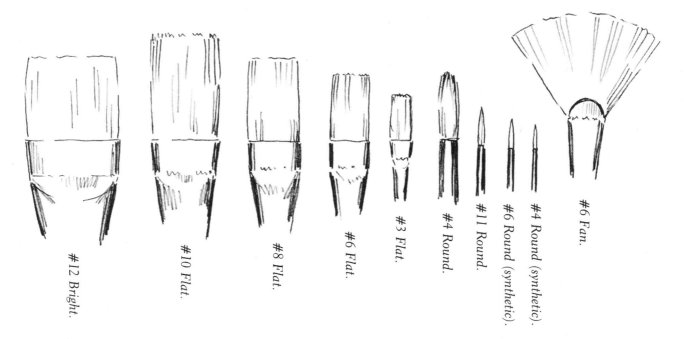

#12 Bright.

#10 Flat.

#8 Flat.

#6 Flat.

#3 Flat.

#4 Round.

#11 Round.

#6 Round (synthetic).

#4 Round (synthetic).

#6 Fan.

Brushes are important to me and I'm not happy painting with any but the best. Bargain brushes seldom hold their shape and are a definite handicap. With this assortment (bristle, unless otherwise noted) you can paint just about anything. You will surely accumulate more brushes in time. Just for fun I counted mine: 273, not including dozens of watercolor brushes! Some of them are pretty ancient, but still useful. Synthetics have to a great degree replaced sables although the latter are softer. Brights give narrow sharp edges, which are very useful for painting rigging and certain details.

I have not shown a filbert (longer and more flexible than a flat, but not an egbert, which is longer still). These latter are useful for dragging wet across wet, as are the fans. I use egberts sometimes when pulling foam streaks down a wave, but don't put them on your "must" list. Lots of painters have never even heard of them.

A tip on brushwork: don't let paint accumulate on your brush. Keep it reasonably clean with your rag and when you go to load it, pick up a good dab on the tip. A mess of paint half-way down to the ferrule won't get you anywhere. For that reason I do a lot of mixing on my palette with a knife and use the brush mainly for applying it.

Some painting knives—actual size. I find the one second from right paticularly useful.

10

the rectified kind sold in art stores; the commercial variety from a hardware store is cheaper—in the jar to cover the wire by at least an inch. When a brush is gently rubbed over the mesh, the gunk will settle to the bottom and can be easily cleaned out at intervals.

Another gadget I prize is a tube squeezer or roller. Insert the end of the tube between the rollers, close, turn the knob, and presto! The paint is forced up the tube toward the top where it belongs, and the bottom—usually a tube's weak spot—can be rolled up neatly. This method is good for toothpaste, too.

The well-equipped sketchbox should also contain a small pair of pliers (cheap ones will do) for removing recalcitrant tube caps. If the pliers don't do the job easily, don't use brute force—you may tear the whole top off the tube. Carry matches in your box as well, and "toast" the cap until the pliers can remove it easily.

There are numerous comforts that add to the pleasure of painting outdoors—stools, umbrellas, hampers of refreshments. Unfortunately, the most scenic spots are often the most inaccessible, and unless you plan a safari, complete with bearers for your gear, my advice is to travel as light as possible. A waterproof cushion or small groundsheet—(ground is often damper than it looks)—is a good idea and so is a spray can of bug repellent.

Returning from a painting session outdoors, you will need some way of carrying your wet canvas. Canvas separator clips are available. These will hold two canvases face to face without letting them touch. Also available are canvas pins—double-pointed pins in a plastic or wood base—but with these you must use a strap to hold the canvases together. Clips are better.

Last, but decidedly not least, let's talk about brushes. I can paint on practically anything, using almost any kind of paint, but if I don't have a really good brush, I'm lost. A good brush (and sad to say, even the best aren't as good as they used to be) should be resilient and keep its shape well and should be able to deposit the required quantity of paint on the canvas exactly as and where you wish.

One develops one's preferences over the years, and of the bristle brushes I happen to like those made by Simmons. For laying in I usually use a large bright (brights are short bristled, thinnish, and flat). For the actual painting I find flats (thicker and longer) serve best, and I often supplement these with filberts, which are a little longer and more flexible than flats and have oval-shaped tips. For small paintings on fine-tooth canvas or panels (eight by ten inches, nine by twelve, eleven by fifteen), I often use soft brushes, rounds as well as flats, of either sable or the new synthetics. Only experience will show you which sizes, shapes, and brands will suit your particular style of working. But be sure you buy the best. Despite the lists of equipment, including brushes, that are furnished each new student in my classes, several inevitably show up with the sorriest affairs, mostly in the wrong sizes and with tips already splayed out like a worn house painter's brush. It is quite impossible for the average student to accomplish anything with tools like these, and the end result is frustration and disappointment. Fortunately, many of the people who appear with these monstrosities don't heed my brush-cleaning drill, either, so in a very short time the brushes harden into chisels and have to be thrown away. A first cleaning with rag and turpentine, followed by thorough but gentle washing with mild soap and warm water will preserve a well-made brush for a long time.

Despite possessing large pots full of a variety of brushes, acquired over a considerable period, I often do an entire painting with the knife. Painting knives (not palette knives) are thin and flexible and come in a wide selection of shapes and sizes. They should be treated as the delicate instruments they are and *not* used to scrape dried paint off a palette or to pry things open with. Once bent—and you can do this by dropping one—they are very difficult to straighten and will never be quite as good as new. If you should put a kink in a favorite knife, don't try to bend it straight with pliers. Hold it absolutely flat on a smooth metal surface—a small anvil is the ideal thing—and tap it smartly with a hammer until the kink is beaten out. A simpler plan is to take good care of your knives in the first place.

The field of artist's materials is a wide one, and obviously there is no place here for anything but a very brief discussion. As you work, you will find that certain materials suit your style. Keep to these and avoid cluttering up your sketch box or studio with a lot of discarded junk.

Watercolor While the Tide's Out *17½x22"*

This sketch is from my Long Island days and was painted on the spot (something I seldom do). There are a couple of bits I could have done better with a little more time, but it worked out pretty well and told the story. Some of the highlights were probably dug or scratched out with a penknife. Today, and working indoors, I would most likely mask out a few of the lights with one of the rubber-type materials made for the purpose. These work just fine but tend to be a bit too "perfect" sometimes. I don't have any scruples about a dab or two of Chinese white, either, although it's easy to overdo it. Watercolor is tough enough, so I figure anything goes.

2

Hulls

Some artists prefer to concentrate on pictures of angry seas smashing against rocks or of waves on the open ocean, but many marine paintings include at least one vessel—a majestic sailing ship, perhaps, a fleet of fishing vessels, or maybe a lone dory. Ideally these subjects would be best handled by paintings made on the spot. A landscape painter can do this. His subject is there, immovable. But the marine painter faces a different problem. The majestic sailing ships have, alas, all but disappeared. Fleets of fishing vessels are hard to come by, too, and if discovered are seldom arranged the way we might want them in our composition. They are definitely not immovable, either. It is disconcerting when the vessel you are drawing emits a puff of diesel exhaust and chugs away in mid sketch. The dory may be easier to find, but again is seldom just where or how you want it. And what of the artist who lives far from the coast and seldom sees a body of water larger than a farm pond?

The answer lies in what I call a cook-up—a combination of sketches or photographs (more on this later) arranged logically in a composition of your own devising. Many of our leading marine painters do this. For example, when you see a contemporary painting of an American harbor, say Gloucester, Massachusetts, showing fishing vessels with sails, then you know the artist has painted it, not as it is, but as it was eighty or one hundred years ago. (Fishermen are practical people, and when the internal combustion engine was developed, sails began to vanish. Now, high fuel prices are forcing a return to sails as an auxiliary power supply, but the all-sail fishing fleets are gone forever.)

The picturesque old fishing villages are changing, too. Neat little houses with aluminum siding have replaced many of the shingle-roofed, clapboard frame homes of years gone by, and many tumbledown wharves—nice to paint, but tricky to walk on—have given way to modern docks and piers. There's nothing wrong with dreaming up an ideal marine subject—as long as you do it right! Otherwise your canvas dream may turn into a nightmare.

Docks, floats, fishhouses are comparatively easy to do—there is a chapter on these further on in the book—but vessels are another story. A badly drawn boat spoils the best-painted marine picture. Boat hulls are quite difficult to draw, and later on I will show you how to make simple models to work from. By reducing a hull to its most elementary form, we can get a good idea of its general shape. More important, by the use of perspective we can be assured that our vessel will sit properly in place in the water and be positioned correctly in relation to other craft in the same scene.

Thinking of a vessel's hull as an oblong helps give an idea of depth and solidity, but hulls are not square-ended blocks. Instead, they are forms made up of many curves, concave and convex, too complicated for the average artist to draw up out of his head. For instance, decks are not usually flat from bow to stern but have a dip or concave curve called the sheer. Many small craft are considerably higher in the bow than at the stern as well. If a hull is imagined to be sliced across at the waterline, however, the plan view can be turned in any direction on a table and the angle planned in

PERSPECTIVE DIAGRAM

If buildings (and their docks) A and B were physically parallel, their vanishing points would be the same. Seldom the case in fishing villages.

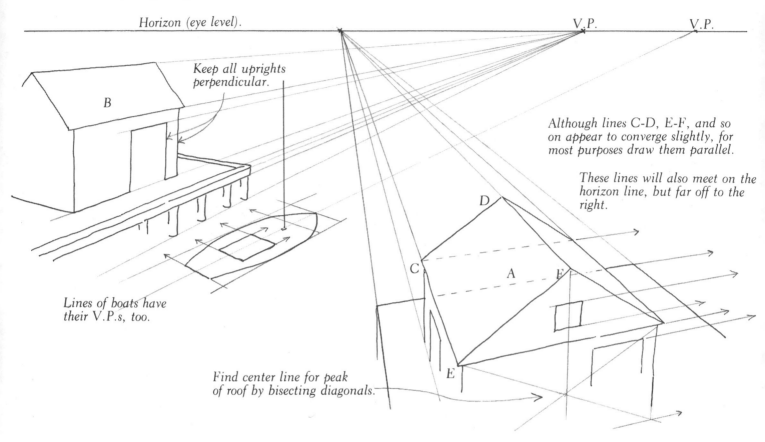

Horizon (eye level).

V.P. V.P.

Keep all uprights perpendicular.

B

Although lines C-D, E-F, and so on appear to converge slightly, for most purposes draw them parallel.

These lines will also meet on the horizon line, but far off to the right.

D

C A F

Lines of boats have their V.P.s, too.

E

Find center line for peak of roof by bisecting diagonals.

relation to the picture's horizon, which is always the observer's actual eye level.

The laws of perspective state that all receding lines that are parallel to each other will appear to meet at a single point—the vanishing point or VP—on the eye-level line. This is also true in drawing the interior of a room. Indoors you have to establish your eye level at the proper height (are you sitting or standing?), but in many cases marine painters can actually see their eye levels, right out there where sky and water meet. The sketch shows how the lines of the larger dock and building appear to converge at the VP. Notice, though, that while the lines in the small building and dock are also parallel to each other, they are not parallel to the lines in the larger objects and so have a separate VP. Vanishing points are very often not in the field of your picture. To draw parallel lines that appear to converge outside the boundaries of your picture, either draw them by eye, extend your eye-level line by adding extra paper to your sketch, or put your sketch on the floor and indicate the horizon lines

and receding parallel lines with the aid of some thread and thumbtacks.

Now let's put some of this to practical use. Say we have a simple boat hull in mind that we want to put into a picture. Draw a plan of your boat on a piece of cardboard, with a center line and several lines at right angles to it. Put this on your table or board and sketch it, being sure your eyes and the horizon you want in your picture are on the same level. Then, where your transverse lines meet the nearest edge of the curve, erect short upright lines to correspond with the heights of the sides of your boat. Connect the tops of these with the VP and draw the uprights at the other end of the transverse lines. Connecting the tops of these lines will give a rough idea of the position of the top of each side (the gunwales). By the same method you can add a cabin, deck, seats, or what have you. If hulls are wider on deck than at the water line or if bows rake forward or stems slope aft, these details can be adjusted on the sketch. Note that any lines parallel to the center line will appear to meet. We can add

other boats by the same process. They may lie parallel to each other—wind and tide sometimes cause this—but otherwise each will have its own sets of VPs.

For harbor scenes, especially when these are to be handled broadly, the above method of drawing hulls, when used in conjunction with photographs or on-the-spot sketches for detail, is often sufficient.

When designing a vessel, a naval architect expresses the often complicated curves and hollows of his design in drawings similar to those shown. I have simplified these a little, showing only the profile, the deck plan, and the shape of the hull (the body plan). These represent the transverse sections you would see if the hull were sliced across at predetermined intervals (stations) at right angles to the keel. The body plan is divided more or less in half, one side showing the stations from bow to midships, the other midships to stern. They are numbered and correspond to the vertical lines on the profile.

You may be wondering what this has to do

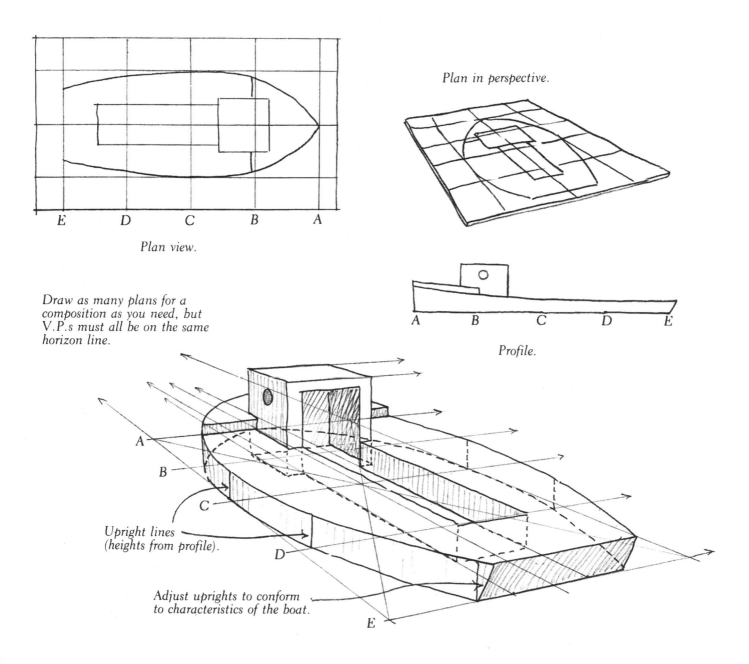

Plan in perspective.

Plan view.

Draw as many plans for a composition as you need, but V.P.s must all be on the same horizon line.

Profile.

Upright lines (heights from profile).

Adjust uprights to conform to characteristics of the boat.

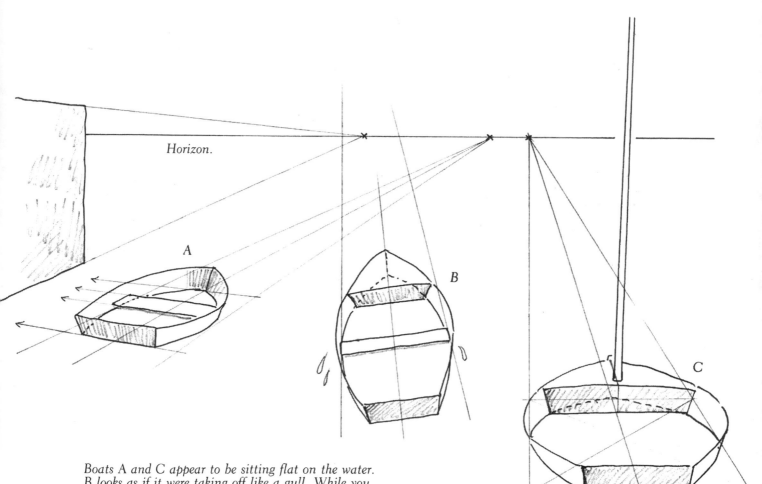

Horizon.

A

B

C

Boats A and C appear to be sitting flat on the water. B looks as if it were taking off like a gull. While you can turn your hulls in any direction, be sure you draw your plans on the same plane.

with marine painting. Obviously the best way to draw a hull is to sit down and sketch one. By following the directions, you can easily make a simple model out of cardboard—I use scraps of matboard—and some masking or freezer tape. If some strips of three quarters by three quarters inch wood (cut about an inch long) and a little glue are available, it will make the job easier.

The lines I have shown are those of a small sailing boat used in Maine for fishing and lobstering years ago. Similar boats are now being built as yachts. They are sometimes called Maine sloops or, because many were built in the town of Friendship, Maine, Friendship sloops. First trace the shape of the profile and transfer it to your matboard—carbon paper will do for this—and carefully cut it out with a mat knife. Be sure to mark the vertical lines (stations) showing where each section is to go. Do the same with the deck plan, marking the center line, the position of the mast, the cabin, and the

coaming (the solid rail running around the cockpit). Mark where the waterline comes on each section. Now cut out the sections, numbering them as on the plan. You will need two of each. Next fasten the sections in their proper places on the profile with a hinge of tape on each side (see diagrams). If you are using the wood strips, glue one on one side of each vertical line level with the top. The oval-shaped piece at the stern (the transom) can be taped on next. It is better if it is marked and cut out in one piece (see diagram).

Next the deck can be fastened in place, either with tape or by glueing to the top of the small blocks. Be sure that the curved sections are fastened at right angles to the profile. Measure the cabin sides and coaming and transfer to heavy paper and fasten as shown. Cut out the cabin top and stick that on. Your frame is complete. Now, starting at the bow, run a narrow strip of heavy paper to the transom, just under the deck level. Repeat this on

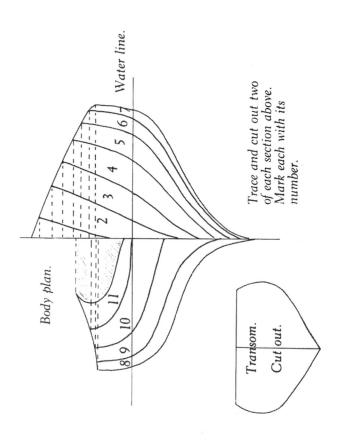

Water line.

Trace and cut out two of each section above. Mark each with its number.

Body plan.

Transom.
Cut out.

the other side. Four or five strips, with maybe an eighth of an inch between, will be sufficient for drawing purposes.

It is very important that a vessel's mast be drawn in the correct position: perpendicular to the keel as seen from the bow and with the proper angle (rake) as seen from the side. This varies from vessel to vessel and is shown in the plans.

A piece of small-diameter dowel from your hardware store will do for a mast. Cut it to the length indicated on the sail plan and fasten it to the deck as shown in the diagram. A piece of heavy thread will serve for supports (shrouds). Glue another piece of dowel on the deck for the bowsprit. A forestay may help to steady your mast.

Not all vessels have bowsprits. Those that do carry them at different angles to the horizontal. This angle is called steeve or steeving.

The addition of bowsprit and mast finishes the vessel enough for it to be used to draw from or to photograph. Prop it up on some cloth or on something to simulate wave motion and sketch it from various angles. You will find that you will not only be able to draw correctly the rather complicated hull form of this particular model but you will also gain an understanding of the way to draw any hull you choose. Plans such as the one above may be found in many books on ships, and your local library probably has several.

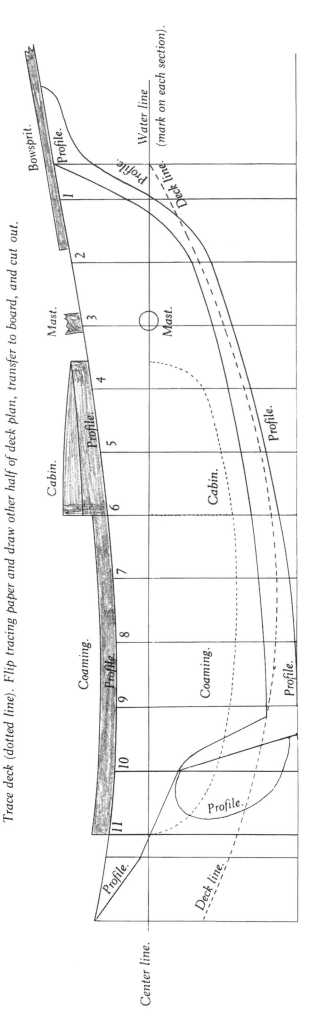
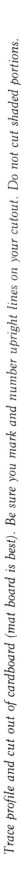

Trace deck (dotted line). Flip tracing paper and draw other half of deck plan, transfer to board, and cut out.

Trace profile and cut out of cardboard (mat board is best). Be sure you mark and number upright lines on your cutout. Do not cut shaded portions.

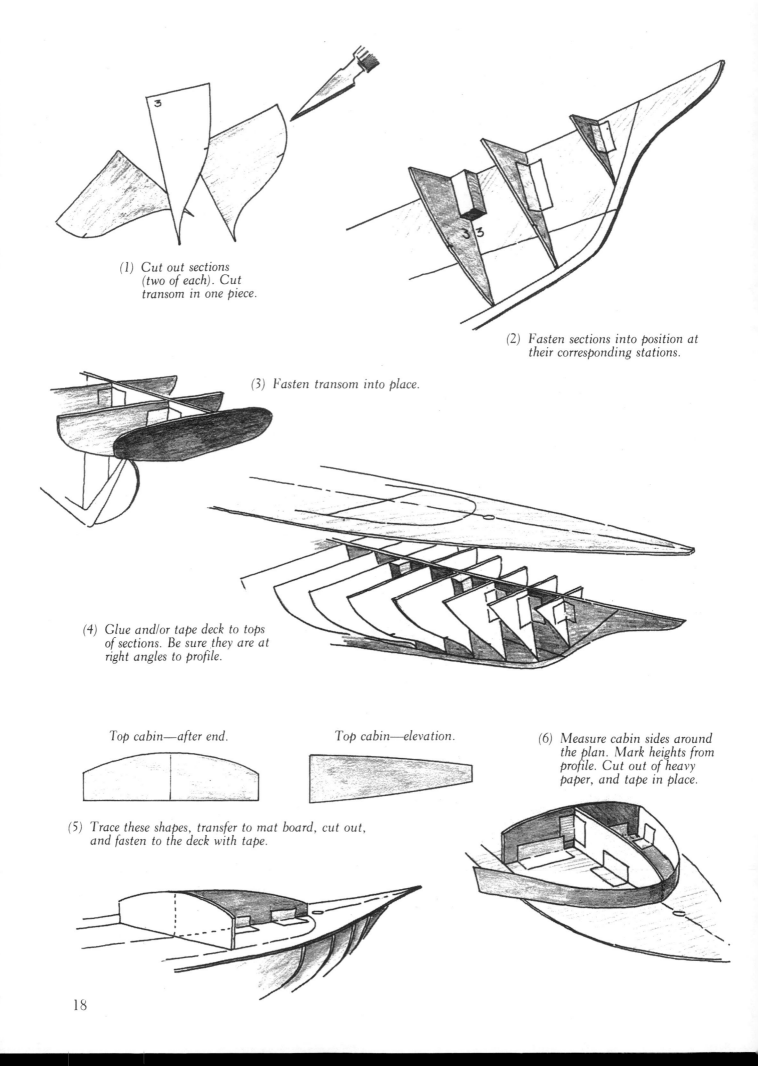

(1) Cut out sections
(two of each). Cut
transom in one piece.

(2) Fasten sections into position at
their corresponding stations.

(3) Fasten transom into place.

(4) Glue and/or tape deck to tops
of sections. Be sure they are at
right angles to profile.

Top cabin—after end.

Top cabin—elevation.

(6) Measure cabin sides around
the plan. Mark heights from
profile. Cut out of heavy
paper, and tape in place.

(5) Trace these shapes, transfer to mat board, cut out,
and fasten to the deck with tape.

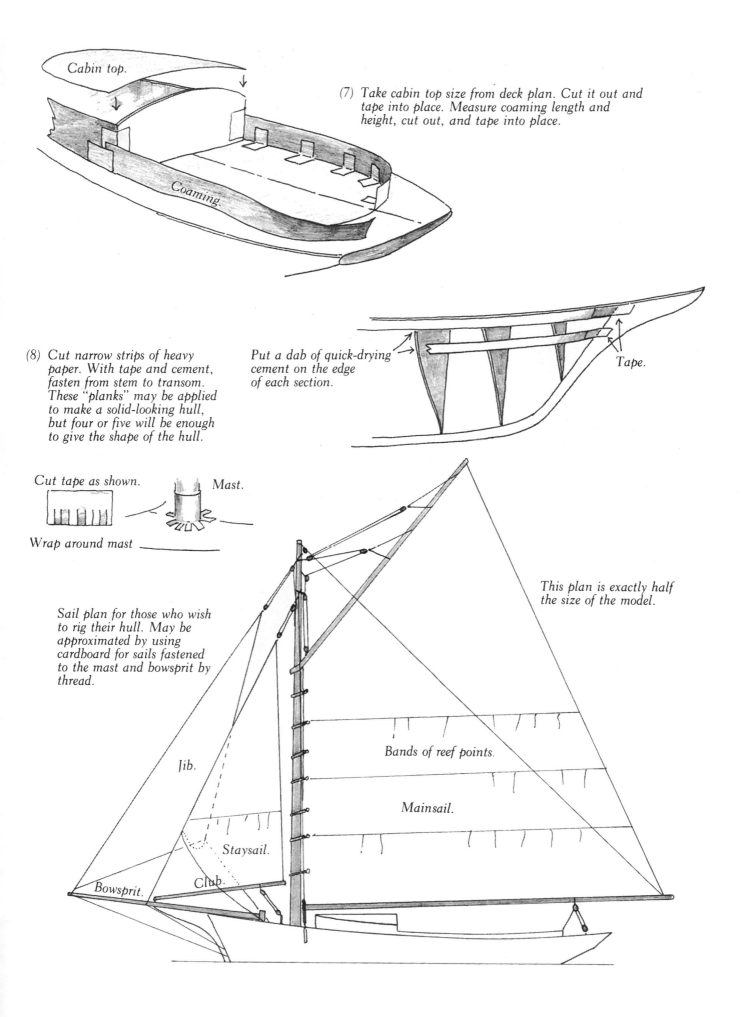

Cabin top.

Coaming.

(7) Take cabin top size from deck plan. Cut it out and tape into place. Measure coaming length and height, cut out, and tape into place.

(8) Cut narrow strips of heavy paper. With tape and cement, fasten from stem to transom. These "planks" may be applied to make a solid-looking hull, but four or five will be enough to give the shape of the hull.

Put a dab of quick-drying cement on the edge of each section.

Tape.

Cut tape as shown.

Mast.

Wrap around mast

This plan is exactly half the size of the model.

Sail plan for those who wish to rig their hull. May be approximated by using cardboard for sails fastened to the mast and bowsprit by thread.

Jib.

Bands of reef points.

Mainsail.

Staysail.

Bowsprit.

Club.

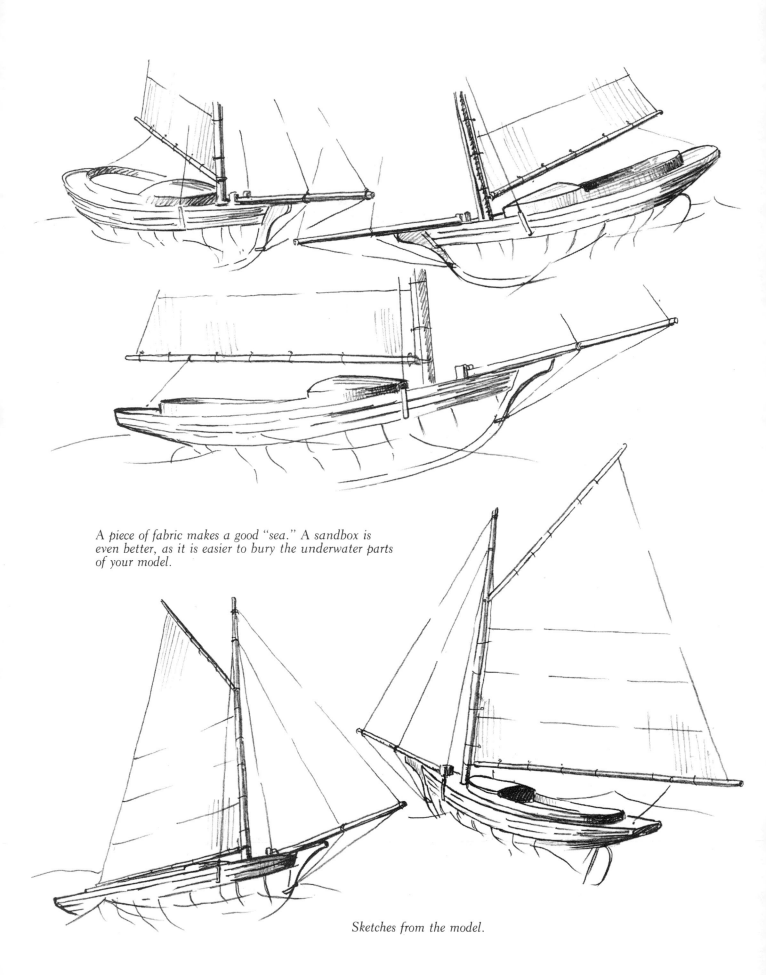

A *piece of fabric makes a good "sea." A sandbox is even better, as it is easier to bury the underwater parts of your model.*

Sketches from the model.

Once you have become accustomed to the feel of a hull and can think of it as something symmetrically shaped and curved yet solid—not a two-dimensional form to be stuck into a painting—then you can begin to set your vessels into your water and give them some of the life and motion of the real thing. Notice how much action you can get into your drawings by showing your ships heaving, pitching, and rolling. Remember, though, that however wild the motion, the laws of perspective still apply. Although the VPs may not be near the horizon, those parallel lines should still appear to meet somewhere.

Illustrated are a few typical hulls showing the great variety of shapes and sizes which the marine painter may encounter.

I mentioned earlier differences in size. Be sure that you know how to use perspective to establish the correct scale of your vessels in relation to each other. You look a little foolish if the small fishing boat you have shown in the background turns out on careful measuring to be larger than the freighter in the foreground. Use your perspective properly and this won't happen.

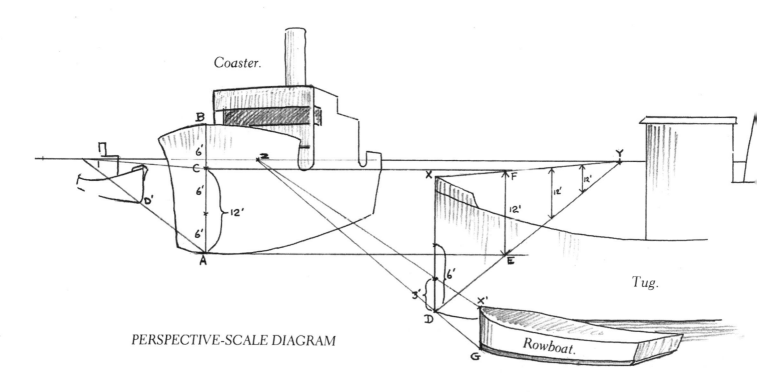

Coaster.

Tug.

Rowboat.

PERSPECTIVE-SCALE DIAGRAM

This diagram shows how you can establish a reasonably accurate relationship between hulls of various sizes at different distances from each other. Reference to a blueprint would give the exact heights of specific ships, bow to water line. Such nicety is seldom necessary, so suppose we say the height A-B on the little coaster is 18 feet. The same measurement on an average tug might be 12 feet.

We have drawn our coaster; now we want to put in a tug closer to us, say at point D. Our problem is to find the proper height, X, in relationship to the larger vessel. First divide A-B (18 feet) by 3. Then draw horizontal lines parallel with horizon from C and A. Pick a convenient spot (Y) on horizon line. Draw line D-Y. Where this crosses horizontal line from A(E), draw a perpendicular to the point where it touches line from C(F). Where a line from Y through F cuts a perpendicular from D(X) is the top of the tug's bow. A tug of the same height at D may be found by the same method, or if convenient, by drawing a line from A through D to the horizon and back to C.

Obviously, if you had the larger tug drawn first and wanted to put in a freighter or other vessel you merely reverse the process. By dividing any known height you can find the relative heights of boats of different sizes, as with the 3-foot rowboat at G. There are endless variations, as long as you have at least one known height to use as a yardstick.

SOME HULLS IN ACTION

It is a good idea to draw the hull in the position you want and then construct the water formation around it—even if most of the hull will be covered. Be sure the hull is well down into the water. In rough weather, particularly, much of the hull is often buried. Also draw through the lines of the hull to be covered by sails—it will give the lines continuity.

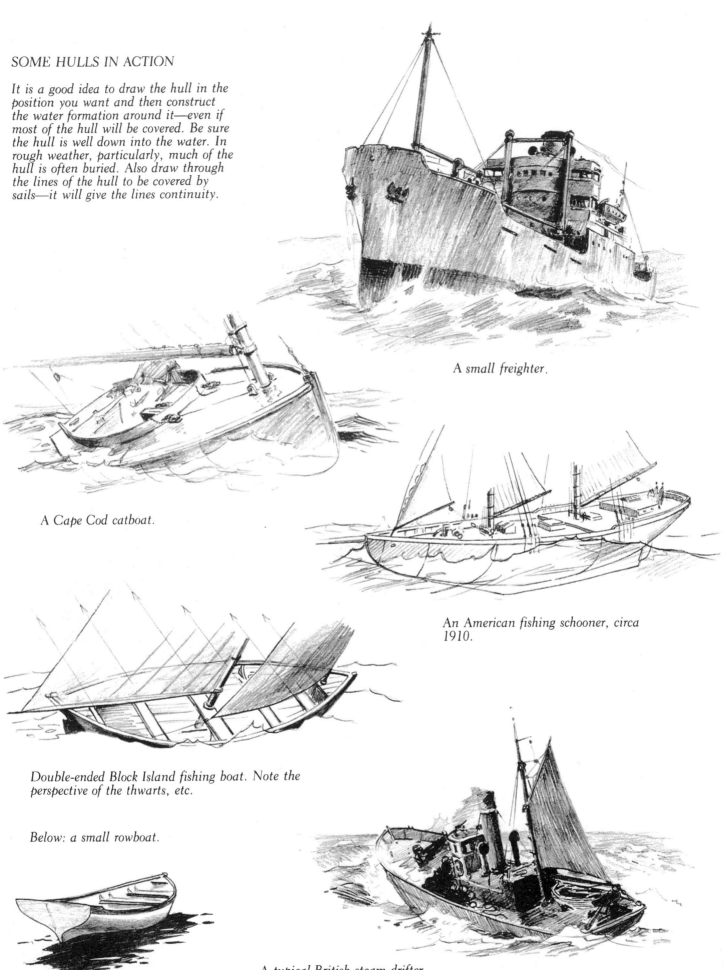

A small freighter.

A Cape Cod catboat.

An American fishing schooner, circa 1910.

Double-ended Block Island fishing boat. Note the perspective of the thwarts, etc.

Below: a small rowboat.

A typical British steam drifter.

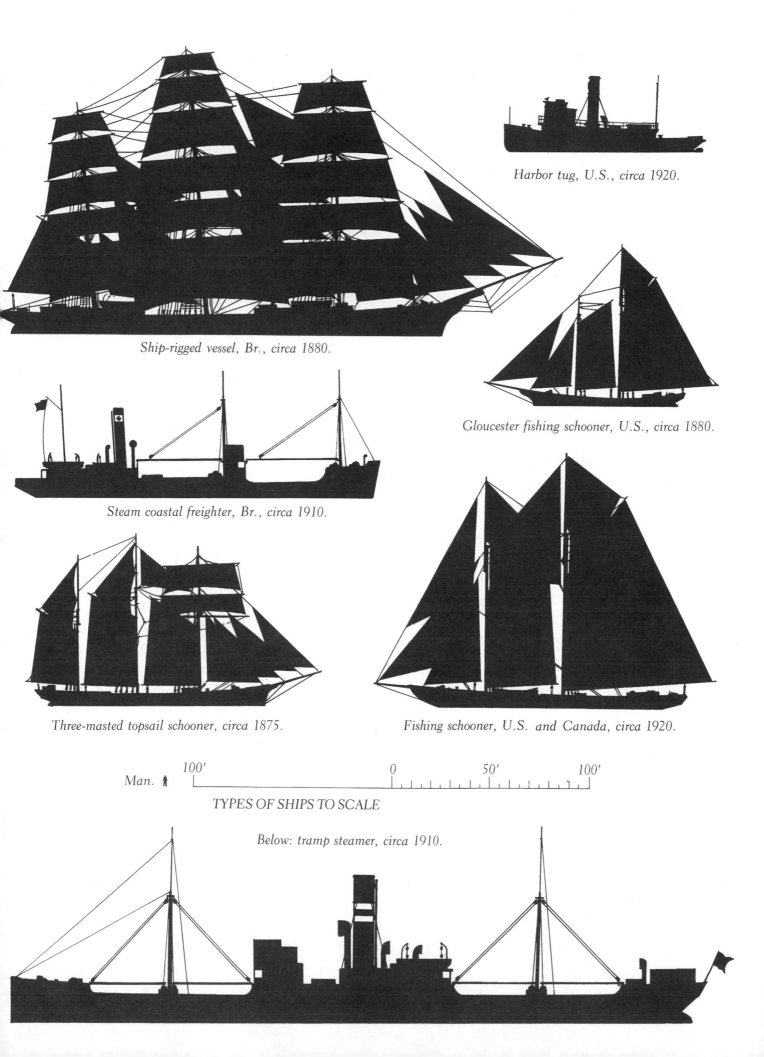

Harbor tug, U.S., circa 1920.

Ship-rigged vessel, Br., circa 1880.

Gloucester fishing schooner, U.S., circa 1880.

Steam coastal freighter, Br., circa 1910.

Three-masted topsail schooner, circa 1875.

Fishing schooner, U.S. and Canada, circa 1920.

Man. 100' 0 50' 100'

TYPES OF SHIPS TO SCALE

Below: tramp steamer, circa 1910.

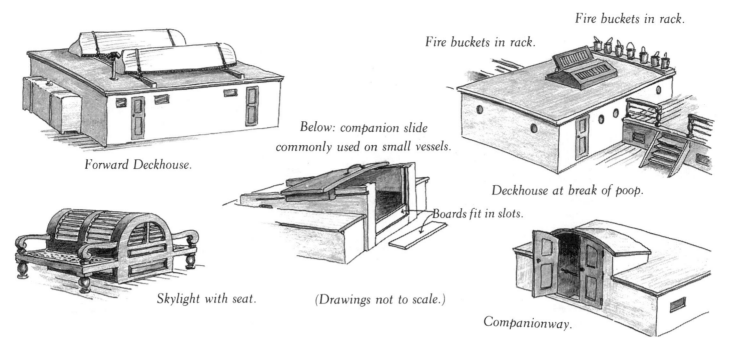

Forward Deckhouse.

Fire buckets in rack.

Fire buckets in rack.

Below: companion slide
commonly used on small vessels.

Deckhouse at break of poop.

Boards fit in slots.

Skylight with seat.

(Drawings not to scale.)

Companionway.

Deckhouses, companionways, and skylights were of many shapes and sizes. Only the upper part would show above a clipper ship's bulwark, which was often 5 or 6 feet high. In smaller vessels bulwarks might be only 30 inches. The poop had an open rail much like a modern steamship, so anything there was visible.

Passenger-immigrant ships had large deckhouses and more skylights. The dining saloon of Rodney, 1874, with much fine woodwork and stained-glass skylights, was 80 feet long, with berths for sixty leading off it. The four hundred or more immigrants were housed between-decks in far less splendor. Such ships carried steam condensers for fresh water and galleys capable of feeding five hundred. In cargo ships deckhouses were smaller and poops usually shorter. Hulls and rigs were similar. Deckhouses were usually painted white. So were the boats, often with a blue gunwale.

A. Forecastle.
B. Catheads and stowed anchors.
C. Capstan.
D. Forward hatch.
E. Foremast fife rail.
F. Spare yards.

G. Ship's boats.
H. Galley stack.
I. Forward deckhouse.
J. Main hatch.
K. Main fife rail.
L. Pumps.

M. Main hatch.
N. Davits.
O. Ship's boats.
P. Mizzen fife rail.
Q. Skylight.
R. Companionway.

S. Wheel box, etc.
T. Bumpkin.
U. Poop.
V. Wash ports.

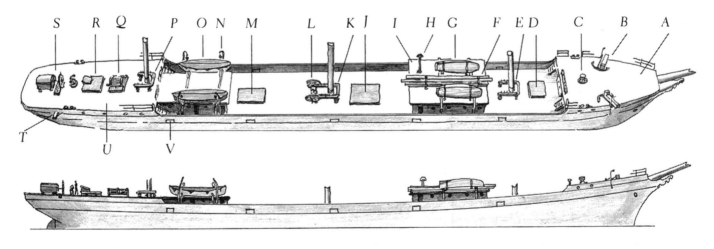

TYPICAL THREE-MASTED SHIP OR BARK, PERIOD 1880–1900

Deck plans varied greatly. The above sketches show a vessel with a raised poop and forecastle. Some were flush decked, and in some the poop was carried forward almost to the after hatch. Hatch placement varied as did the placement and length of the forward deckhouse. Long poops and big deckhouses were mostly found in ships which carried passengers and/or a number of apprentices.

Do not use the so-called tall ships as examples. Most of these were specially designed as training ships to carry many cadets, but no cargo; the size of deckhouses and number of ship's boats are proportionally large, plus there is much safety netting, more exhaust stacking and so on, and sometimes even a navigating bridge. A far cry from a deep-laden vessel beating her way around the Horn with a crew of eighteen or twenty men and a couple of boys.

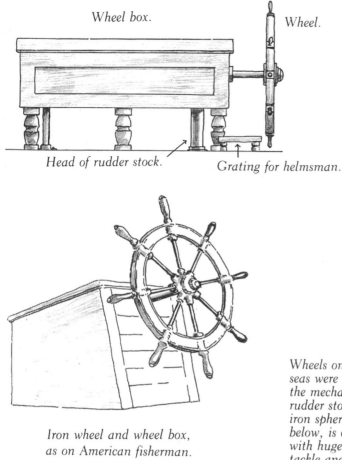

Wheel box.

Wheel.

Head of rudder stock.

Grating for helmsman.

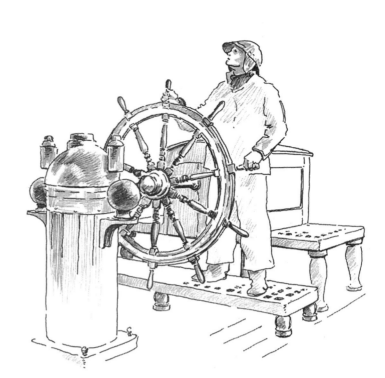

Iron wheel and wheel box,
as on American fisherman.
All sizes. One above about
2' in diameter.

Wheels on large vessel might be 4 or 5 feet in diameter and in rough
seas were held by two men. The wheelbox, seen above with seats, held
the mechanism which transmitted the movement of the wheel to the
rudder stock. In front is the binnacle holding the compass. The soft
iron spheres compensate for magnetic material in the hull. The tiller,
below, is one of the oldest and simplest steering devices. In large ships
with huge rudders, holding the tiller by hand was impractical, so
tackle and a drum turned directly by the wheel was used. Such a
device would have been found on the Constitution and others of her
period.

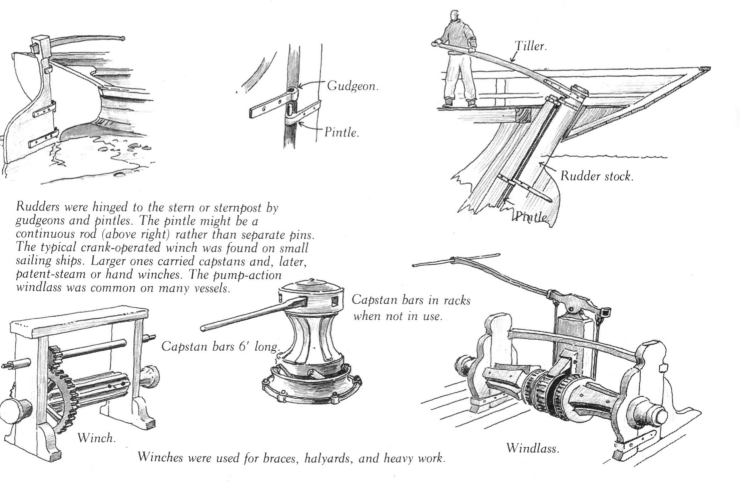

Gudgeon.

Pintle.

Tiller.

Rudder stock.

Pintle.

Rudders were hinged to the stern or sternpost by
gudgeons and pintles. The pintle might be a
continuous rod (above right) rather than separate pins.
The typical crank-operated winch was found on small
sailing ships. Larger ones carried capstans and, later,
patent-steam or hand winches. The pump-action
windlass was common on many vessels.

Capstan bars in racks
when not in use.

Capstan bars 6' long.

Winch.

Windlass.

Winches were used for braces, halyards, and heavy work.

One of the difficulties in drawing hulls is the proper placing of the various components—masts, deckhouses, and so on—in relation to the hull and to each other. Photos, if available, are seldom at the angle you want. Often you must improvise, and "imagining" a hull with masts properly spaced and deckhouses the right width and angle is not easy. I don't know if the method shown below and on the opposite page is in common use. If it is, I have never come across it and I "invented" mine years ago and have found it very useful, particularly when working from a blueprint of a specific boat.

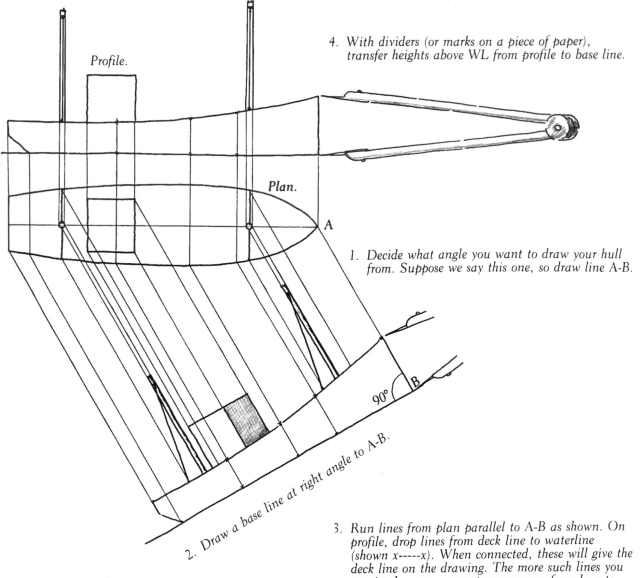

Profile.

Plan.

4. With dividers (or marks on a piece of paper), transfer heights above WL from profile to base line.

1. Decide what angle you want to draw your hull from. Suppose we say this one, so draw line A-B.

2. Draw a base line at right angle to A-B.

90°

3. Run lines from plan parallel to A-B as shown. On profile, drop lines from deck line to waterline (shown x-----x). When connected, these will give the deck line on the drawing. The more such lines you put in the more accurate your curve from bow to stern (sheer) will be.

Note: Do not draw shrouds on far side of hull until you have put the drawing in perspective. The point where the shroud is fixed to the deck may be above or below the point shown.

This is the way I transform a profile and plan into an angled view. If no plan is available, I draw a rough one, estimating length, beam, and position of deckhouses, mast, and the like.

The method looks complicated but is very simple. After determining the angle you want, draw lines from the salient features down to the base line (which must be at 90° to these lines). Then take the heights above the waterline from the profile, mark them on the corresponding lines, and connect them. The resulting drawing will not be in perspective. Put in a horizon line, estimate your vanishing points, and correct your drawing accordingly. If you tape your drawing to your drawing board at the desired angle, you can draw your parallel lines with a T-square. Extra detail can be put in by eye.

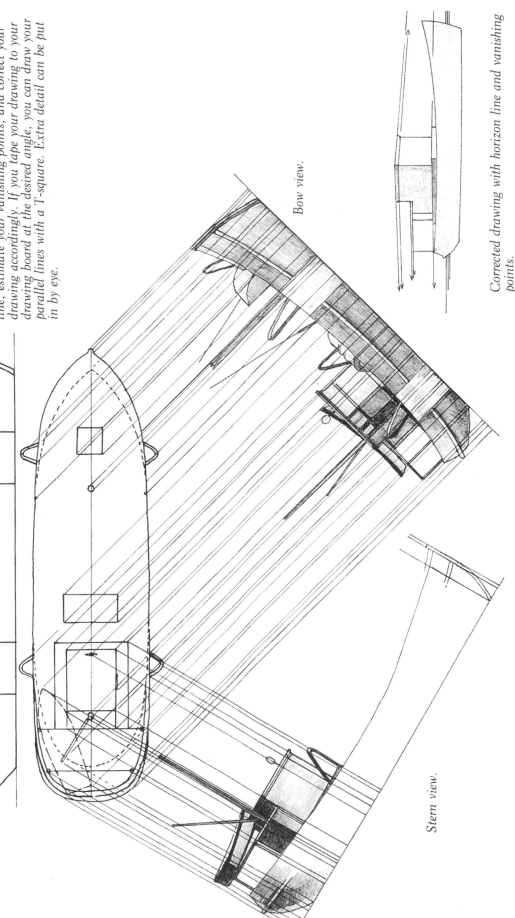

Bow view.

Stern view.

Corrected drawing with horizon line and vanishing points.

27

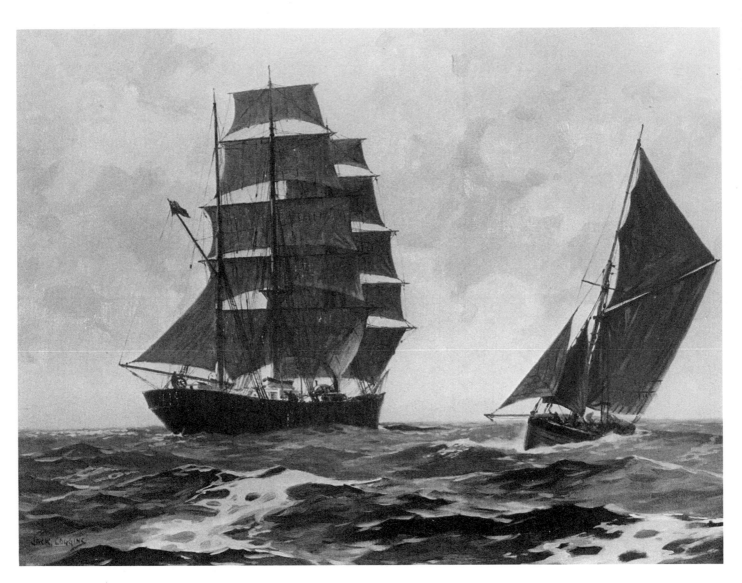

Oil on board Bark and Bawley *14x18"*

A *bawley* is a small open fishing sloop that was often seen around the mouth of the Thames many years ago. Here is one beating to windward while a three-masted bark, with the wind over her port quarter, proceeds on her way with all square sails set. This was painted on an acrylic-coated Masonite panel, which gave me the smooth but not slick surface I like for a small and fairly detailed painting. I have not tried to put in too much rigging but have indicated most of the essentials. Usually only a suggestion of a line is needed, as in the flag halyard at the peak of the bark's gaff. Only about a half inch is shown, but the ensign is correctly placed and the eye follows the invisible halyards to the deck.

3
Masts and Rigging

In the days before the internal combustion engine nearly all vessels, even the smallest, carried at least one sail. Sails need a mast and spars to spread on. Rigging is necessary to support the masts and bowsprit as well as to haul the sails up and down and to keep them trimmed to the wind. The supporting rigging, because it is fixed or capable of only minor adjustments, is called the standing rigging. The movable rigging used to operate the sails or other gear is called the running rigging. The drawing of the sloop shows which is which.

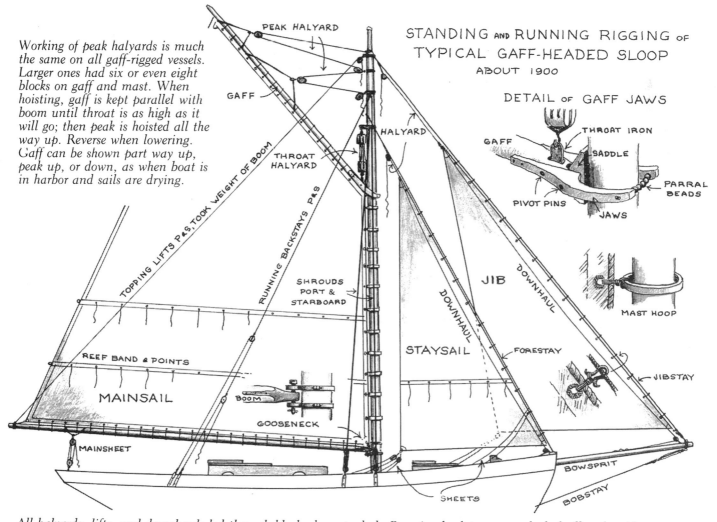

Working of peak halyards is much the same on all gaff-rigged vessels. Larger ones had six or even eight blocks on gaff and mast. When hoisting, gaff is kept parallel with boom until throat is as high as it will go; then peak is hoisted all the way up. Reverse when lowering. Gaff can be shown part way up, peak up, or down, as when boat is in harbor and sails are drying.

STANDING and RUNNING RIGGING of TYPICAL GAFF-HEADED SLOOP ABOUT 1900

DETAIL of GAFF JAWS

PEAK HALYARD

GAFF

HALYARD

THROAT HALYARD

TOPPING LIFTS P&S TOOK WEIGHT OF BOOM

RUNNING BACKSTAYS P&S

SHROUDS PORT & STARBOARD

JIB

DOWNHAUL

DOWNHAUL

STAYSAIL

FORESTAY

REEF BAND & POINTS

MAINSAIL

BOOM

GOOSENECK

JIBSTAY

MAINSHEET

SHEETS

BOWSPRIT

BOBSTAY

THROAT IRON

GAFF

SADDLE

PARRAL BEADS

PIVOT PINS

JAWS

MAST HOOP

All halyards, lifts, and downhauls led through blocks down to deck. Running backstays were slacked off on lee side (side away from wind) so the boom could swing out. On some vessels, the boom had jaws like a gaff but was not curved and had no throat iron.

1. Fore staysail.
2. Mizzen upper topsail halyard leads down to port.
3. Mizzen topgallant halyard to starboard.
4. Mizzen royal halyard to port.
5—5—5. Signal halyards.

B—B, etc. Braces for each square sail, port and starboard. Took names from sails. Thus: fore royal brace, and so on.

M.T.S. Main topmast staysail.

M.S. Main staysail.

M.T.S. Mizzen topmast staysail.

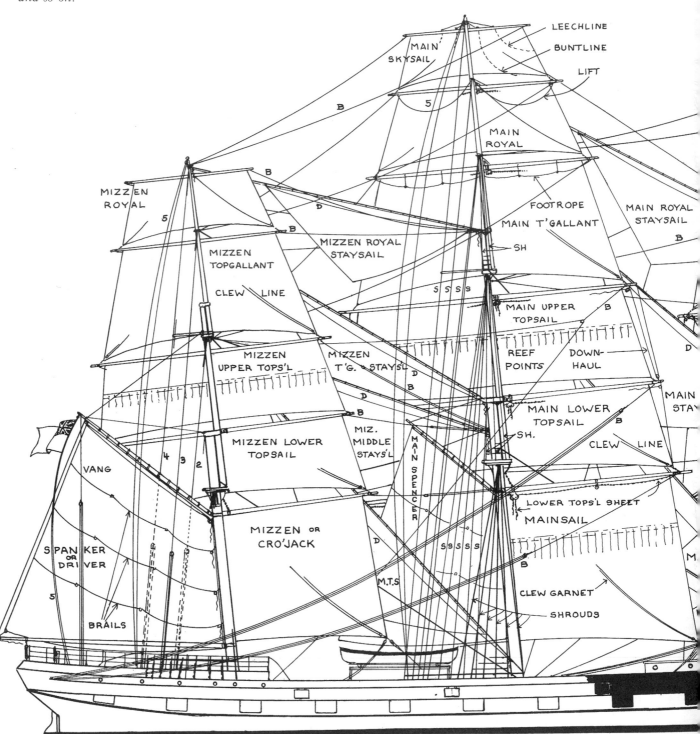

Each jib and staysail had a halyard and a downhaul (D), shrouds (SH), and stays (S), which were the same port and starboard on all masts (not shown on mizzen).

For clarity, square-sail halyards are not shown on main. Sheets (chain) are shown on foremast and main sail only. Leechlines and buntlines shown on foremast and skysail only.

Each yard had a foot rope. Clew lines and clew garnets are indicated. Vangs on spanker and spencer (to steady gaff), port and starboard. Brials (to furl sails to masts) on each side of sail.

One of the ship's boats is shown for scale—also a figure on forecastle. Wash ports hinged on out-board side to free decks of water. Painted ports on white strake were favored by many ship owners. In a small-scale drawing it is impossible to show all rigging details. All halyards, sheets, downhauls, clew lines, buntlines, and leechlines, for instance, led ultimately down to the deck—and there were seventy-four of the last two alone. For clarity, only the foremast is fully rigged. For the same reason none of the jib and staysail sheets and halyards is shown except on the flying jib. Even an incomplete drawing like this may look complicated, but everything was logical and filled a purpose, and a little study will give you a fair idea of how things worked.

Ships often differed slightly in rig. Not all at this date carried a skysail or a mizzen middle staysail or main spencer. Rigs were often altered, and Loch Etive ended as a bark. Unlike sails in plans, real canvas billowed, slatted, flogged and on occasion blew to rags. Use this drawing for what it is, a blueprint to help you construct an authentic and workable painting.

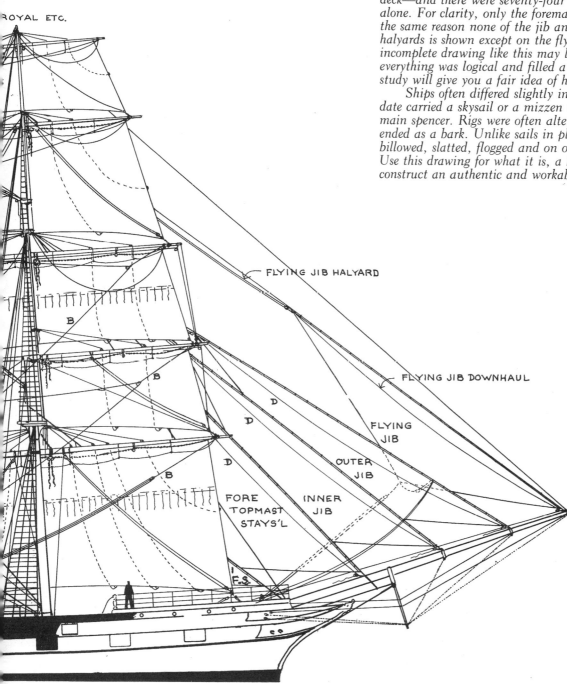

ROYAL ETC.

FLYING JIB HALYARD

FLYING JIB DOWNHAUL

FLYING JIB

OUTER JIB

INNER JIB

FORE TOPMAST STAYS'L

B

D

F.S.

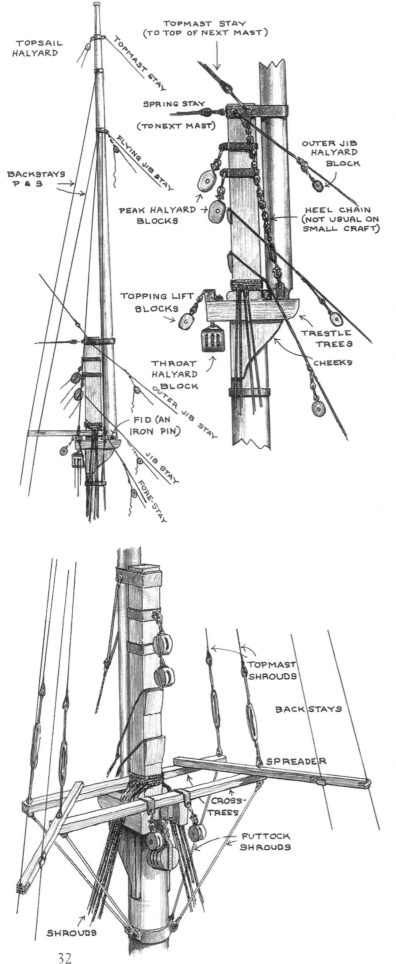

TOPSAIL
HALYARD

TOPMAST STAY
(TO TOP OF NEXT MAST)

TOPMAST STAY

SPRING STAY
(TO NEXT MAST)

FLYING JIB STAY

OUTER JIB
HALYARD
BLOCK

BACKSTAYS
P & S

PEAK HALYARD
BLOCKS

HEEL CHAIN
(NOT USUAL ON
SMALL CRAFT)

TOPPING LIFT
BLOCKS

TRESTLE
TREES

THROAT
HALYARD
BLOCK

CHEEKS

OUTER JIB STAY

FID (AN
IRON PIN)

JIB STAY

FORE-STAY

TOPMAST
SHROUDS

BACK STAYS

SPREADER

CROSS-
TREES

FUTTOCK
SHROUDS

SHROUDS

On large ships, such as the square-riggers that were the glory of the great days of sail, there were several masts and many yards and sails. The huge *Preussen*, the only five-masted full-rigged ship ever built, had forty-seven sails, totaling 50,000 square feet. She had 35,424 feet of standing rigging. Her running rigging—hemp, wire, and chain—totaled 102,303 feet, over nineteen miles!

Smaller vessels were also complicated, as is shown by the drawing of the *Loch Etive*, a vessel of only a quarter of the *Preussen*'s tonnage. (*Loch Etive* was a fine ship and for a time had a third mate, who later found fame as a writer—Joseph Conrad.) Some marine painters specialize in ships of this sort (and can name every piece of rigging, too). You may never want to paint a full-rigged three-master, but there are lots of small craft with far less complicated rigs that can add a great deal to a picture if they are handled right. You don't have to detail all the rigging; suggestion is often enough. Just be sure you don't paint a sail filled by a strong breeze with nothing to hold it from flowing out like a flag.

Many small vessels, like the Friendship sloop, had only one mast. Sometimes to gain extra height and so spread more sail, a second small mast was set above the first. This was called a topmast and could be removed or sent down in bad weather. The Friendship sloops often carried one in the summer and removed it when winter brought rough weather. Rigging of a topmast varied greatly. The one pictured in some detail gives a good idea.

Other small craft had two or even three masts, and sometimes one or more of these had topmasts as well. The big ships had masts above the topmasts called the topgallant masts. These also carried square sails on yards. The detailed drawing shows how these were usually rigged.

Details differed, but the principle was the same on other masts and in other rigs. Many masts were round above the trestle trees, not squared as in the diagrams (top). The heel of the topmast rested on the fid. When this was removed the mast could be lowered.

In older ships, shrouds were set up by deadeyes, not turnbuckles as shown. In many cases, instead of using spreaders the after crosstree was made longer. Ratlines are not shown in the diagram at left.

The topmast details are typical of many fore- and aft-rigged masts.

32

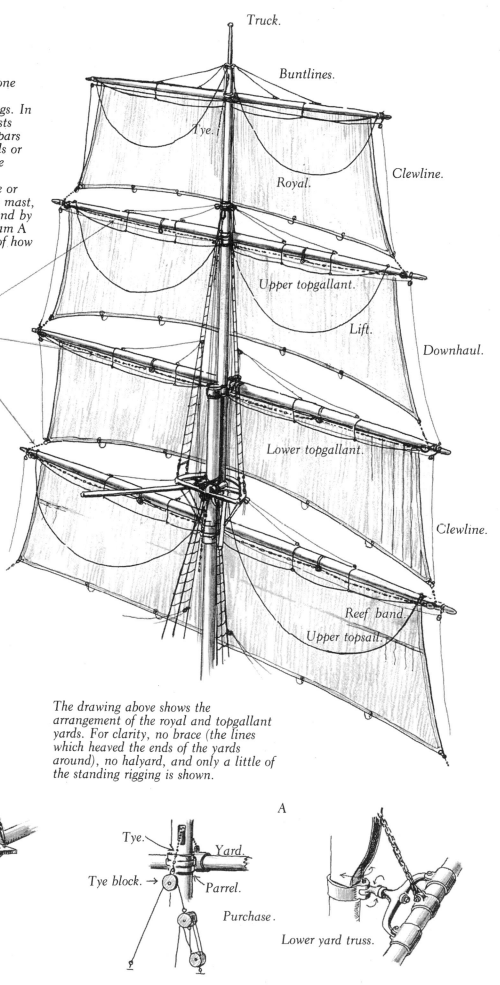

Royal and topgallant masts were one spar. The places where two masts overlapped were called the doublings. In some later ships, main and topmasts were one spar also. The movable spars slid up and down on parrels, bands or hoops of some kind. The yards were heavy and the hauling tackle correspondingly stout. A chain (tye or tie) passed through a sheave in the mast, down to a large block (tye block) and by more tackle to the deck. The diagram A below, not to scale, gives an idea of how this is set up.

Sheets, which got a lot of wear where they ran through the sheaves at the yardarm, were often wholly of chain, as in the drawing, or chain shackled to wire or rope. They led down to the deck, as did all clewlines, buntlines, and downhauls.

Below: doublings of lower mast and topmast, showing top, sheet blocks, starboard shrouds, and fittings (trusses), which hold yards yet permit them to swivel.

Truck.

Buntlines.

Tye.

Royal.

Clewline.

Upper topgallant.

Lift.

Downhaul.

Sheet.

Lower topgallant.

Clewline.

Reef band.

Upper topsail.

The drawing above shows the arrangement of the royal and topgallant yards. For clarity, no brace (the lines which heaved the ends of the yards around), no halyard, and only a little of the standing rigging is shown.

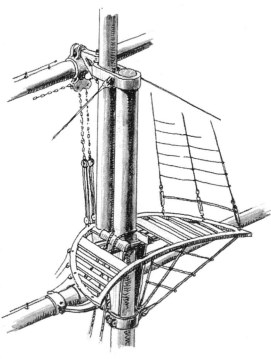

A

Tye.

Yard.

Tye block. →

Parrel.

Purchase.

Lower yard truss.

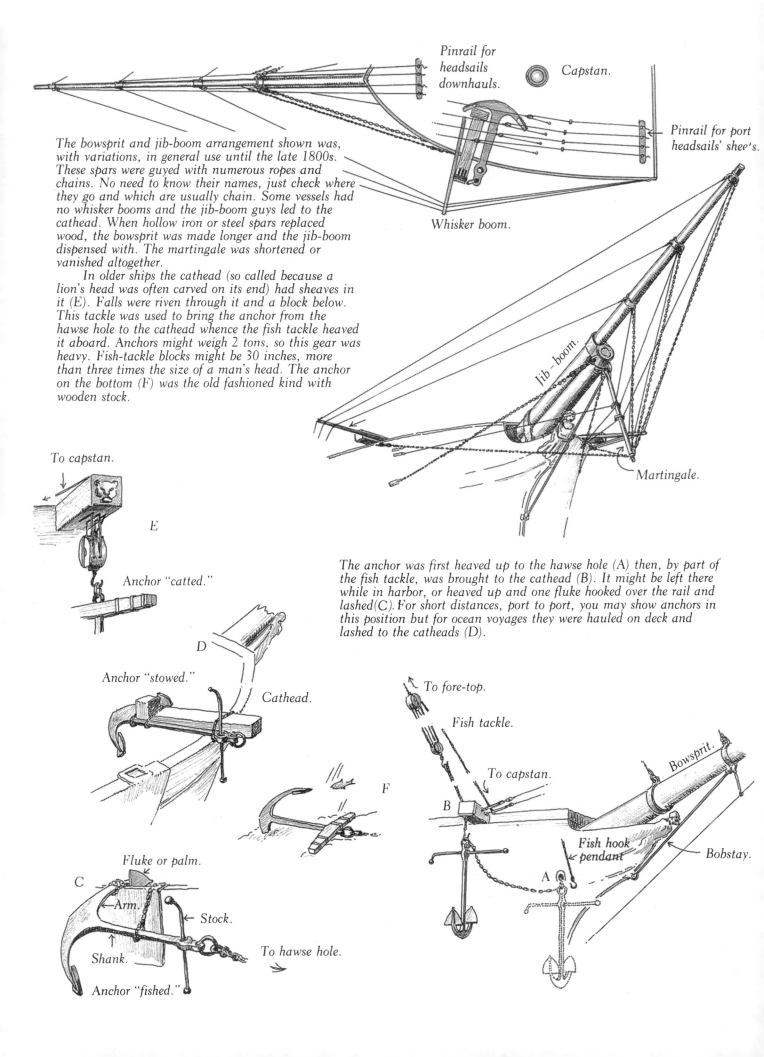

Pinrail for
headsails
downhauls.

Capstan.

Pinrail for port
headsails' shee's.

Whisker boom.

The bowsprit and jib-boom arrangement shown was, with variations, in general use until the late 1800s. These spars were guyed with numerous ropes and chains. No need to know their names, just check where they go and which are usually chain. Some vessels had no whisker booms and the jib-boom guys led to the cathead. When hollow iron or steel spars replaced wood, the bowsprit was made longer and the jib-boom dispensed with. The martingale was shortened or vanished altogether.

In older ships the cathead (so called because a lion's head was often carved on its end) had sheaves in it (E). Falls were riven through it and a block below. This tackle was used to bring the anchor from the hawse hole to the cathead whence the fish tackle heaved it aboard. Anchors might weigh 2 tons, so this gear was heavy. Fish-tackle blocks might be 30 inches, more than three times the size of a man's head. The anchor on the bottom (F) was the old fashioned kind with wooden stock.

Jib – boom.

Martingale.

To capstan.

E

Anchor "catted."

The anchor was first heaved up to the hawse hole (A) then, by part of the fish tackle, was brought to the cathead (B). It might be left there while in harbor, or heaved up and one fluke hooked over the rail and lashed(C). For short distances, port to port, you may show anchors in this position but for ocean voyages they were hauled on deck and lashed to the catheads (D).

Anchor "stowed."

D

Cathead.

To fore-top.

Fish tackle.

To capstan.

Bowsprit.

B

Fish hook
pendant

Bobstay.

F

A

Fluke or palm.

C

Arm.

Stock.

Shank.

To hawse hole.

Anchor "fished."

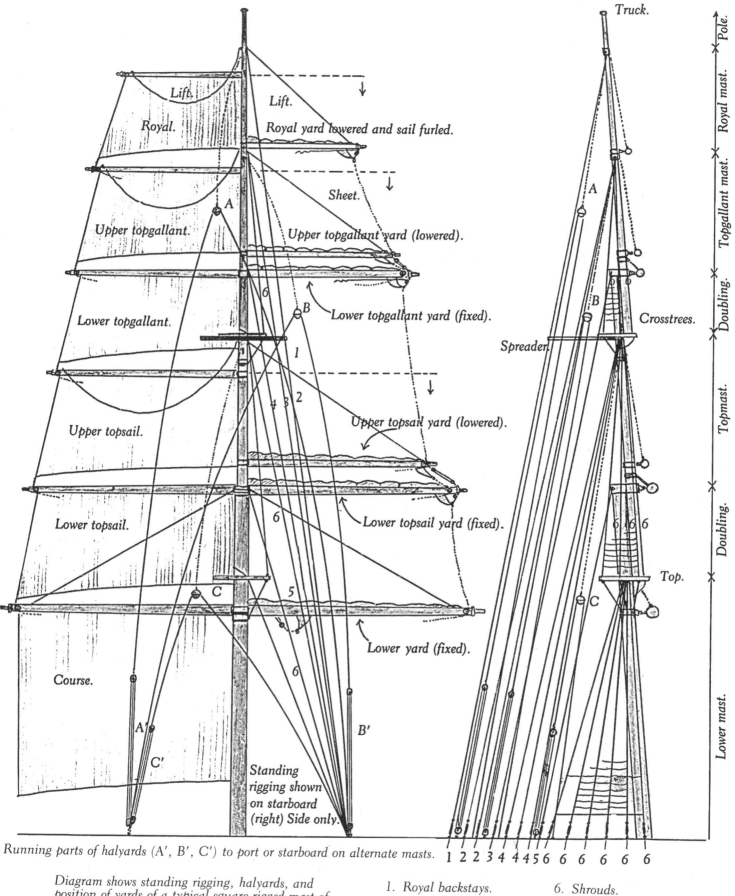

Lift.

Lift.

Royal.

Royal yard lowered and sail furled.

Sheet.

A

Upper topgallant.

Upper topgallant yard (lowered).

6

B

Lower topgallant.

Lower topgallant yard (fixed).

1

4 3 2

Upper topsail.

Upper topsail yard (lowered).

6

Lower topsail.

Lower topsail yard (fixed).

C

5

Course.

Lower yard (fixed).

A

6

B'

C'

Standing
rigging shown
on starboard
(right) Side only.

Truck.

Pole.

Royal mast.

A

Topgallant mast.

Doubling.

B

Crosstrees.

Spreader.

Topmast.

6 6 6

C

Doubling.

Top.

Lower mast.

1 2 2 3 4 4 5 6 6 6 6 6

Running parts of halyards (A', B', C') to port or starboard on alternate masts.

Diagram shows standing rigging, halyards, and
position of yards of a typical square-rigged mast of
post-clipper-ship era. For clarity, the tyes and halyards
are shown off-center. The tye-blocks would normally
fall in line with the masts.

1. Royal backstays.
2. Topgallant backstays.
3. Topmast cap backstays.
4. Topmast backstays.
5. Lower cap backstays.

6. Shrouds.
A. Royal tye.
B. Upper topgallant tye.
C. Upper topsail tye.

Masts had supporting lines, called stays, and sails, called staysails, were set on some of these. There were other fore-and-aft sails forward and one or two on the mast nearest the stern. A vessel with at least three masts, all of them with square sails, was called a full-rigged ship. Most had three masts, a few had four, and one, the *Preussen*, had five. A vessel with two or more masts with square sails and the aftermost mast (the mizzenmast) rigged with fore-and-aft sails was called a bark, or barque, as it is often spelled. The drawings, much simplified, show some of the different types.

When starting a ship painting (assuming that the preliminary composition sketches have been made and the position and size of the vessel in relation to the canvas has been established), I always begin with a full-scale working drawing. On this is planned the position and set of yards and sails and the more visible and vital portions of the rigging. Obviously it is not possible (nor desirable) to put in all the details, any more than a landscape painter need show every leaf and blade of grass. But even the merest suggestion of a brace or sheet is usually enough to tell the viewer that the yard or sail is properly secured and not left unsupported like a three-legged card table. The diagrams in this chapter show more detail than you may need to know, but it is essential to see how gear looks and works no matter how impressionistically you intend treating the final product.

The sketch below was based on a photo. Detail in old photos is often lost. By picking up part of a line or the edge of a sail it is usually possible to trace the line or shape to its logical conclusion. From plans or profiles you can construct a working drawing using method on page 27.

5. Next indicate the yards, checking their lengths and angles to masts.

7. Don't bring lower corners (clews) of sails right down to yards below. Leave room for the sheets.

8. From a profile, plot positions of heads and tacks of fore-and-aft sails. Erase hidden parts as you go along. To avoid confusion, shade in staysails on your working drawing.

3. Mark terminals of shrouds and stays and draw them in. Some may be ultimately hidden but put them in lightly anyway.

11. Buntlines, clewlines, leechlines, and so on usually led through fairleads on shrouds to pins at the bulwark. All are close together and should be so indicated.

4. As many as fourteen lines may terminate in each area A—A—A. Only indication is possible. Remember that shrouds and their ratlines will appear heavier.

9. When sails, braces, and standing rigging are in, indicate bunt and leech lines to tops. These are thin compared to shrouds and stays, as are jib and staysail halyards.

10. Lighter lines such as braces and halyards often become lost in finished paintings, especially in shadow. Lines from yardarms will give direction and are usually visible against sky.

6. Sketch in sails. In stern view as shown, start with foremast. As sails on mainmast are drawn, erase those on the foremast which are hidden.

2. Locate masts on an approximate center line from a profile or photo, and draw in lightly.

12. Last, put in deck details, houses, boats, and so on. Plot the positions of these from plans or profiles. If from photos (often blurry or confused), be sure to try to make out details and simplify if necessary.

1. Start by sketching in the bare hull. Don't bother with deckhouses and so on yet.

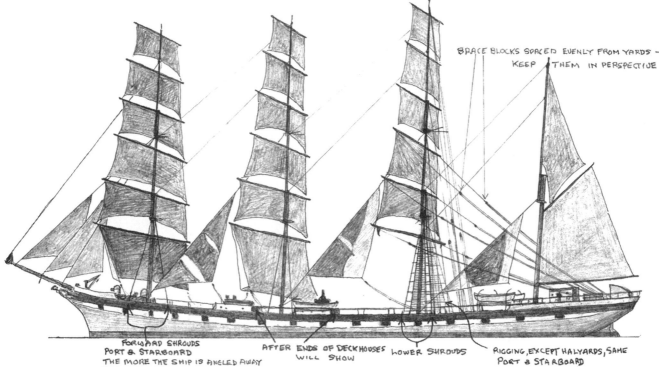

BRACE BLOCKS SPACED EVENLY FROM YARDS —
KEEP THEM IN PERSPECTIVE

FORWARD SHROUDS
PORT & STARBOARD
THE MORE THE SHIP IS ANGLED AWAY
THE GREATER THE SPREAD

AFTER ENDS OF DECKHOUSES
WILL SHOW

LOWER SHROUDS

RIGGING, EXCEPT HALYARDS, SAME
PORT & STARBOARD

Four-masted bark Archibald Russell, *1905. Length 291 feet. Breadth 43 feet. Like most steel ships of her era, her square-rigged masts were all of the same height and all yards were interchangeable.*

The view above is from slightly astern so that the foremost shrouds appear forward of the masts. The rest of the rigging will also change angle as you change your viewpoint. You can check the position of the rigging by the method shown on page 27. A ship this size usually had five lower shrouds and maybe nine stays on each side of each square-rigged mast, plus three or more halyards with their blocks and tackle. Add braces and you have a lot of rigging, without the lifts, buntlines, and so on. Try to indicate this convincingly without making a blueprint out of it.

Note the way the shadows fall. These can be useful in breaking the monotony of a lot of white canvas and can help show the curves of the sails they fall on. Be sure if you have to fake shadows that you project them with reasonable accuracy.

In the sketch above notice how the yards do not appear centered on the masts. This is because the yards are fastened a little way out from the masts and because of the thickness of the masts themselves. Note too that the sails are not uniform in shape or set. Perfectly set and fitted sails tend to make a painting stiff and wooden.

The 407-foot Preussen, *below, was the only five-masted full-rigged ship ever built. Like most over-sized sailers, she was not considered particularly handsome. Launched in 1902, she went ashore after a collision in the Channel in 1910 and broke up.*

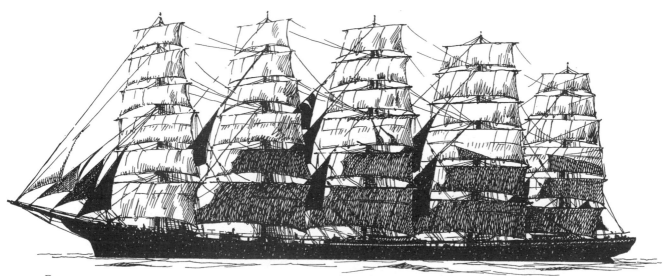

Preussen.

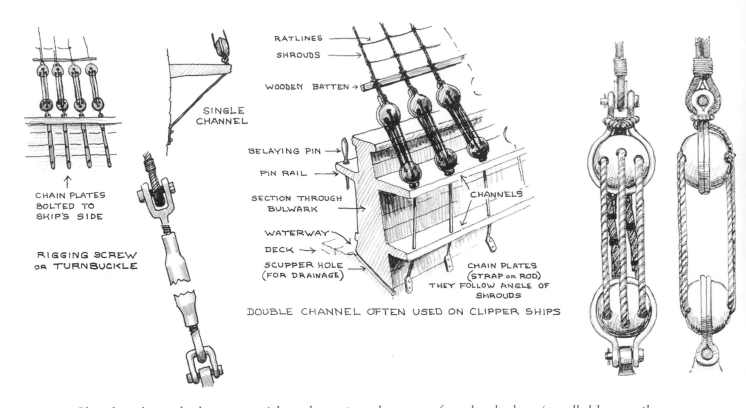

CHAIN PLATES BOLTED TO SHIP'S SIDE

RIGGING SCREW OR TURNBUCKLE

SINGLE CHANNEL

RATLINES
SHROUDS
WOODEN BATTEN

BELAYING PIN
PIN RAIL
SECTION THROUGH BULWARK
WATERWAY
DECK
SCUPPER HOLE (FOR DRAINAGE)

CHANNELS

CHAIN PLATES (STRAP OR ROD) THEY FOLLOW ANGLE OF SHROUDS

DOUBLE CHANNEL OFTEN USED ON CLIPPER SHIPS

Shrouds and some backstays were tightened, or set up, by means of wooden deadeyes (so called because they resembled skulls) and lanyards. One end of the lanyard was knotted and the other passed through the eyes of both, being hauled taut by a block and tackle. The end was then "seized," as shown. The lower deadeye was held by an iron strap fastened to a chain, rod, or bar. This was usually fastened to a heavy timber called a channel, which held the deadeyes clear of the bulwarks. In small vessels the rods (chain plates) were bolted directly to the ships' side. When wire began to replace rope, deadeyes gave way to rigging screws. The diagram shows how ratlines were rigged.

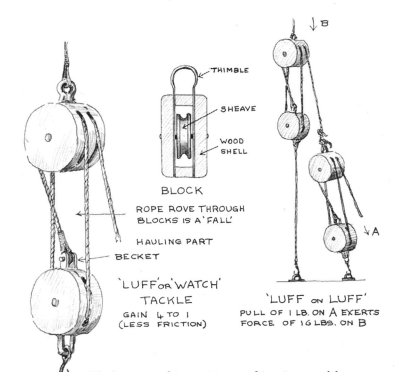

THIMBLE
SHEAVE
WOOD SHELL

BLOCK

ROPE ROVE THROUGH BLOCKS IS A 'FALL'

HAULING PART
BECKET

'LUFF' OR 'WATCH' TACKLE
GAIN 4 TO 1 (LESS FRICTION)

B

A

'LUFF ON LUFF'
PULL OF 1 LB. ON A EXERTS FORCE OF 16 LBS. ON B

So that spars and sails can be managed, most ropes on even small craft lead through pulleys called blocks in nautical parlance. A block consists of a shell of wood or metal containing one or more sheaves over which rope is passed to form a purchase.

A block and tackle (pronounced táy-kel) affords either a change of direction of pull or a direct mechanical advantage (the purchase). Combinations of blocks provide greater advantages. Blocks of different sizes are used by the dozens on even comparatively small vessels. The *Preussen*, by the way, had 1260. It is important to keep the blocks in scale. The largest block on a twenty-foot sailboat, for instance, might be no bigger than a goose egg whereas that on a big schooner or square-rigger might be nearly twice the size of a man's head.

Blocks are used in various combinations and have as many as four sheaves. The more sheaves, the greater the mechanical gain but the more rope to pull and more friction. Luff tackle was much used. A tackle was often made fast to the hauling part of another.

Larger ships had heavier gear. Many blocks were about the size of a man's head. Halyard and brace blocks might be twice that or more. Blocks usually show clearly against skies or sails but don't paint them too dark or they will look like a lot of black spots. The smaller the block, the lighter I paint it.

When working from a drawing or a plan, it helps to establish a man-size scale and apply this as you go along. This way you won't be painting a nine-foot giant steering a small boat or a crew of midgets scurrying up the rigging of a three-master. You don't have to be meticulously accurate about all of this; enough to avoid obvious errors, though.

Bear in mind that the scale of certain things will not change in relation to the comparative size of different vessels. The rungs of a ladder, for instance, will be just as far apart on a seven hundred-foot liner as they are on a sixty-foot fishing trawler. The same goes for height of railings, deck houses, life preservers, and so on.

MAN-SIZE SCALE DIAGRAMS

Railings are usually about 40" high so you can use them as a rough yardstick.

Pilings and crossbeams might be

Knowing a few average measurements helps.

Average rowboat about 18" X-W.

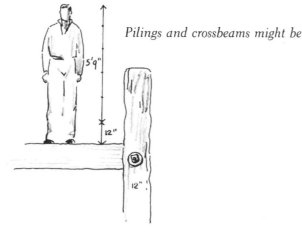

Deckhouse 7' to 7'6".

Doors 6'.

Bulwarks 4' to 5'.

Rope 3" in diameter.

Coaming 1' (doors on ships don't come down to the deck).

A large block might be this big in relation to a man. Many would be at least as large as his head.

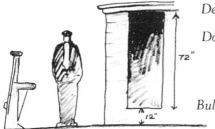

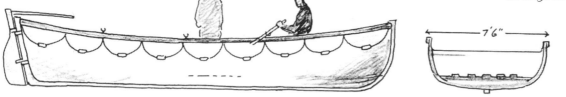

Ship's boats varied in length and beam but were seldom more than 30" to 36" deep. Figures in 24' boat would look about this size.

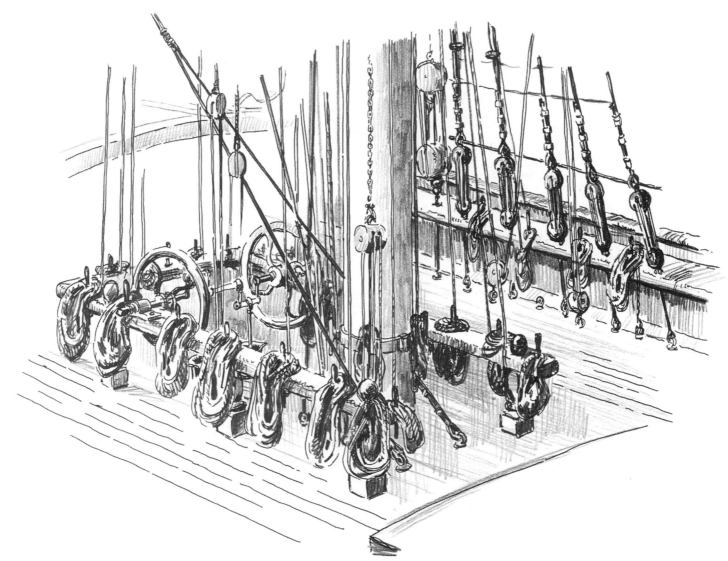

Fife rail and part of port pinrail of a square-rigged vessel, looking aft.

The sketch above gives a general idea of the fife and pin rails and some of the lines leading down from aloft. Standing parts (the fixed ends of rope or gear) usually came down to ringbolts on bulwark, pin rail, or deck. After a line was secured (belayed) around a pin, it was coiled more or less neatly and slung over the pin as shown. Some of the lighter running gear was belayed aloft at tops or crosstrees but most led down to the deck. Each mast had fife and pin rails. Those on fore and aft rigged masts (schooners, for instance, and the after (jigger) mast of barks do not have to accommodate as many lines and are smaller. Both fife and pin rails vary from the above sketch in smaller vessels.

Also secured to bulwark, pin rail, and/or deck were the lower blocks of such tackle as required a purchase (halyards and braces, for instance). The pumps were often located between the fife rails, usually at the mainmast. Long crank handles fitted the squared ends of the axles, which drove the short pump-rods. The water thus raised was discharged on the deck. Most vessels take on a little water—wooden ones often a good deal—and the clatter of the pumps was often heard many hours each day.

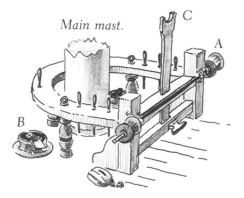

Main mast.

Left: typical main fife rail of small coasting vessel or fisherman. Winch (A), often mounted on bitts. Pumps (B), port and starboard. Handles were inserted in sockets. (C) is crotch for foresail boom, with cleat for fore sheet.
Right: pin rail fastened to shrouds.

Rope comes in different sizes and should be indicated in such a way that the standing rigging, such as shrouds and some stays, appears considerably heavier than, say, the running rigging. Don't get heavy handed with rigging, though, or your work will turn out more like an architect's drawing. Lines should be made to fade, even vanish in places, rather than be painted evenly for their full length.

How I indicate rigging depends entirely on the way I am handling the painting. If the general effect is to be rather on the tight side and the subject is fairly complicated, I often draw the rigging—or as much of it as I want to indicate—in India ink and, for the lighter rigging, medium hard pencil. (I handle the hull and sails the same way.) The sky is then painted thinly over the whole area and let dry. Enough ink or pencil will show through to act as a guide. The rigging I paint with small round brushes, sable or synthetic. I keep a good supply of these, for once they don't point any more they are of little use. By the way, rigging lines are seldom straight and often have quite a curve or sag to them, due to weight or wind or both. When laying in, I often use long curves, such as those aircraft engineers and naval architects use. For the actual painting I use a maulstick for support.

All this is for the detailed approach, for which I paint either directly on a primed Masonite hardboard or on a fine-toothed canvas. For a more direct approach the preliminary drawing is simplified or sometimes eliminated altogether and I work from my sketch. In the *alla prima*, or all-at-once, technique, the sky, mast, sails, hull, and so on are all laid in rapidly. The rigging is put in last, as is natural, but still wet into wet. Instead of soft bristle rounds, which do little except plough a furrow in the wet paint, I often use the chisel edge of a large bright just gently laid on at right angles to the line, not drawn down it, and repeated as necessary. A long painting knife is also very useful. Pick up a small amount of paint evenly along one edge of the knife and apply it at right angles to the canvas. In this way a suggestion of a line can be made even on a fairly thickly painted area.

Observation will show you that light appears to flow around a cylindrical object, such as a spar or a rope. The larger the diameter of the object the darker it will seem to be. Use this knowledge and paint your rigging as it diminishes in thickness with lighter paint. Some small ropes seen from a distance seem almost to disappear. Remember you are not reproducing an architect's sail plan; you are painting your subjects as you would actually see them. If a line is so small as to be scarcely visible, indicate it that way or suggest a little of it at either end and leave the rest out. If this is done correctly, the eye will connect the two ends without your having to draw it all the way through. Leave a little to your viewers' imaginations; it's much better than presenting them with a glorified blueprint.

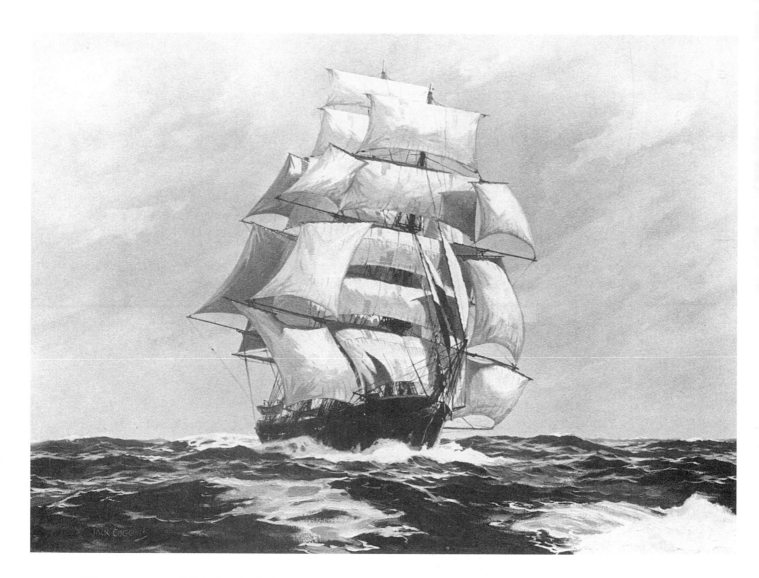

Oil on canvas With Stun'sails Set *22x28"*

A *clipper ship with the trade winds aft, everything up and drawing. Blue skies—deep blue sea—a sailor's delight. It was days like these which made the deep-water men forget the misery of Cape Horn and its freezing, gale-lashed waters. Here in these latitudes with piles of white canvas and fleecy clouds, bright blues and greens are in order to set the mood.*

—From the collection of Mark Kurtz

4

Sails

Cargo ships, naval vessels, power boats all make fine picture material, but there is a romance and pictorial beauty to sail that, in this age of diesels and gas turbines, still appeals to the old salt buried deep within many of us. A partial return to commercial sail may come in the next few years—the price of fuel will see to that—but at the moment those artists who want to portray sailing vessels must, with a few exceptions, stick to painting yachts or else do some careful research into the vessels of days gone by.

Many who buy our wares have little or no knowledge of ships and the sea and are satisfied with the general effect of a marine subject without becoming involved in the specifics. Others know a great deal, and I must warn you that no sharper critic exists than the amateur seaman. No one likes to be caught out in an error, however trivial, and just one mistake will cast doubt on the artist's technical knowledge. So do your homework! Besides, getting things absolutely right is a considerable satisfaction and is usually well worth the time and effort expended.

The amount of detail involved in painting sailing ships depends entirely on the effect the artist intends to produce. A painter bent on faithfully reproducing a vessel with a particular rig—say a square-rigger—needs more knowledge of the subject than someone using a free technique. The drawing and notes were part of my research for a fairly detailed painting of a three-masted bark.

Don't get the idea that a lot of detail must always be shown. Too much usually has an overpowering and deadening effect and ends up defeating its own purpose. A suggestion is often more effective. But to suggest an object the artist must first be well acquainted with that object. A figure, for instance, can be indicated in three or four strokes—and it may look great. But you had better know your figures; otherwise you will end up with an amateurish blob.

Some very fine ship painters have managed to convey the image of a completely rigged vessel with a minimum of hard detail. After all, a painting should tell the viewer a lot more than that the artist knew all the ropes. As I said before, to suggest you first have to know. Several well-known marine artists served aboard sailing ships. Anton Otto Fischer went to sea when he was sixteen and rounded the Horn more than once. He certainly knew *his* ropes, yet he never allowed his knowledge to interfere with the accurate yet lively and pictorially romantic rendition of his many sea paintings. Clifford Ashley sailed aboard the whalers he depicted so well, and Gordon Grant also was a Cape Horner. Ashley, in particular, had a very impressionistic style. Grant and Fischer were both nationally known illustrators as well as fine-art painters. Although the word *illustrator* is used as a term of reproach by critics and the so-called painters of the smear-and-daub school, the distinction must be made purely by content and not artistic merit. In the old days a lot of greats were illustrators. Winslow Homer and Edwin Abbey are but two that come to mind. Paintings by both men are owned by the Metropolitan in New York, as well as other museums, and that's good enough for me!

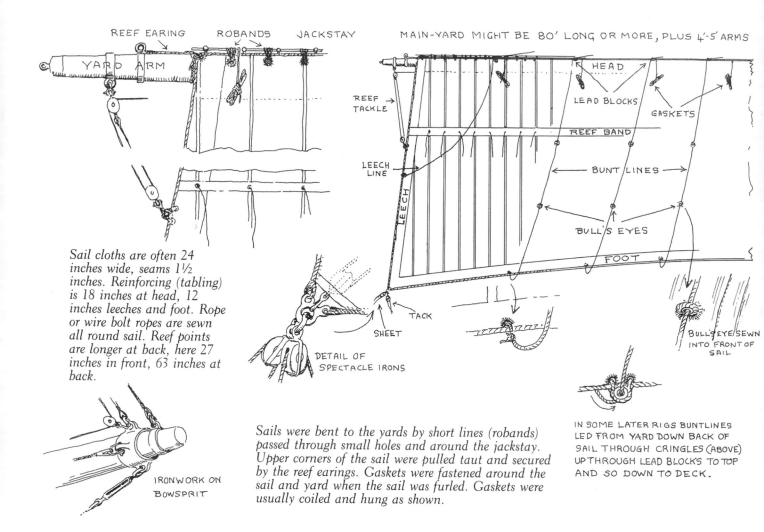

REEF EARING ROBANDS JACKSTAY MAIN-YARD MIGHT BE 80' LONG OR MORE, PLUS 4'-5' ARMS

YARD ARM

HEAD

LEAD BLOCKS

GASKETS

REEF TACKLE

REEF BAND

LEECH LINE

BUNT LINES

LEECH

BULL'S EYES

TACK

FOOT

SHEET

BULL'S EYE SEWN INTO FRONT OF SAIL

DETAIL OF SPECTACLE IRONS

Sail cloths are often 24 inches wide, seams 1½ inches. Reinforcing (tabling) is 18 inches at head, 12 inches leeches and foot. Rope or wire bolt ropes are sewn all round sail. Reef points are longer at back, here 27 inches in front, 63 inches at back.

IRONWORK ON BOWSPRIT

Sails were bent to the yards by short lines (robands) passed through small holes and around the jackstay. Upper corners of the sail were pulled taut and secured by the reef earings. Gaskets were fastened around the sail and yard when the sail was furled. Gaskets were usually coiled and hung as shown.

IN SOME LATER RIGS BUNTLINES LED FROM YARD DOWN BACK OF SAIL THROUGH CRINGLES (ABOVE) UP THROUGH LEAD BLOCKS TO TOP AND SO DOWN TO DECK.

Note: Round bar davits were in use on sailing and early steamships from mid-1800s to the present. Their placement on deck varied. Boats on after deckhouse (below left) are usually as shown, but sometimes skids ran from rail to rail with nothing underneath. On launching, canvas cover was removed, chocks hinged down, and the boat hoisted off skids. Guys were slacked and boat shoved aft (the davits turning) until the bow cleared the forward davit. By heaving on the guys and pushing the boat, the bow was swung outboard. More heaving and the stern was out too and the boat in lowering position.

 Boats on forward deckhouse were often lashed bottom-up. Sometimes there were davits there, too, in which case paint boats chocked as before. Otherwise boats were turned over and hoisted out by tackles to yards. When boats were carried on a long poop they were sometimes swung outboard (bottom right) to make more deck space for passengers and be ready for instant lowering in case someone went overboard. Show broad canvas gripes (which held boat against strongback) but no boat cover. For scale, remember that the average boat was about 5 feet high at bow, 7 feet wide, and 25 feet long.

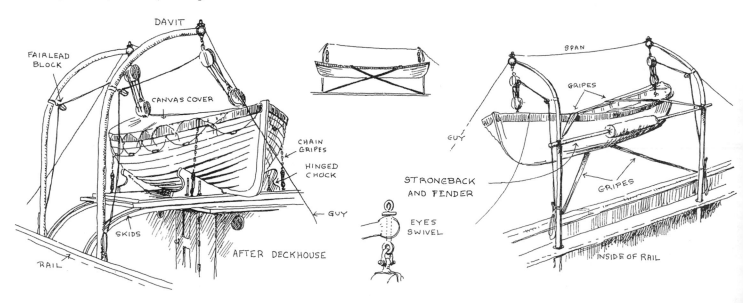

DAVIT

FAIRLEAD BLOCK

CANVAS COVER

CHAIN GRIPES

HINGED CHOCK

GUY

SKIDS

RAIL

AFTER DECKHOUSE

EYES SWIVEL

SPAN

GRIPES

GUY

STRONGBACK AND FENDER

GRIPES

INSIDE OF RAIL

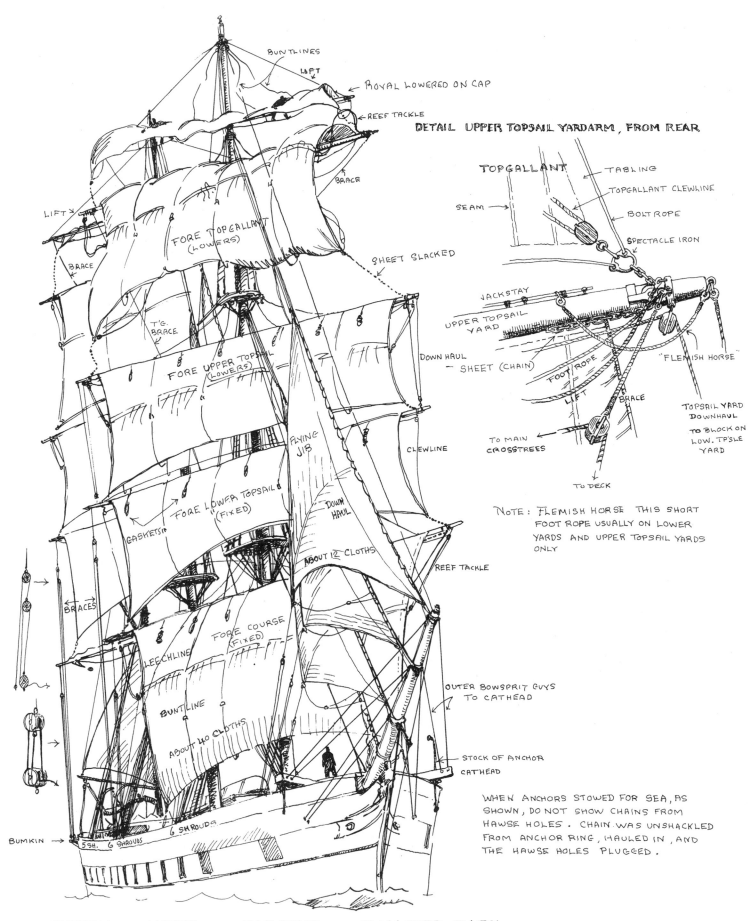

BUNTLINES

LIFT

ROYAL LOWERED ON CAP

REEF TACKLE

DETAIL UPPER TOPSAIL YARDARM, FROM REAR

BRACE

TOPGALLANT

TABLING

TOPGALLANT CLEWLINE

SEAM

BOLT ROPE

SPECTACLE IRON

LIFT

FORE TOPGALLANT
(LOWERS)

SHEET SLACKED

JACKSTAY

BRACE

UPPER TOPSAIL
YARD

T'G.
BRACE

FORE UPPER TOPSAIL
(LOWERS)

DOWN HAUL
— SHEET (CHAIN)

FOOT ROPE

FLEMISH HORSE

FLYING
JIB

LIFT

BRACE

CLEWLINE

TO MAIN
CROSSTREES

TOPSAIL YARD
DOWNHAUL

TO BLOCK ON
LOW. TP'SLE
YARD

FORE LOWER TOPSAIL
("FIXED")

DOWN
HAUL

TO DECK

GASKETS

ABOUT 12 CLOTHS

NOTE: FLEMISH HORSE THIS SHORT
FOOT ROPE USUALLY ON LOWER
YARDS AND UPPER TOPSAIL YARDS
ONLY

REEF TACKLE

BRACES

FORE COURSE
(FIXED)

LEECHLINE

OUTER BOWSPRIT GUYS
TO CATHEAD

BUNTLINE

ABOUT 40 CLOTHS

STOCK OF ANCHOR

CATHEAD

WHEN ANCHORS STOWED FOR SEA, AS
SHOWN, DO NOT SHOW CHAINS FROM
HAWSE HOLES. CHAIN WAS UNSHACKLED
FROM ANCHOR RING, HAULED IN, AND
THE HAWSE HOLES PLUGGED.

BUMKIN

5 SH. 6 SHROUDS

6 SHROUDS

SKETCH AND NOTES FOR PAINTING OF 3-MASTED BARK

Sea-going Egyptian vessel, circa 1500 B.C.

Phoenician galley, circa 700 B.C.

Egyptian vessels are often shown in reliefs or tomb models with a boom along the foot of the sail. Wood was scarce and construction light. Note rope lashings at the bow and stern and rope truss to prevent the ends sagging. The Phoenicians were noted seamen and their sturdy ships traded beyond The Straits (Gibraltar). The Vikings voyaged far, to Greenland and America. Their graceful seaworthy ships influenced northern design for centuries. The position of the steering oar gave us our term starboard (steerboard).

Norse ship, circa A.D. 800.

Mediterranean ship with lateen rig.

The first sails were square—the simplest form and still in use. Early examples of this kind could be reduced in area by unlacing a wide strip at the bottom, called a bonnet. Later reef points were introduced. Such sails were used to run before the wind or with the wind well abaft the beam.

Later seamen, perhaps the Vikings, tried to sail a little closer to the wind by stretching one tack as far forward as possible and hauling the yard around (see sketch). The Egyptians, who could sail *up* the Nile with the prevailing northerly winds but for many centuries had always had to row back against the wind, finally changed the shape of the square sail by hoisting it in a different position. Thus was born the nuggar. In recent times vessels so rigged could still be seen on the upper Nile.

From that rig it was a simple step to the lateen. Variations of this rig have been in use ever since, particularly in the Mediterranean and Middle East.

It was not long before European seamen combined the lateen with square sails in various combinations. The ships of Columbus were of this type. The *Nina* was originally rigged with lateen sails only but was altered en route to America. Sometime in the sixteenth century somebody decided to cut a sail to fit the space between the foremast and its stay, and the ancestor of our jibs and staysails was born. The spritsail also appears to have been invented in the sixteenth century. Along about that time someone whacked off the forward part of a lateen yard and, lo, the gaff rig appeared on the scene.

46

Nile boat, circa 2000 B.C. Single rudder oar with tiller.

Nile nuggar making the transition between rig at left and lateen. Still used in the early part of this century.

Combination of lateen and square sail, Mediterranean, early fifteenth century.

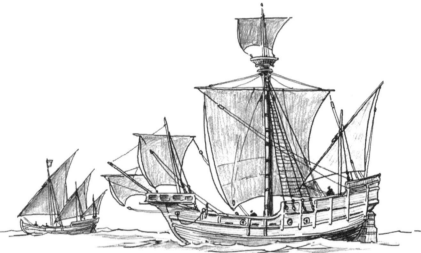

This is possibly how Columbus' Santa Maria was rigged in 1492. At left, the Niña as she was originally rigged.

The nuggar may have been the ancestor of the lateen (latin) rig seen by the early northern voyagers to the Mediterranean and still popular in those seas. This rig and its variations was used both alone and in combination with the square sail and finally merged into the familiar sailing types of the last century. The spritsail, which being loose-footed (not stretched along a boom at the bottom) could be brailed up along the mast in a squall, was used not only in small boats but by the Dutch and in the famous Thames barges, some of which still exist as yachts. The lateen on the mizzenmast finally gave way to the gaff rig, which sail later received a boom.

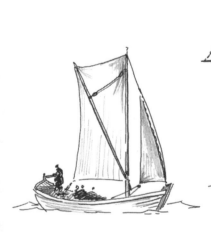

Small vessel with sprit and jib, circa 1590.

Staysails appeared on larger vessels in the middle of the seventeenth century.

The transition from mizzen to lateen to gaff began in the early 1700s.

Rake *is defined as the angle in a fore-and-aft direction, between the center line of a mast and the perpendicular. Most masts rake somewhat, forward or aft, mostly the latter. The peculiarities of some rigs call for extreme rakes but in the 1880s the angles were usually about as in the diagram. Steeve is the angle the bowsprit makes with the horizontal. In some older types this might be considerable. As bowsprits became shorter they tended to be closer to the horizontal.*

Above: With a leading wind a square-rigger's yards were braced in a way which gives the appearance of a twist or screw, each yard braced in a little more than the one below. One reason was that when the square-rigger was close-hauled (sailing as close into the wind as possible, and few square-riggers could point closer than 70°), the telltale flutter of the leading edge of the uppermost sails warned that she might be in danger of being "taken aback." This happened when the wind struck the front of the sails and forced them suddenly round, with risk of damage aloft. This would have been much more likely had all the yards been parallel. When sailing with a following wind the yards could be trimmed about the same angle.

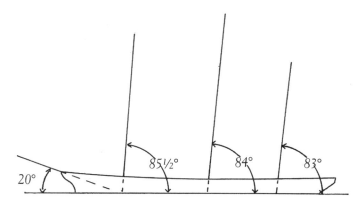

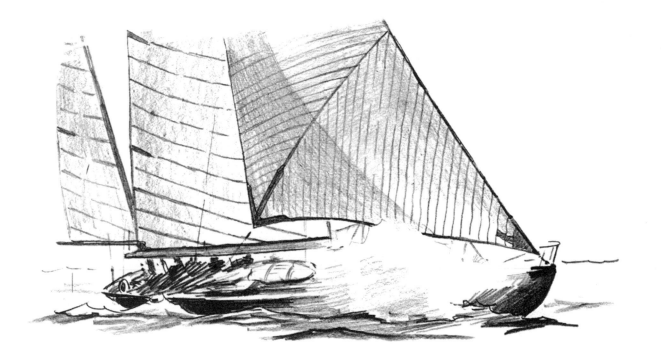

This sketch of a yacht with the light behind the sails shows how clearly the seams and reinforcing stand out. Seams should follow contours of sail and are useful in showing bulges, wrinkles, and so on. The more direct the light, the sharper the seams show. Where canvas is wet it become more transparent and appears lighter in tone.

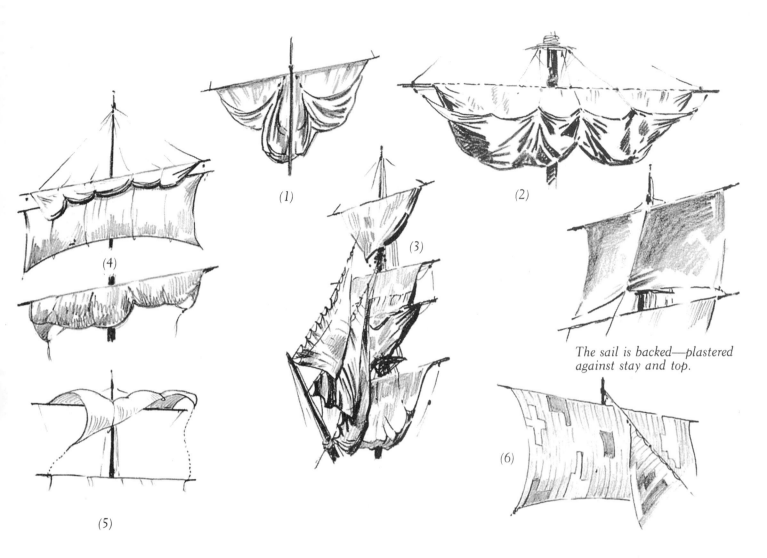

(1)

(2)

(3)

(4)

The sail is backed—plastered against stay and top.

(5)

(6)

Sails were not always perfectly set and drawing hard. In port they had to be dried (numbers 1, 2, and 3) and were hung loose or looped up in various ways. As long as the results are logical you can do almost anything. Sails were not furled when canvas was temporarily reduced. In (4) the topgallant yard has been dropped when ship is hove-to to pick up a pilot and the course is partially hauled up by buntlines and clews. Or sheets were let fly, as in (5). Sails were in frequent need of repair and usually showed a variety of patches, often both lighter and darker than the original cloths. Patches were sometimes horizontal or diagonal but usually in strips of one or more panels, as in (6).

Sails are made up of widths of canvas, called cloths, sewn together. The standard size was twenty-two inches, and the bolts of sailcloth were ninety yards long. The seams, about one and a half inches wide, were plainly visible and may be indicated to advantage. (Don't overdo it. Remember, they should not show up as dark as the rigging.) They are very noticeable when strong sunlight is behind the sail. Worn sails were often repaired by sewing on new or used cloths or parts of cloths. Strengthening bands of canvas—always sewn on the forward side of the sail—like reef bands, tabling, and belly bands also show up when the sail is back lighted. Not all sails had these, however. The edges of the sail were always sewn into strong rope edgings, or bolt ropes.

The buntlines and leech lines lead from the edge of the sail to the yard, along it to the tops, and then down to the deck. They haul up the sail to help in reefing or furling. They are fairly prominent and should be shown. The gaskets are for passing around the sail when furling. They are not always left coiled and hanging ready as shown on page 44. A large expanse of blank canvas, however, can be annoying and any authentic gear helps dress things up. The reef tackle is self-explanatory.

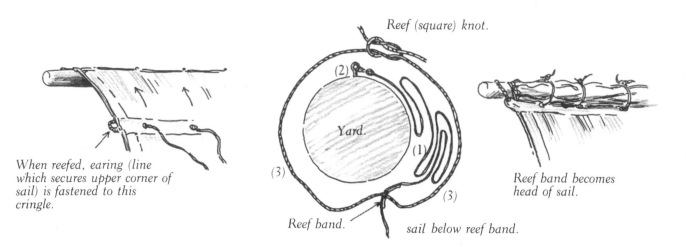

Reef (square) knot.

Yard.

When reefed, earing (line which secures upper corner of sail) is fastened to this cringle.

Reef band. *sail below reef band.* *Reef band becomes head of sail.*

Center diagram shows in cross section how the sail was reefed: (1) sail gathered in to yard, (2) jackstay, (3) and (3) reef points tied around sail and yard.

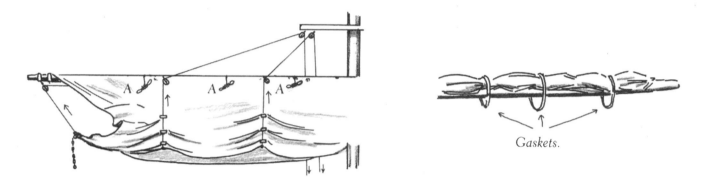

Gaskets.

Left above: furling a sail. Sheets and tacks are let go. The sail is hauled up to yard by buntlines and clewlines. Men out on yard roll up sail tightly and fasten by tying gaskets around yard.

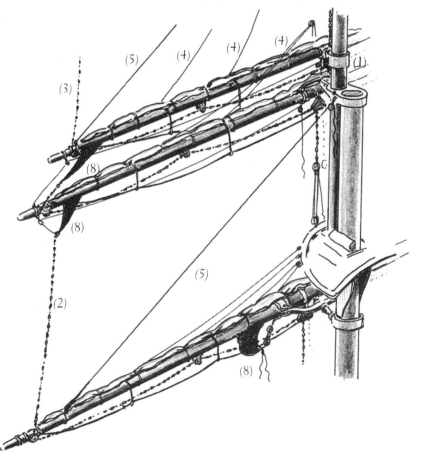

This diagram shows how the sails looked when they were furled. The yards partially shown are the lower, lower topsail, and upper topsail. The upper topsail yard has been lowered, its parrel (1) sliding down the topmast. The lower topsail sheet (2) has been slacked, as has that of the lower topgallant (3) The areas marked (4) are the buntlines and (5) the lifts. Also shown are the downhaul (6) and the clewline (7). The sails have been stowed along the tops of the yards and the gaskets passed around to secure them. The diagram shows you more detail than you may want to know but it will enable you to indicate the gear correctly as well as the proper position of the clews (8). In bad weather extra gaskets might be used but it was not uncommon for a sail to blow out of its gaskets and be torn to shreds. Or a sheet might part and the sail flog itself to pieces, while the flying chain struck sparks from any metal gear in range.

FURLING THE MAINSAIL

I have made the reefing process sound easy, yet despite reef tackles and buntlines, to stand on a swaying, jerking foot rope, doubled over a yard often slippery with sleet, and claw with bleeding fingers at wildly flogging canvas sometimes frozen stiff as a board, while the masts whirled in 70-degree arcs, called for tough seamen. A slip usually meant a fall, and a fall meant a broken neck on the deck far below or a watery grave in the cold, dark, foam-streaked ocean.

Obviously, this is a pretty simplified version of the history of sail, but it will serve to give an idea of the development of the sailing rigs we are familiar with. There are innumerable variations, and there is no room here for all the technical details.

The following sketches show some of the more common rigs. Sails had to be reefed or furled, and it is well to know how this was done. Some yards on square-rigged ships were fixed, some could be raised or lowered; see diagrams on page 35. The artist should also know which sails were likely be set or taken in under certain conditions such as storms and heaving-to, or while fishing. The sketches make this clear.

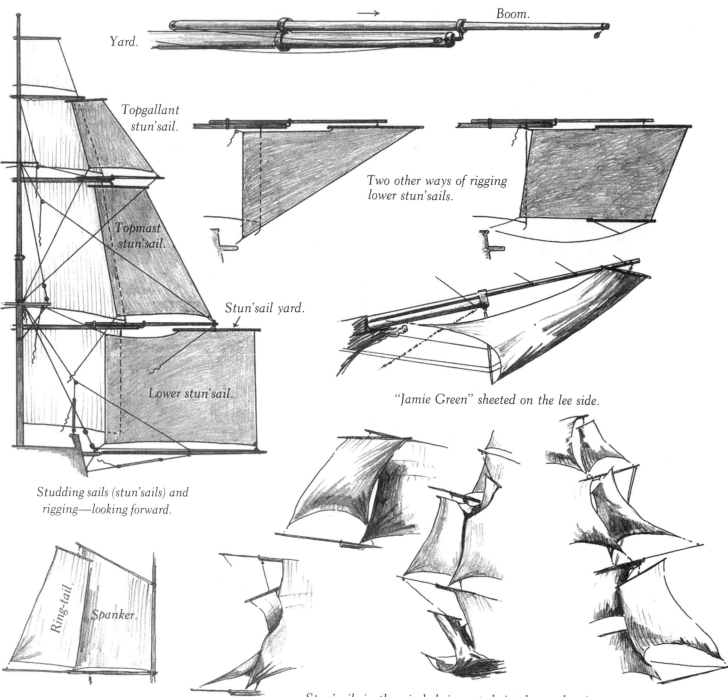

Yard.

Boom.

Topgallant stun'sail.

Two other ways of rigging lower stun'sails.

Topmast stun'sail.

Stun'sail yard.

Lower stun'sail.

"Jamie Green" sheeted on the lee side.

Studding sails (stun'sails) and rigging—looking forward.

Ring-tail.

Spanker.

Stun'sails in the wind, being set, hoisted, or taken in.

Speed was often very important, especially in the days before the development of efficient steamships. Ships' hulls were designed for easy passage through the water (not like the bluff-bowed craft of the eighteenth century) and for their ability to carry a lot of sail. To gain an extra knot or two (a knot is a speed of one nautical mile—two thousand yards—an hour) a variety of extra sail was carried, skysail yards were often set above the royals and sometimes masts were made higher and sails (moonrakers) were set above the skysails. A "Jamie Green" might be slung under the jib-boom and a ring-tail set outside the spanker.

Until the days of the large economical carriers and small crews most ships carried studding sails or stun'sails. These, shown in the diagram, were rigged out from the yardarms and added considerable yardage to a vessel's canvas. Although set aft of the regular sails they were light and flexible and in a stiff breeze billowed out forward, as shown in the sketches. They have been dismissed by some sailormen as being more trouble than they were worth, but in the '50s and '60s no captain of a crack clipper would sail without them. They were not used in beating to windward. Running with the wind aft they may correctly be shown set to port and starboard. With the wind abeam or on the quarter they should be shown on the windward side (on the lee side they would be blanketed and would not draw). A clipper with stun'sails set and drawing was a fine sight and a favorite subject of marine painters.

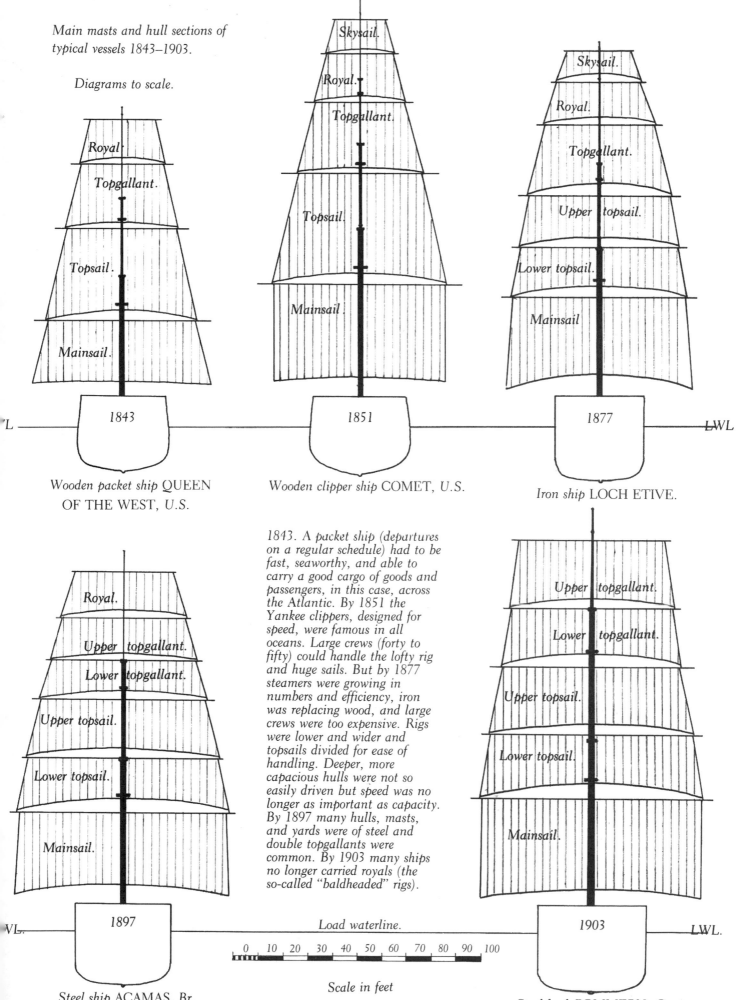

Main masts and hull sections of typical vessels 1843–1903.

Diagrams to scale.

Royal.
Topgallant.
Topsail.
Mainsail.

1843

Wooden packet ship QUEEN OF THE WEST, U.S.

Skysail.
Royal.
Topgallant.
Topsail.
Mainsail.

1851

Wooden clipper ship COMET, U.S.

Skysail.
Royal.
Topgallant.
Upper topsail.
Lower topsail.
Mainsail

1877

Iron ship LOCH ETIVE.

L — — — LWL

Royal.
Upper topgallant.
Lower topgallant.
Upper topsail.
Lower topsail.
Mainsail.

1897

Steel ship ACAMAS, Br.

1843. A packet ship (departures on a regular schedule) had to be fast, seaworthy, and able to carry a good cargo of goods and passengers, in this case, across the Atlantic. By 1851 the Yankee clippers, designed for speed, were famous in all oceans. Large crews (forty to fifty) could handle the lofty rig and huge sails. But by 1877 steamers were growing in numbers and efficiency, iron was replacing wood, and large crews were too expensive. Rigs were lower and wider and topsails divided for ease of handling. Deeper, more capacious hulls were not so easily driven but speed was no longer as important as capacity. By 1897 many hulls, masts, and yards were of steel and double topgallants were common. By 1903 many ships no longer carried royals (the so-called "baldheaded" rigs).

Upper topgallant.
Lower topgallant.
Upper topsail.
Lower topsail.
Mainsail.

1903

Steel bark POMMERN, Ger.

VL. — — — Load waterline. — — LWL.

0 10 20 30 40 50 60 70 80 90 100

Scale in feet

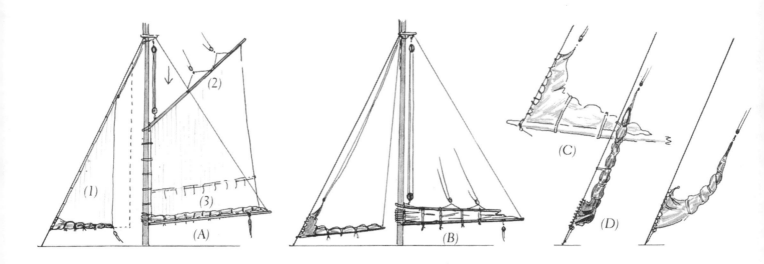

Reefing (A). The forestaysail (1) is lowered, reef points tied around foot of sail, and the sail rehoisted. The gaff (2) is lowered and points tied under the foot between foot and boom (3)—not around the boom. Jibs were not reefed but taken in when reducing sail. Furling (B), if the staysail has a boom, when sail is furled along the boom and gaskets are tied. The gaff is lowered on top of the furled sail and gaskets tied around all. Jibs (C) are furled as shown with gaskets passed around sail and jib-boom and/or bowsprit. Staysails were often furled as in (D). The fore-and-aft rigged ships could sail closer to the wind than square-rigged ones and are usually depicted as beating to windward, lee rail buried and canvas flat. When they did run before the wind, booms were well out and sometimes one was to port and one to starboard (wing and wing). Topsails came in various shapes and when furled were usually made fast above the crosstrees.

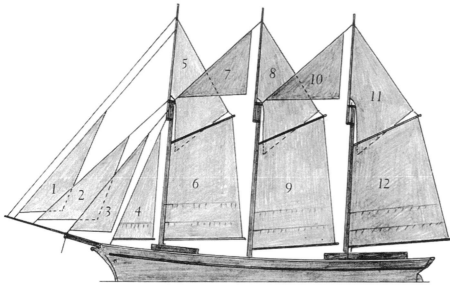

Sails of three-masted schooner:

1. Flying jib
2. Outer jib
3. Inner jib
4. Fore staysail
5. Fore gaff topsail
6. Foresail
7. Main topmast staysail
8. Main gaff topsail
9. Mainsail
10. Mizzen topmast staysail
11. Mizzen gaff topsail
12. Mizzen

A two-master is the same less numbers 10, 11, and 12.

Left: wing and wing. Wind aft, head sails not doing much. Right: Grand Banker lee rail under. Fore gaff topsail not set but she is hoisting a fisherman staysail. Sails being set or taken in blow in interesting shapes and add variety to a painting. Just be sure you know (from the diagrams in chapters 3 and 4) roughly how the operations work.

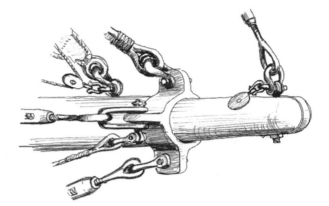

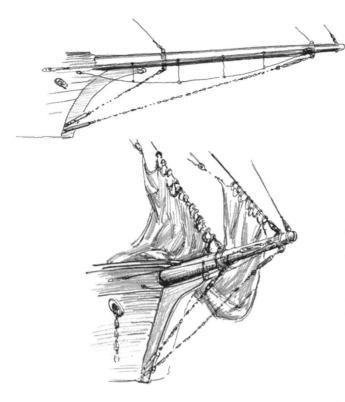

In a small-scale painting there is no need for minute detail. However, if you are doing just a bow view, for instance, an indication of a strap and a couple of blobs of paint for fastenings may not be enough.

Bowsprit ironwork came in many patterns. Above is part of one. Below is a bit of detail of another showing the way the footropes were rigged. For a bowsprit with jib-boom and martingale, see page 34.

Because fore-and-afters (sloops, small schooners, and so on) are relatively easy to draw I often use them in paintings especially in harbor scenes. In such scenes it is not necessary to use the whole of a vessel or vessels, masts and all. Good compositions can be concocted using part of a bow or stern; perhaps some activity on deck (see chapter 2) and one or more small boats, barges or whatever. Sails play a considerable part in my picture planning. They may be hoisted all or part way or hang slack, draped over decks, sides or bowsprits. If you remember just how they are rigged and raised and lowered you can make some good pictures which will be accurate enough to satisfy your nautically-minded critics. Here are a few tips which may help.

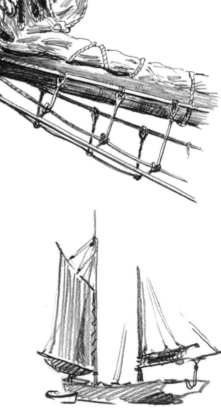

On a calm day in port any arrangement of sails is permissible.

Just be sure sails, gaffs, and booms show proper support, even if these are only indicated.

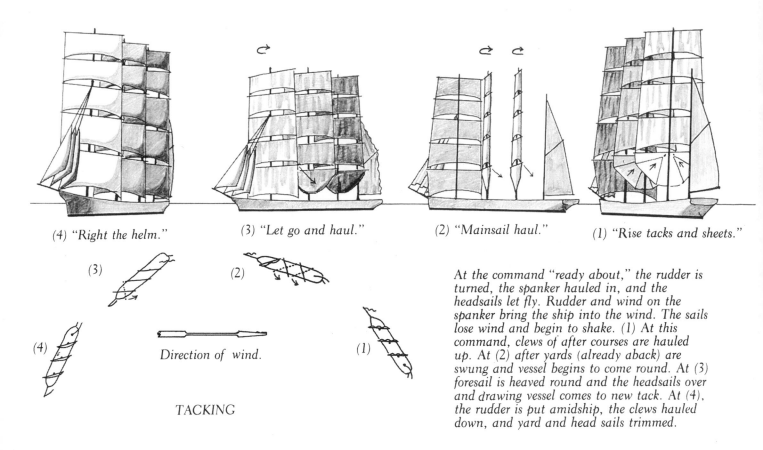

(4) "Right the helm." (3) "Let go and haul." (2) "Mainsail haul." (1) "Rise tacks and sheets."

(3) (2)

(4) (1)

Direction of wind.

TACKING

At the command "ready about," the rudder is turned, the spanker hauled in, and the headsails let fly. Rudder and wind on the spanker bring the ship into the wind. The sails lose wind and begin to shake. (1) At this command, clews of after courses are hauled up. At (2) after yards (already aback) are swung and vessel begins to come round. At (3) foresail is heaved round and the headsails over and drawing vessel comes to new tack. At (4), the rudder is put amidship, the clews hauled down, and yard and head sails trimmed.

Sailing ships cannot go directly to windward. By trimming yards and sails a properly designed vessel can sail at an angle to the wind (about 70° for a square-rigger and some 45° in a fore-and-aft rigged ship) and progress to windward is by a series of zigs and zags. After each zig, or tack, the vessel must turn into the wind and turn so that the wind is on the other side. This is called tacking. A vessel with the wind coming over the starboard (right looking forward) side is said to be on the starboard tack. After turning she will be on the port tack.

The diagram above shows how a four-masted bark was tacked. Tacking a big ship called for good judgment and if the ship did not come about properly (missed stays) the ship had to be maneuvered off the wind and the operation tried again. Or the order "wear ship" was given. This meant turning the ship away from the wind and circling around on the other tack (diagram below). In heavy weather and big seas (if there wasn't wind enough) this was often done, although, of course, distance was lost. Tacking a fore-and-after was easy by comparison but even a small yacht can miss stays if the helmsman isn't careful. A vessel in stays, head to wind and unable to come round on the other tack, is said to be "in irons."

WEARING

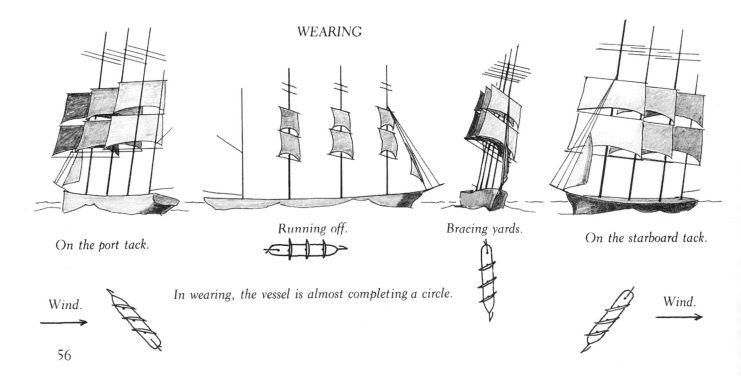

On the port tack. Running off. Bracing yards. On the starboard tack.

In wearing, the vessel is almost completing a circle.

Wind. Wind.

Heavy weather—furling the main upper topsail.

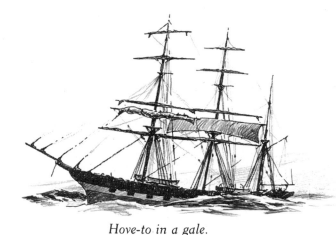

Hove-to in a gale.

Obviously ships could not carry all their sails in bad weather, although some captains maintained a reputation for carrying canvas long after others would have reefed down. It is as well to vary the combinations of your sails as it is the color of your skies. Pictures of ships always bowling along with everything set under bright blue skies can get monotonous.

The following text and diagrams will help you show your vessel in different conditions of wind and weather. In what sailors call a fresh breeze (winds, 19 to 24 mph), all plain sail (no stun'sails or fair-weather sails) might be carried. Diagrams (of ship with single topgallants) show her in (1) a strong breeze. As you might expect the skysails (if any) and royals came in along with the upper staysails and flying jib. Ocean-wave heights depend on wind velocity, the duration of blow from constant direction, and fetch (distance from wind's point of origin). You can scale your waves roughly with known height of ship's side or other dimension. Number (2) shows the ship with sail further reduced, and in (3) it is down to storm canvas. Other combinations were used, depending on direction of wind in relation to ship's course and the best points of sailing.

If unable to make headway or if the wind and sea grew too wild, the vessel might be hove-to as in sketch at top right under the main upper topsail. The yard was braced so there was slight pressure behind sail, a forward-movement offsetting tendency to be driven astern. Ships riding thus could often weather violent storms with a minimum of damage. Other sails might be used, perhaps a small triangular sail (trysail) set in place of the spanker, a foretopmast staysail, and a fore and main lower topsail. In ordinary weather, when a ship had to stop, perhaps to pick up a pilot, she hove-to by backing some sails but leaving others drawing—the ones balancing the others, as in the sketch below. To slow quickly, courses were clewed up, royals and topgallants let fly, her outer jib lowered, and sheets of the other headsails slacked. If you keep your combinations of sail, wind, and sea logical, you can make your ship do just about anything.

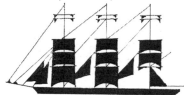

1. Strong breeze—wind force 6, 25 to 31 mph. Sea rough, 8 to 13 feet. Many whitecaps.

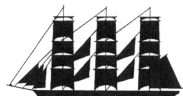

2. Moderate gale, force 7, 32 to 38 mph. Sea very rough, 13 to 20 feet. Foam streaks.

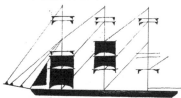

3. Strong gale, force 9, 47 to 54 mph. High sea, 20 to 40 feet. Foam-blown spray.

Easing down. Courses clewed up, upper sheets slacked off.

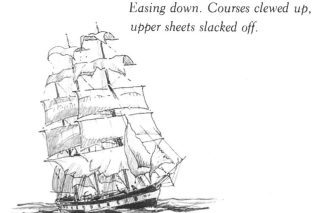

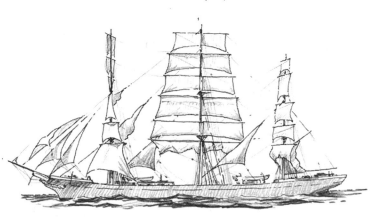

Hove-to waiting for the pilot. Main yards aback.

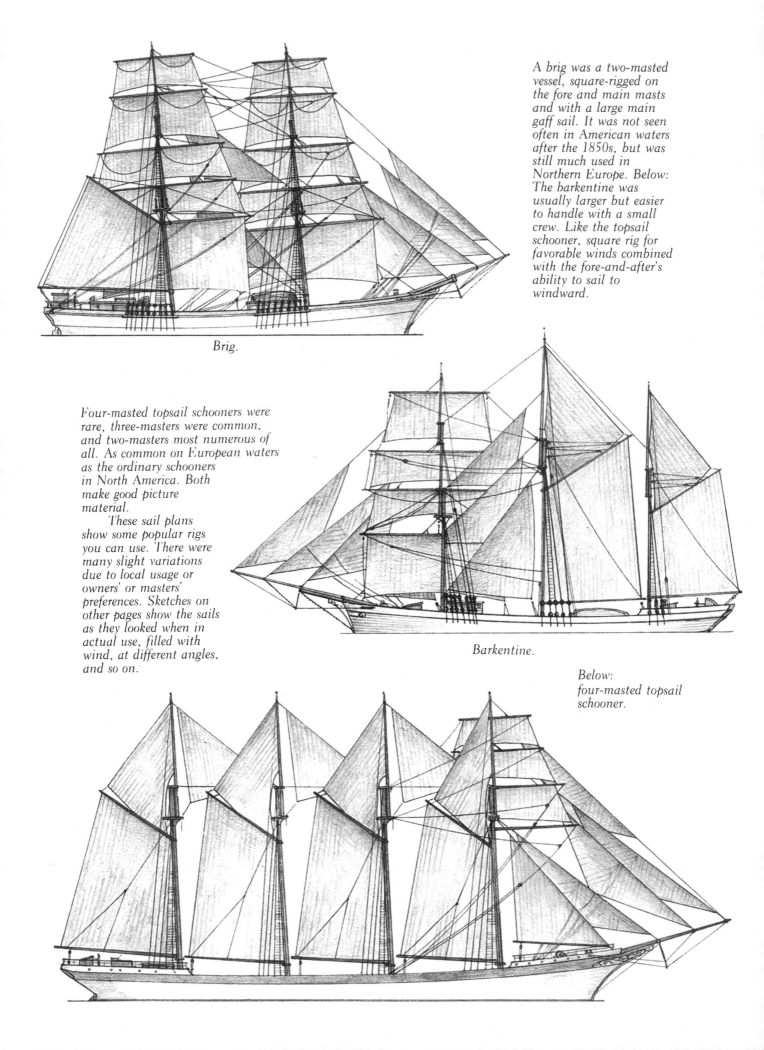

A brig was a two-masted vessel, square-rigged on the fore and main masts and with a large main gaff sail. It was not seen often in American waters after the 1850s, but was still much used in Northern Europe. Below: The barkentine was usually larger but easier to handle with a small crew. Like the topsail schooner, square rig for favorable winds combined with the fore-and-after's ability to sail to windward.

Brig.

Four-masted topsail schooners were rare, three-masters were common, and two-masters most numerous of all. As common on European waters as the ordinary schooners in North America. Both make good picture material.

These sail plans show some popular rigs you can use. There were many slight variations due to local usage or owners' or masters' preferences. Sketches on other pages show the sails as they looked when in actual use, filled with wind, at different angles, and so on.

Barkentine.

Below: four-masted topsail schooner.

A brigantine, which some call a hermaphrodite brig. A true brigantine had square topsails on the main but no square mainsail. When a gaff topsail replaced the square topsails, many called this a brigantine. In any case, it is a popular rig, especially on European waters. The ketch was easier to handle than a schooner with its large main sail and long boom. Much used in Northern Europe, both as coastal traders and fishing vessels. The topsail schooner below combined ease of handling and ability to back and work to windward with advantages of square sails when running with the wind. Two-, three-, and four-masted topsail schooners were common on the European side but were not so often seen in American waters.

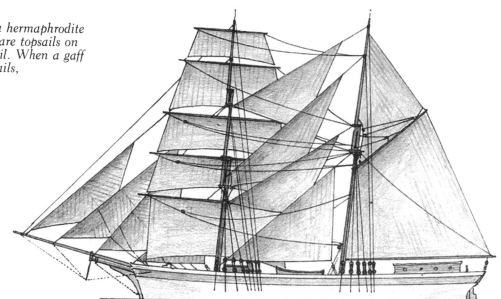

Brigantine or hermaphrodite brig.

Two-masted topsail schooner.

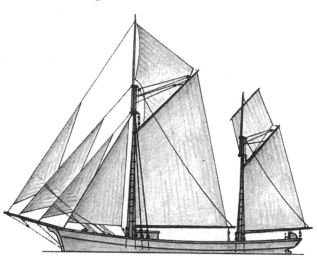

Ketch.

Below: three-masted schooner.

The schooner was the favorite rig in North America. Some were less than 50 feet. Others—three-, four-, five-, and six-masters, ranged up to around 330 feet while a giant 5,000 ton, seven-master was 385 feet long. Gaffs on the large ships were hoisted by steam-driven winches. Crews were small. The 5,000-tonner had only sixteen men. From 1879 to 1921, over 1,500 three-masters alone were built.

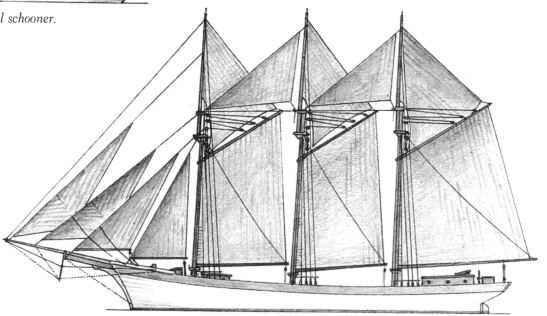

Oil on canvas Rough Going 24 × 30″

Rough seas are fun to paint and the stormy skies that go with them lend themselve to dramatic lighting and cloud effects. There were reflections of the sky in the lighter parts of the water, and much gray-green and gray-blue where the foam was boiling and bubbling. It is rough and windy and the foam patterns are soon broken up. Wind-driven spray fogs the background and the dark hull brings the bursts of foam into high contrast.

5

Painting Water

It seems a little strange that with so much of the globe covered by water so few artists know how to paint it. I suppose there is a trick to it, but I've been painting water for so many years that, if there is, I've forgotten it long ago. Long hours of study and observation have been assimilated to the point where painting an area of water, smooth or rough, has become more or less automatic. In other words, I see the effect I want—although I'm in my studio in the country—and can work on it without bothering about the mechanics of it, the color and shape, for example. This comes only with a lot of practice, and that's what it will take before you become proficient.

Looking back to my student days, I regret that someone, probably several someones, gave me the impression that copying was very bad. I don't believe that today. An amateur who has mastered the rudiments of drawing and painting might do himself a lot of good by actually copying, brush stroke for brush stroke, one of the acknowledged masters, Waugh, for instance.

Frederick Judd Waugh's marine paintings, or most of them—despite criticism that they are too slick and mannered (Sargent receives the same criticism)—are among the finest ever done. A fellow artist once said to me, "Waugh's surf is too stiff; it looks like whipped cream." Yes, it does, but real surf often looks like that. But Waugh was a master at giving that frozen mass depth, motion, and transparency. Color prints have been made of many of his works, and the purchase of a couple might repay the artist many times over. When you have found out how a few good marine artists handle their paint and solve their problems, then forget them and do your own thing.

One of the things that seems to bother students is their difficulty in making water appear wet and fluid. An approaching wave may seem like a moving hill—and it is, with tremendous power behind it—yet light reflects from it; it glistens and sparkles; its edges are transparent; and its depths translucent. Until you can reproduce at least some of these qualities, your hill may appear solid—but it won't be water!

A wave, even a small one, is formed much like a mountain range. Outlying hills and valleys range back, one behind the other, ever higher until the crest is reached. Obviously, the direction and intensity of light have much to do with the way we see a wave. The angle at which we look at it and the angles that the many planes that form its surface make with the sky also affect the way we see it. Looking directly down deep water often appears black or very deep blue. But looking at the same water from close to its level, as from a small boat, the planes, seen obliquely, reflect so much light from the sky that the water appears a varicolored gray, depending on the light and the color of the sky. An expanse of water often appears as a light gray, with some darks toward the high parts of each hill. The higher and steeper these hillocks are, the darker the darks. These darks are not shadows but the momentary positioning of certain planes so that they do not reflect much light. The sensible way to paint such a sea is to paint your overall light area first and then cut in with the darks.

In scale diagram above, a 120-foot whaleship rides the long swells of the Southern Ocean. Wave lengths are shown as 800 feet from crest to crest and heights of 35 feet trough to crest. Not dangerous in mild weather, but the 30-foot whaleboats would seldom sight each other and only the ship itself when on the crest of a wave.

Diagrams show a "mountain" formation and the way light from different angles will change the appearance of a wave. The shapes of planes are the same in all four diagrams.

A wave with the light behind it will, of course, appear darker. Fewer planes will pick up the light, and some of the wave will be in actual shadow. When the light is low, as at sunset, a wave in the foreground might appear quite dark, with a few planes reflecting the sky opposite the sun (behind the viewer, in other words). Those planes at a small angle to the light will reflect the brilliant light above the horizon—at times almost a dazzle effect. In this case the water is painted dark to begin with, with lights slashed into it.

Talking about dazzle, we have all looked across water toward the sun and noticed the almost painfully bright light reflected, as if by mirrors, from the many planes of the surface. This can be painted, but it means knocking everything else in the picture down in value. Remember, light doesn't come in a tube, like viridian or cadmium red. You can only approximate the effect of light by deliber-

ately toning down your painting so that the lights—which would be mainly white, because that's the lightest thing on your palette—will stand out. Nothing else in your picture should be as high in key; without the contrast there will be no illusion of bright light.

Waves may be likened to ranges of hills, but they are never regular. Avoid painting them as if they were straight furrows in a plowed field. On the contrary, they lump up, subside, and heave up again in seeming disarray. Even the huge swells of the southern ocean, sometimes half a mile from crest to crest, are not unbroken for any great distance. (When storm waves flatten out into long undulations, they are known as swells.) Furthermore, seas tend to build up irregularly, sometimes joining forces momentarily to produce a larger wave than usual. Wind does not always accompany swells, which may result from a storm long past or

Above: Here the wave heights are the same but the lengths are only some 200 feet. Shorter and steeper waves often break when their height is more than one-seventh their length or the slopes steeper than 30°. A breaking crest might easily overwhelm a small craft. At right, intermingling series of waves of different lengths create irregular waves, some of which may be of great size. Seas like this can be dangerous even to large ships, and a small vessel may be rolled over or "pitchpoled." Cross winds and strong current can also cause a confused sea. Comparatively shallow water also creates a short, steep sea.

very far away. In mid-ocean long glassy swells are not uncommon. At the beach, even when the sea appears calm, a sizeable surge may be noticed at the water's edge. In the southern ocean, where the winds blow endlessly around the world, these long swells may be thirty feet or more in height, but in ordinary weather whale ships launched their boats and men pursued the whale across these watery hills and valleys as a matter of course.

Waves are raised by winds, and even a small lake can produce a nasty chop at times. Waves are measured in height from crest to trough and in length from crest to crest. Accurate measurements are almost impossible, but in 1938, in mid-Pacific, a U.S. Navy tanker, the *Ramapo*, measured the highest recorded wave. This monster was estimated at 112 feet! The average storm wave probably does not exceed thirty feet—plenty high enough. Even a ten-foot sea, wind driven, is considered rough, and

for small boats a three-foot wave can be uncomfortable. Short, choppy seas are more of a hazard to small and medium-sized vessels than are longer swells. It is the steepness of a wave that makes it dangerous, especially when it becomes so steep that its crest plunges forward and breaks. Small vessels often weather severe storms safely, riding even very large seas like gulls, but a steep breaking sea may sometimes roll a boat over or pitch-pole it (tumble it end over end). Yachts have been known to survive this treatment, though at the expense of great damage and sometimes the loss of any crew members on deck.

When the breeze is strong enough, the crests of even very small waves break and form whitecaps. Where these subside, they leave little patches of foam. As the wind increases and the wavelets become waves, the breaking becomes heavier and more frequent and the streaks and ribbons of foam

For some reason the camera tends to flatten out pictures of rough water. Partly I think because the viewer's angle usually is too high—often the upper deck of a large vessel. The painter, with little danger to himself, can fearlessly place himself at wave-top height or in the very troughs. A slight exaggeration of the lights and darks will help separate individual waves, and some artistic license many be taken with the foam patterns. These may be softened or exaggerated and their shapes simplified and made to lead the eye where desired.

Scale is important. Taken by itself a small wave may have much the same characteristics as a giant. It's the size of the ships that count. Don't make your waves too regular and avoid a repetition of the triangular shape; a broad curve, as in the sketch below, may be more effective. Notice also that the waves, being very large, are far apart and so fade off and become indistinct. The smaller your boat is in proportion to the canvas, the greater the feeling of solitude and danger. Had I been painting this I might have added a bit of sea at either side. And don't be afraid to make a picture long and narrow if your composition calls for it.

longer and larger. These ribbons make lovely patterns, very white where they first form, slowly changing to grayed greens with touches of blue as they dissolve.

Foam, or anything else lying on the water for that matter, does not advance as the wave itself advances. The best way to think of wave motion is to run your hand along under a rug or tablecloth. The wave moves forward, but except for the up-and-down motion, an object on the surface remains in relatively the same place. So as the ocean wave goes on, it leaves the residue of its broken crest behind it.

As winds increase to gale force and waves build up, the surface is whipped by the gusts. Instead of broad patterns, the foam appears as many small streaks. Eventually, almost the entire surface appears white. Crests are blown off and visibility reduced by flying clouds of spray.

Waves in shallow waters tend to be shorter and steeper than in mid-ocean and consequently more dangerous. As waves approach the shore, the mass of water at the bottom is retarded by friction while the crest moves forward and finally breaks into surf. At this moment, when the wave is curling over and beginning to break, the upper part of the curve becomes translucent, which is especially noticeable if the sun is behind it. This curling-over motion is tricky to paint without making the curved wave appear too hard and metallic. The foam must be handled just right, too. Observation and the study of photographs of wave action are essential. One of the mistakes beginners make is to paint the foam too fluffy, like cotton wool. The whipped cream approach is better, if you remember that what you are trying to portray is fluid and actually in constant motion.

Once the wave has broken—and it seldom breaks all along its length simultaneously—the mass of foaming water surges up the beach, often heaping itself over the retreating remnants of the previous wave. The patterns made by the foam are very interesting and decorative. When painting them, remember that if the beach is sandy, the color of the water has more tans and yellows in it. This is true not only of the water in the shallows but also of the incoming wave, which picks up a certain amount of sand as it churns its way ashore.

Waves breaking against a rocky shore react differently. In many cases the shore may shelve more or less steeply and the waves will tend to break or begin to break before they hit the rocks. Occasionally the geological formation is such that a near-vertical cliff facing open ocean has really deep water at its base and no reefs or other rocks to seaward. Under these conditions an onshore gale will send huge waves smashing directly against the cliff, sending clouds of spray hundreds of feet into the air. These great explosions of surf should be handled with care in a composition, however. If made the focal point of the picture, the interesting play of the surrounding water and foam tend to become lost.

The action of waves hitting, covering, and retreating from a formation of rocks is a complicated affair and calls for much study. While naturally always different in detail, this action is logical and, within limits, predictable. There will be the advance of the wave, perhaps curling over and breaking or with its crest tumbling down its sloping face. As it moves forward, it will strike vertical faces of rock with an explosive effect, while rushing more or less unimpeded over sloping areas. Narrow passages between rocks are filled with advancing mounds of foam, forced higher as the passages grow narrower. The area immediately to seaward is a mass of foam patterns swirling around half-submerged islands of rock.

When the limit of the advance has been reached, the retreat begins. From every nook and cranny water pours back, streaming off the rocks in cataracts of foam. This retiring mass then meets the advancing surge of the next sea. After a few confused moments, the backwash is absorbed into the new assault, and the process begins again. If the new wave is not as high—big waves seem to come in series: three or four big ones followed by several smaller ones—the backwash is sometimes enough to check the new wave's course, causing it to subside in a welter of conflicting piles of foam.

Tumbling water traps tiny air bubbles. This effervescent effect makes the water lighter in places, so that a small area may show a mixture of heavy foam, very light, mottled with patches of light gray greens or greenish blues and with occasional flashes of darker color where the boiling action is not as marked. As all this smother is more or less transparent, the color of the rocks beneath it will

(1)

(2)

Shore-breaking waves are steep as they come in but once broken the mass of foam and water rushing up the beach tends to flatten out and often become intermingled with the backwash of the previous wave. The way you paint the foam patterns establishes the angle of the wave. As it curves over (1) the pattern should hook over, too, while in (2) the foam is quite flat and the patterns, seen from a low angle, are indistinct. Waves do not always curl over. In (3) the cresting foam is slipping down the smooth face of the wave, which may subside in a mass of foam. Check the direction of the light and be consistent with your shadows. Foam, although light in tone, shows light and shade like everything else. And don't make the "holes" in the foam patterns too dark or they will dominate the painting.

(3)

(1)

(2)

(3)

The sketch at top shows remnants of a
wave almost at its limit, checked by the
backwash of its predecessors. A second,
already much diminished, is following,
while behind another is breaking and
about to rush forward. Where the water
has reached farthest the wet sand is first
mirrorlike—see sketch (3)—then dark as
the sand absorbs the water. The gentler
the slope of the beach (2) the farther the
foam-edged surges reach. Often these
cross or overlap. The water in these is so
shallow that the color of the beach shows
through, along with some reflected color
from the sky. Where the beach is steeper (1)
the run-off is swifter, with more
disturbance where the retreating water
meets the on-coming foam. Much
depends on the state of sea and
wind—the rougher and windier, the
more turbulence. Be sure your foam
patterns appear flat and that some (not
all) of the foam edges have a thin
shadow line.

Hits vertical surface
Explosive effect

Steep wave curls
and breaks

ADVANCING WAVE

Very light, much foam
Some blue-green patches
Sloping area
Rock may show thru

Foam forced into clefts
in rocks

Flattish surfaces reflect light

Waterfall
effect

Backwash hitting
advancing surf. Confused motion

Whole area mostly creamy
foam, with flashes of turquoise
or light green

Backwash streaming off
rocks. Transparent in places.
color of rocks and seaweed
will show through.

Boiling effect

RETREATING WAVE

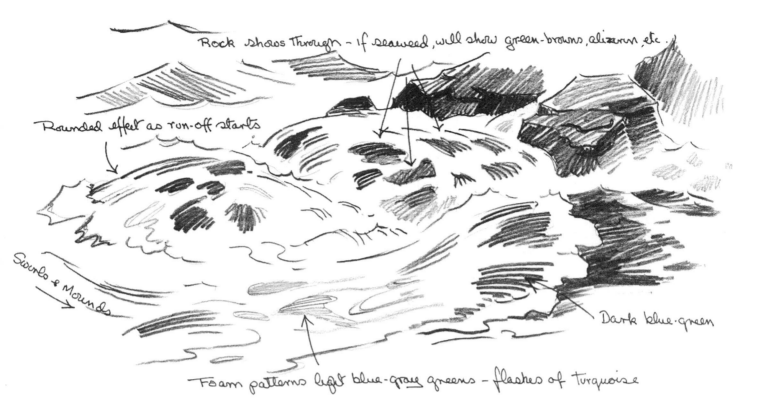

Rock shows through – if seaweed, will show green-browns, alizarin, etc.

Rounded effect as run-off starts

Swirls & Mounds

Dark blue-green

Foam patterns light blue-gray greens – flashes of turquoise

From sketches in an old notebook: Wave patterns never repeat exactly—but closely enough so that you can make quick sketches of the motion and color notes for future reference.

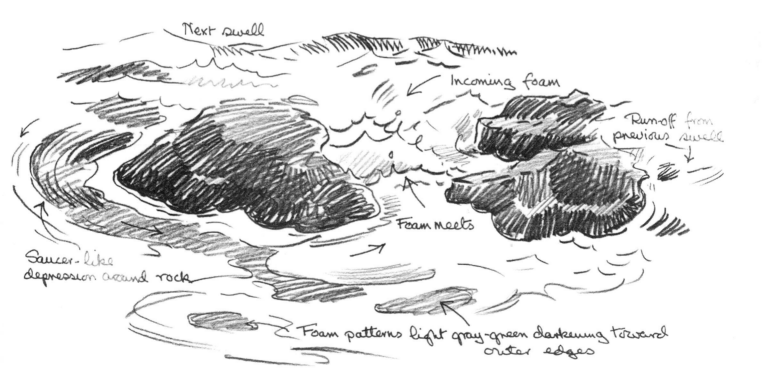

Next swell

Incoming foam

Run-off from previous swell

Foam meets

Saucer-like depression around rock

Foam patterns light gray-green darkening toward outer edges

69

occasionally show through. If, as is often the case, the rocks are covered with seaweed, this will show also and there will be suggestions of reds and browns and greens.

I would again suggest studying, if not the real thing, then good color photographs of this wave action. Once you get the idea of what goes on firmly in your head, then you can begin to compose your own rock-and-sea pictures. Start with pencil or charcoal roughs, then progress to very quick sketches in watercolor or oil. Take plenty of time to work out good compositions, so that areas of dark rock are nicely balanced by masses of light water and foam. See that these forms make pleasing shapes and the patterns guide the eye in the direction you want it to go.

A bad storm is usually accompanied by heavy rain and much wind-driven spray, so much so that visibility is greatly reduced. This can be dramatic, and lowering clouds and spray-shrouded cliffs may make a great picture. Bad weather out to sea or the remnants of a gale that has blown itself out will leave seas rough enough for anyone, although the sky may be clear and the sun shining brightly. Seas don't have to be high to make a good painting, though. Sometimes a bit of quiet water, along with some rocks, will make a pleasing picture, depending on the color, composition, and handling to offset any loss of dramatic effect.

The rocks themselves can add or detract from a painting, and natural formations should be carefully studied. Don't rely on putting in some dark blobs that look like well-rotted potatoes. Some rocks are rounded, depending on the geologic formation of that particular piece of the coast—the area around Peggy's Cove in Nova Scotia, for instance, and around Cape Ann in Massachusetts, to name only a couple. But the rocks around Peggy's Cove are like huge humps, split with many transverse cracks and gulleys, in some of which a man can easily stand. An unusual formation, but not typical.

More common are rocks which appear to be layered, the strata often varicolored, with the layers often running at sharp angles to the horizontal. If part of a large formation, this layering may continue right down into the water. More likely the cliff face may have been undercut by thousands of years of weathering and battering, and the foot is now littered with huge chunks that have fallen from above. Often there seems to be no set pattern, just a crazy quilt of rock split and twisted as it was thrust up in some upheaval in the past.

As many rocks have a vaguely blocky shape, take advantage of this and be sure you keep a very definite contrast between your light areas and your shadows. The basic shape of a rock formation will be found to have innumerable ledges, cracks, crevices, bumps, and hollows. Use good judgment with these. Too few and your rocks will look unreal. Too many and you may find the detail will overwhelm the rest of your painting. Note that rocks subject to the action of the water and the constant grinding of smaller rocks and pebbles are smoother and more rounded than those above the high-water mark. Wet rock, which water or spray has just drenched, will glisten and pick up highlights from many points. Caution—don't overdo this. A little goes a long way. Flatish areas when wet will also reflect a great deal of light when viewed from a low angle. This is great for color, for blues and warm grays from the sky may be repeated in the rocks. Color in rock may be partly a matter of geology—some rocks are definitely warm reddish brown, others cool dark gray—but mainly they will be what you choose to make them. If your picture plan—once I have a composition sketch down, I see my pictures in color in my head—calls for cold, dark cliffs, for heaven's sake, paint them that way. No one is going to call you on it. If you want to portray a specific rock formation, that's different. But dark cliffs don't mean you can't work some gorgeous color into them: blues, greens, purples, and browns. Flat planes may give you a chance to introduce some flashes of cerulean or turquoise. What I'm getting at is that what appears from a distance as a gray mass doesn't have to be dull. Never mix up a mess of dark gray and paint your rock formations solid. When I'm painting rocks, I use just about every color on my palette, which is one of the things that make rock-and-sea pictures so much fun. As long as you keep your rock formations and the play of water over and around them logical, the color schemes are limitless.

Keep in mind when you plan your composition what it is you want to paint. Mainly surf with incidental rocks? Or a rock formation with some surf and foam? And always subordinate the details to the main structure of the picture.

A FEW ROCK FORMATIONS FROM MY SKETCHBOOK

Obviously, any change in direction of the light will alter the appearance of the rocks completely. Just be consistent and see that your shadows fall in approximately the right places. Don't make your shadows too heavy and solid. Backlight may bring considerable light into shaded spots and there may be warm reflected lights from adjacent rocks in sunlight. Not all rocks are covered with seaweed below highwater line, but if they are there is a chance for some rich reds, yellows, and greens. Don't forget the local color of the rock itself. They come in many colors. Scale can lend weight and importance. Look how massive the tiny figures make the rocks appear in this sketch done at Peggy's Cove.

High sun, high key. Below: Almost posterlike simplicity can be effective.

Light low right—considerable shadow.

A major factor to consider when planning a seascape is the angle at which light hits water and rocks, both the height of the sun above the horizon and its position relative to the viewer. With the sun high in the sky, water tends to appear lighter and shadows minimal. A low sun creates more shadow on the waves and more chance for highlights where light hits low-angled wave facets and rock surfaces. It is a good idea to make numerous small sketches such as those on this page. They help establish lighting patterns and tonal composition and, if successful, form the basis for the finished painting. These oil sketches were done in black and white because I think it is often easier to see tonal arrangements and patterns without the distraction of color.

Dazzle—you must keep key low for contrast. Below: simple patterns and tonal plan.

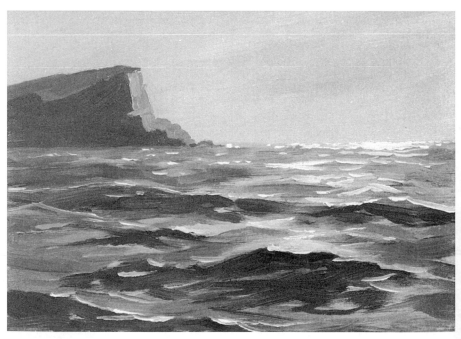

Much sky reflection and some highlighting.

Rocks don't have to be darker than the water. In the sketch above the sun is behind the viewer and it would be quite logical for the incoming wave to appear darker in tone than the sunlit rocks. The above is a composition sketch of the kind I do before final planning for a painting. Notice that I have placed darks behind light areas and vice versa. I might have elaborated on the rocks before making a large painting (usually the larger the picture, the more detail) but there is always the danger of getting fussy. Remember that on every rock face each turn toward or away from the light will mean a change of tone and that some of these facets may, especially if wet, pick up considerable color from the sky. Quiet scenes (below) can be very effective and give opportunities for reflections of rocks and sky and the fun of trying to paint a small pool so that it looks transparent and with a wet surface. The same problem arises when painting a shallow stream. I usually paint the bottom of the pool or stream and then try to put a watery surface, with reflections, ripples, and so on, on top. Receding tides leave small pools in depressions in the rocks and incoming surf will often reach hollow places above the area of turbulence.

I find it harder to make a dramatic composition of an open sea scene than one of surf and rocks. In an open ocean canvas I make use of cresting waves and blowing spray. A sketch in chalk, pencil, and poster white allows me to work out the direction of wave action and foam patterns. Spray from breaking crests may appear fairly definite on the windward side while to leeward the wind-blown mist partially obscures the waves behind. The stronger the wind the more apparent the smoky effect. Spray will be formed when a crest breaks or a wave strikes an obstruction. Without wind it may rise in patterns of semisolid foam or in clouds of fine droplets, and an advancing crest may trail spray behind it like smoke behind a speeding locomotive. Spray patterns cast shadows. Paint them lightly using clean, clear grays.

Decorative spray patterns from my sketchbook. Notes read: "Spray quite solid—sheets and drops silhouette against sky—large drops—fountain effect." Simplified sketches like these done at close range help you develop more elaborate compositions.

Spray has been the downfall of many a marine painter, and I admit I still find it a challenge. If it is painted too solid, it doesn't look real; if it's painted too light and transparent, it doesn't look to have any weight at all; and if it's painted fluffy, it looks awful! The answer lies in a combination of solidity and airiness, fairly solid in places—usually the center of the mass—and transparent and windblown at the top and sides. A small area of it can be quite definite in shape and very decorative, with individual globs and almost leaflike translucent patterns.

Seen from a distance spray appears as a cloud; all individual forms are lost. On a windy day the cresting waves appear to smoke, and this misty look is useful in giving distance and mystery to a painting. Spray and foam will be more dramatic if shown against a dark sky or line of cliffs. But don't make the mistake of painting your spray and foam pure white. Save that for a few highlights. Spray and foam have light and shadow like anything else, depending, of course, on the direction of the light source. I use very light clean grays, usually on the warm side, for my spray and foam, with shadows and highlights where called for. Depending on the sun, the shadows may be deeper and the lights warmer and lighter.

Great detail is not necessary. It is essential to *know* what you want to portray, but sometimes a carefully painted passage has far less effect than a few well-placed slashes with a painting knife.

Note the varied tones of the shadow patterns in these explosions of spray. Some, as under the down-plunging foam at right, are quite dark. Left, shadow sides of bursts appear darker than sky.

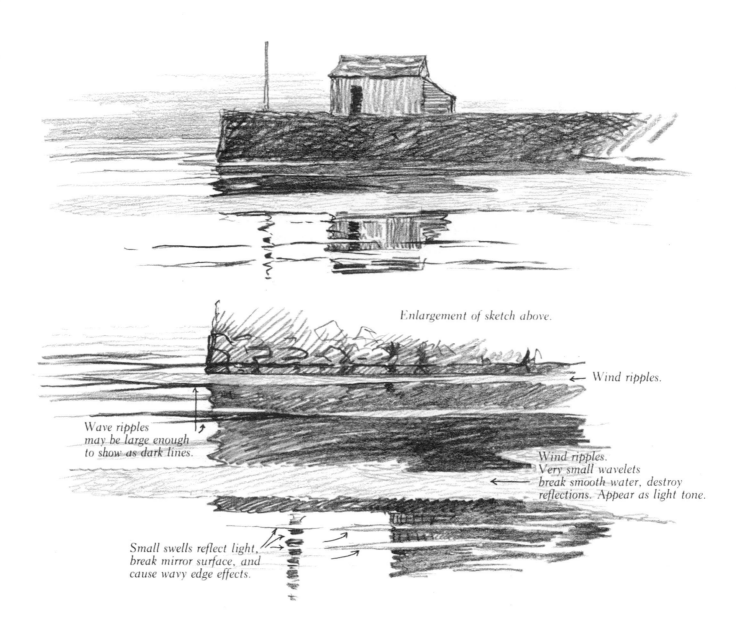

Enlargement of sketch above.

← *Wind ripples.*

*Wave ripples
may be large enough
to show as dark lines.*

*Wind ripples.
Very small wavelets
break smooth water, destroy
reflections. Appear as light tone.*

*Small swells reflect light,
break mirror surface, and
cause wavy edge effects.*

Harbor scenes call for smoother water than we have been talking about, water which at times and in places can be glassy and reflective like a mirror. In other cases the calm surface is rippled by wind—even a gentle breeze produces tiny wavelets that darken the surface. Look at any pond and you will see this effect, and note, too, that the riffling of the surface may only extend over part or parts of the area. This is because wind does not usually blow evenly but tends to bounce up and down (you may have noticed this in an airplane). This effect is very useful to the artist, as it allows a large area, which

might have appeared entirely glassy, to be broken up with streaks and patches of varying darkness. The nice thing is that you can arrange these areas of smooth and riffled water to suit your own purposes, to break up a reflection, for instance, or to introduce a band of light reflection into a dark passage. Smooth water may be predominately light or, in shadow, mainly dark. I usually paint the whole area in the predominant tone, then introduce the opposing darks or lights.

Still water is often broken by a slight swell or series of wavelets, and these can be used to good

Large, almost imperceptible swirls, curving ripples, quiet swelling or boiling motions, or hollows, depending on swiftness of current and depth of water. Usually the shallower the water the more agitated the surface. Smooths will reflect objects or light.

effect. Tides and currents, even those scarcely noticeable, may produce a swirling effect that can be used to break up a monotonous surface. This movement is usually small, though, and should be used sparingly.

Unless opposed by a breeze, a tide will swing anchored vessels in line with its direction and, if powerful enough, will cause small ripples to form behind anchor lines where they enter the water. Perhaps some disturbance—ripples or swirls—will occur at vessels' sterns.

Reflection of the sky in glassy areas may show subdued blues, purples, and grays. Because harbors are shallow and the water far from clear, the water shows up as a yellowish green, and the reflected lights from the sky will be influenced by this tone. This is generally true in northern waters, but where the water in clearer—in the West Indies, for instance—the dull green may not be as pronounced. If there is a sandy bottom reflecting the brilliant sunlight, turquoise and transparent blue green may result.

As in all sea painting, the color of the sky has a major effect on the color of the water. When painting a harbor scene, I often repeat the sky color, toning it down a little, and use my dark-gray yellowish greens for shadows and ripples.

Don't make the edges of your shadows, reflections, and ripples too sharp. A ripple or a small swell is rounded and will not show a knife edge. If you paint a shadow on water (or anything else) with too hard an edge, it will look cutout and unreal.

In painting water, either rough or smooth, remember that it is a fluid and should give the appearance of being able to flow in any direction. This can only be portrayed by careful analysis of the movement. Notice I didn't say careful painting. To me this implies fussy brushwork. Once you know what your brush or knife stroke should do, what it should tell the viewer, then as far as I am concerned the broader and splashier the treatment the better.

Pictures involving smooth water usually mean reflections of some objects. As always, the best way to study is from nature, but by following a few simple rules, you can accurately portray reflections of ships, docks, or anything else. By the way, don't confuse reflections with shadows. Strong light will cast shadows on the water, as on land, yet whereas the reflection of an object will always be between you and the object, a shadow might be cast in any direction, depending on the angle of the sun.

As the diagrams make clear, the thing to remember is to treat all reflected objects as if the plane of the water continues under all such objects in the whole painting. Thus in drawing the reflection of a house on a bluff, imagine the water passing under the bluff in an unbroken sheet. A mirror laid on a table, a short dowel or a pencil stub—as long as they are cut square and will stand upright—and a book or a small box will help you visualize what I am talking about.

First of all, the reflection of an upright object, like a piling rising out of the water, will appear the same length from where it enters the water to the point nearest you, as from the entry point to its top. The image of each point to be reflected appears as far below the surface of the water as the point is above. The diagram illustrates this.

If a post is leaning, the reflection of the top appears directly under the actual top and the same distance below a horizontal line drawn where the post enters the water, as the actual top is above it.

If the post is leaning toward you, estimate the place were a line dropped vertically from the top would enter the water (call this x). Prolong the line down the same distance below x as the top of the post is above. Join this point with that where the post enters the water and this will give the length and direction of the reflection. Notice that the reflection is longer than the post. The same procedure applies if the post is leaning away. Estimate point x, measure from the top of x and the same distance below x, and link up as before. This time, though, the length of the reflection is shorter.

Let's assume the post is on a dock. If it is on the near edge, there is no problem. The height from the top of the post to the waterline of the dock will be repeated exactly below. But if the post is on the other side of the dock, we estimate where the waterline would be on that side, then repeat the distance from it to the top of the pole. Notice that very little of it shows. Had our dock been wider, it wouldn't have shown at all. Consider the reflection of a house and notice the lines running to their respective vanishing points. Because the house is on land, the same procedure is followed as in estimating the reflection of the pole on the dock.

Last, let's look at the reflection of something we cannot see, in this case the underside of a scow or punt. Again we estimate where vertical lines from the transom would hit the water (x) and drop down, still vertically, an equal distance. From these points run lines back to where the hull cuts the water, add the transom, which will have the same dimensions in the reflection as the hull itself, and your reflection is complete. The same method can be applied, for instance, to a dock raised on pilings.

Water does not always provide an absolutely mirrorlike reflective surface. If the surface is disturbed by small swells or ripples, the reflection is distorted and will be interrupted by the reflection of light from the sky. Only the horizontal planes will truly reflect the image; others will show lengthened but distorted reflections, while still others will show no reflection at all. For this reason, depending on the angle of sight of the viewer and the angles of the planes caused by the undulations of the surface, the distorted and interrupted reflection will be greatly lengthened.

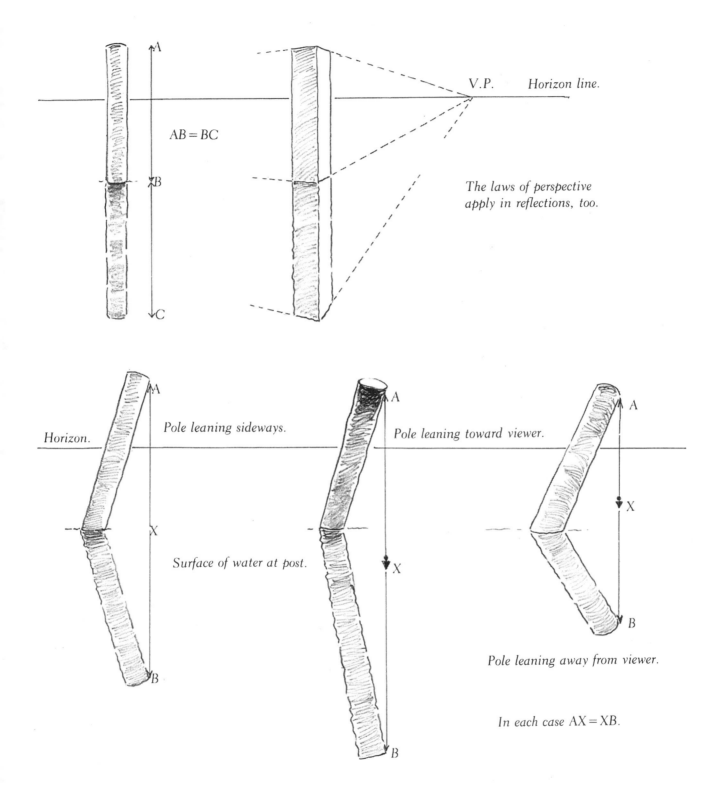

V.P. *Horizon line.*

AB = BC

*The laws of perspective
apply in reflections, too.*

A

C

Horizon. *Pole leaning sideways.* *Pole leaning toward viewer.*

A

X

A

Surface of water at post.

X

B

B

A

X

B

Pole leaning away from viewer.

In each case AX = XB.

Note that the reflections of tops A—A—A are not repeated in B—B—B. This would only be true if the surface plane of the water was at eye level. To test this, cut a piece of thick dowel about 10 inches long (see that the end cuts are square) and then cut it in the middle at an angle (around 30°). Glue the two bits together to form an angle. Keeping the joint horizontal, hold the piece at various distances below your eye level and notice the changing shapes of top and bottom. Also note that the ellipse formed where the pole enters the water is on a different plane from those at the ends.

79

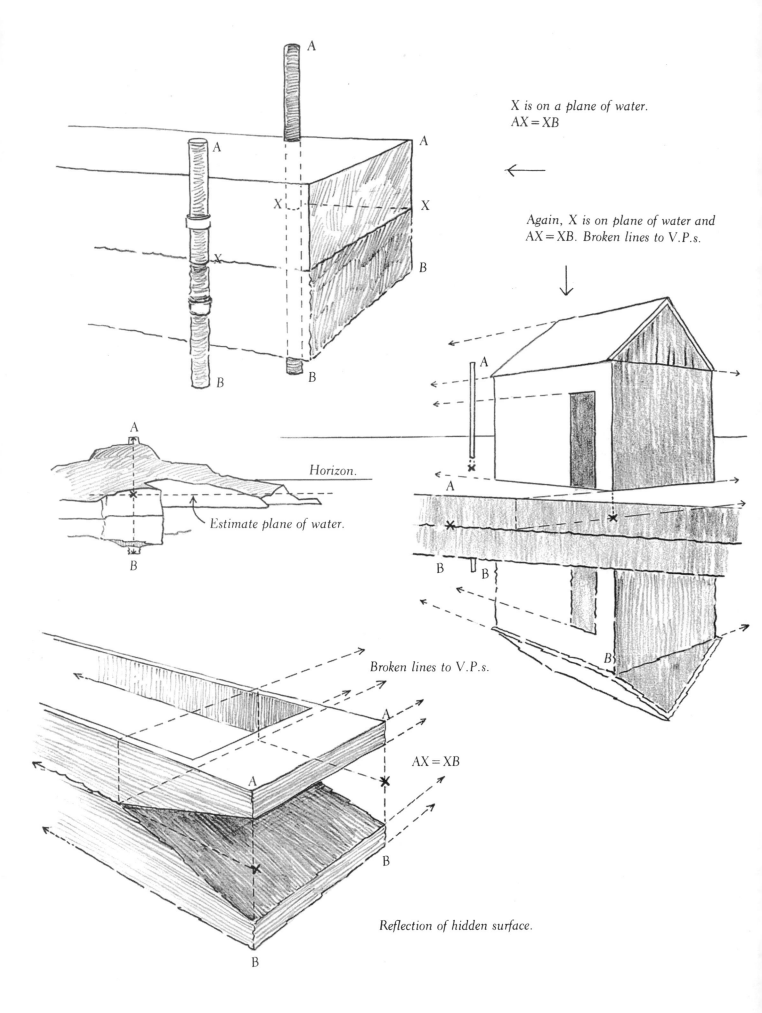

X is on a plane of water.
AX = XB

Again, X is on plane of water and
AX = XB. Broken lines to V.P.s.

Horizon.

Estimate plane of water.

Broken lines to V.P.s.

AX = XB

Reflection of hidden surface.

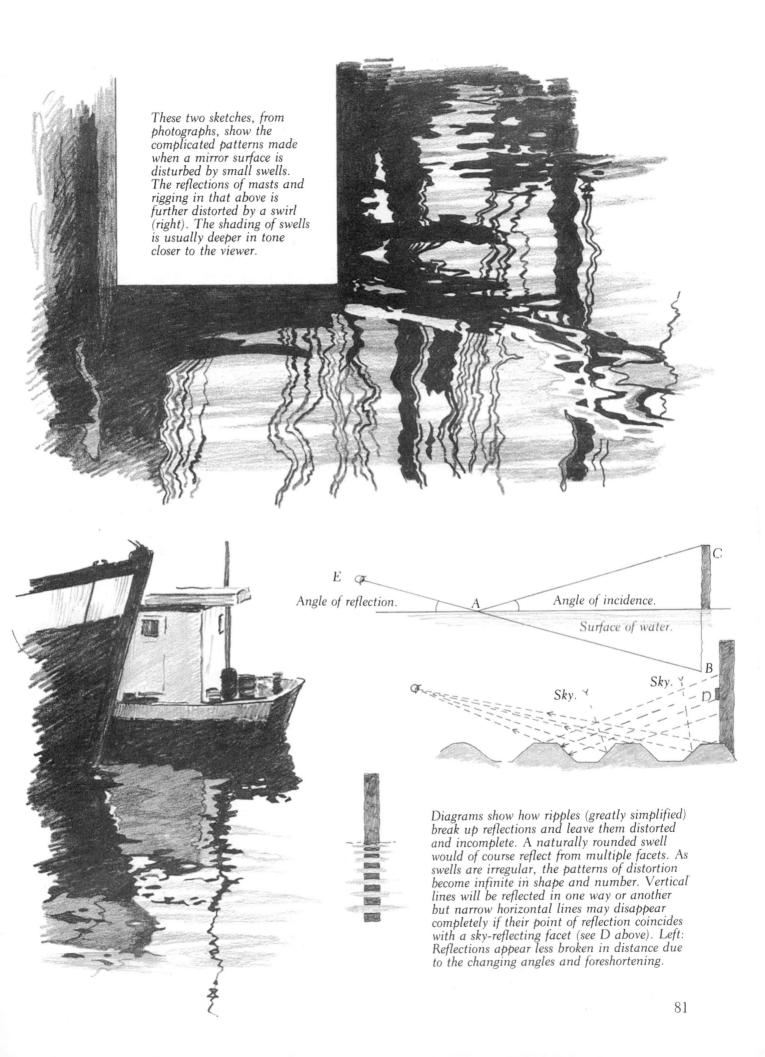

These two sketches, from photographs, show the complicated patterns made when a mirror surface is disturbed by small swells. The reflections of masts and rigging in that above is further distorted by a swirl (right). The shading of swells is usually deeper in tone closer to the viewer.

E

Angle of reflection.

A

Angle of incidence.

C

Surface of water.

B

Sky.

Sky.

D

Diagrams show how ripples (greatly simplified) break up reflections and leave them distorted and incomplete. A naturally rounded swell would of course reflect from multiple facets. As swells are irregular, the patterns of distortion become infinite in shape and number. Vertical lines will be reflected in one way or another but narrow horizontal lines may disappear completely if their point of reflection coincides with a sky-reflecting facet (see D above). Left: Reflections appear less broken in distance due to the changing angles and foreshortening.

81

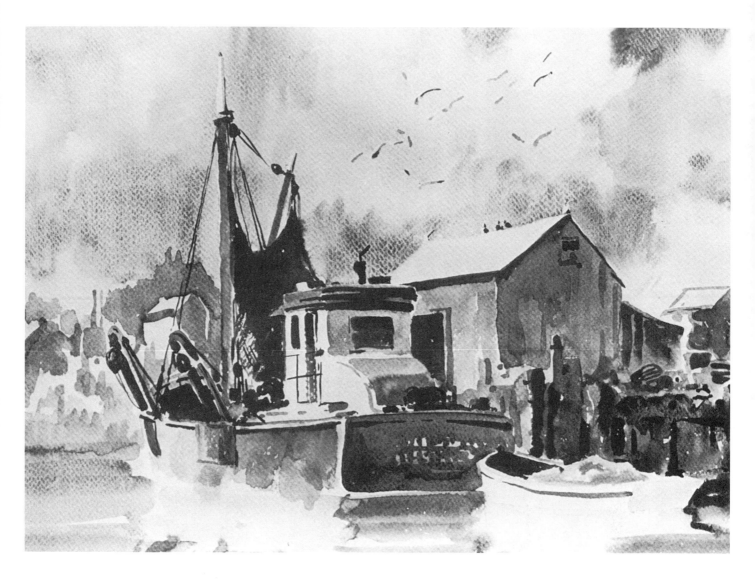

Watercolor on rough paper Sunny Morning *15x20"*

This was a quick sketch which I have included because I liked both the feeling of light and the way the sky came out. Notice how, on rough paper, some of the pigment in the washes settles to the bottom of the hollows in the grain. To enhance the feeling of light I left several areas of white paper showing. Also, the shadows were left light and airy and the detail in the distance kept to a minimum.

6

Skies

In any outdoor picture the sky plays an important part. The degree of importance depends on the composition. This is particularly true of marine subjects because water reflects the sky and depends on it for much of its tone and color. Even if very little sky is actually shown in a painting, its effect on the water will be the same. If the water is smooth, it will reflect the sky and cloud formations near the horizon will be mirrored. More often the surface will be broken enough so that only in a general way will the sky be mirrored, planes of the water picking up reflections from all angles. This, plus some cast shadows, is what gives water its color and values. Water has little color of its own and depends almost entirely on what it picks up from the sky.

Dramatic effects can be made by contrast—light sails against deep blue or a white lighthouse and breakers against purple-black storm clouds. A dark grouping of buildings or sails against a light sky is another example. Don't be afraid to force these effects. If a sky blacker or bluer than nature helps emphasize the point you are making, then paint it that way. You're making a picture, not a meteorological chart.

One suggestion—a sensible one, which applies equally to landscape painting—is that if your composition is complicated and busy, your sky should be as simple as possible. Lots of masts, sails, roofs, cranes competing for interest with masses of contrasting clouds usually makes for confusion. Conversely, a simple foreground makes a good foil for a sky filled with towering thunderheads or a magnificent sunset.

Studying the sky is easy. Unless you live in a cave or subway, you see at least part of it every day. A series of quick, small sketches in oil, watercolor, or pastel—and I mean quick, because the sky changes very rapidly indeed—will teach you more than any number of books.

Your observations will teach you that clouds have soft edges. Like any rounded form, the receding edge will become a little blurred and lose its definition. If you don't paint them this way, they will have a cut-out-and-pasted-on look. In nature they are also usually not as dark or light as they appear at first glance. An approaching squall, for instance, may look a deep blue black—and you may rightly decide to paint it that way—but contrast it with, say, the shadowy part of a nearby roof and you will see that, by comparison, the black sky fades to a gray. In the same way a white cloud is seldom pure white in comparison with, perhaps, a piece of paper from your sketch book. Remember, white is the highest key on your palette. Save it for emergencies, so to speak, and tone your white clouds down a little.

I am not going to make any suggestions about color mixing for skies—or for anything else. I don't believe in recipes and formulae. There are so many ways of arriving at the same end, so many color combinations that give the desired effect, that it would be mad, as well as presumptuous, to attempt to list them. Any serious student will take the time to experiment, to mix a little of this with a little of that and note the results. A day spent doing this is worth any amount of time copying the masters' prescriptions. Just remember, if you want clear

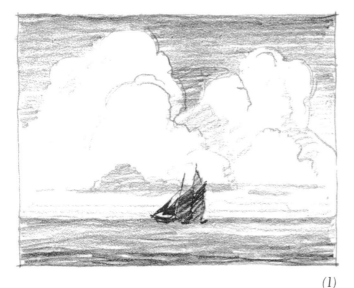

(1)

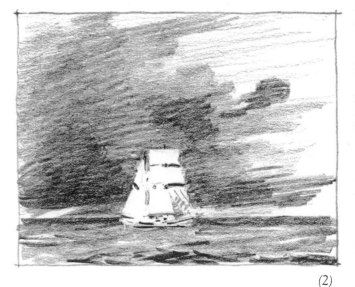

(2)

(3)

Sky and foreground must complement each other, in design as well as color. In (1) the towering clouds dwarf the vessel, dark is contrasted against light and simplicity is depicted against a complex background. In (2), light is contrasted against dark, the ominous clouds menacing the ship. Number (3) exploits the dramatic possibilities of a sunlit object against a dark sky. Here, because the buildings and rocks are fairly detailed, the sky has been kept simple. The same holds true of (4), although the dark is here contrasted against a strong light. Cloud patterns are infinite in shape and can be made to conform to and enhance any foreground design or, in the case of (5), very little design at all. The sky here, in proportion to the whole canvas and in boldness of design, is the dominant motif and if properly handled can "carry" the whole picture.

(4)

(5)

(6)

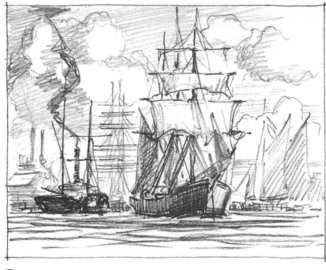

(7)

With a complicated subject, as in (6), I like to keep the sky as plain as possible. What may happen if you don't is shown in (7) where yards, rigging, clouds, smoke, and so on become a jumble. Also in (6) I have contrasted the tracery of masts and rigging of the ship in the background with the massed tones of the one nearest. The shape and direction of the clouds in (8) contrasts with the tilted vertical mass of the vessel. Cloud movement can be made to help a composition, adding motion, or opposition where a feeling of solidity is to be emphasized. Number (9) has some strong contrasts but note that although the storm clouds are dark they are not nearly as dark as some of the tones in the dock and buildings. Gray days can be lovely and colorful. In (10), a unifying gray pulls everything together, and sky, water, and masonry are much the same tone, with contrasting darks in boats and buildings.

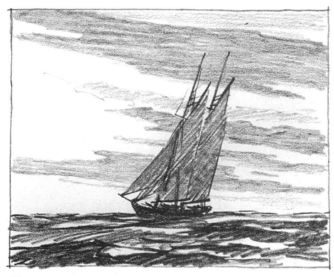

(8)

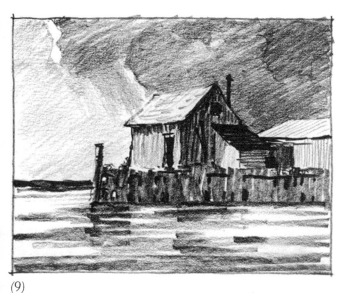

(9)

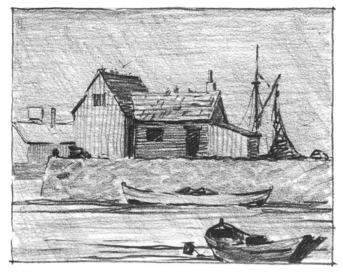

(10)

color, keep your mixtures clean. Dirty brushes and a cluttered, messy palette will result in a muddy painting.

Paintings usually have an overall color scheme, and the sky plays a predominant role in this. The sky generally sets the key for the painting, and its mood is reflected in the handling of the rest of the picture. See that the two parts mesh together and that the atmosphere created by one is in tune with the other. A bright, gay sky will not usually go well with a dull, heavily grayed foreground. Light, however, especially late sunlight, can be made to strike objects shown against a dark sky or background with dramatic effect. Here, though, the light creates the atmosphere and makes the picture, while the darker surroundings only act as a foil.

Objects seen against a sunset sky appear dark, but at second glance are often not as dark as we

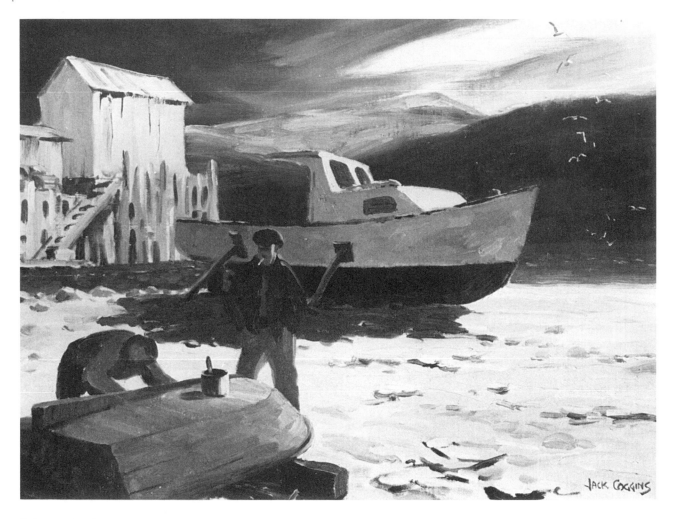

Oil Clouds and Shadows *18x24"*

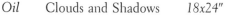

I forced the darks and lights a bit in this picture mainly because I liked the rather exciting contrasts in the final pencil sketch from which it was painted (as valid a reason for doing a canvas as any). A good sketch usually makes a good painting. It certainly carries well, but is difficult to hang in a show in consequence as it tends to jump out from a wall of paintings in any grouping. As in many of these freely painted canvases of mine, I spend almost as much time on the preliminary sketches as I do on the finish. I was going to highlight the head, shoulders, and left arm of the standing figure, but decided to let him blend with the shadow side of the boat.

think. They are darker than the sky behind but can still pick up a good deal of light from the sky above and to the rear and sides of the viewer. It is not until the sun is gone and the rest of the sky is darkening that an object, a ship under sail, for instance, will appear almost black against the afterglow.

Watch out for sunsets, by the way. They are tricky things to paint, and it is easy to be carried away by an array of pink and orange clouds floating against a background of greeny blue. Sunsets are natural, all right, but at times they appear just plain gaudy, with some most peculiar color mixtures. It is my experience that these buckeye concoctions of Mother Nature should be avoided. Watch and marvel, but don't try to paint them—they will inevitably look a bit tawdry as well as overwhelm anything else in the picture. On the other hand, sunset skies, if on the quieter side, can add a great

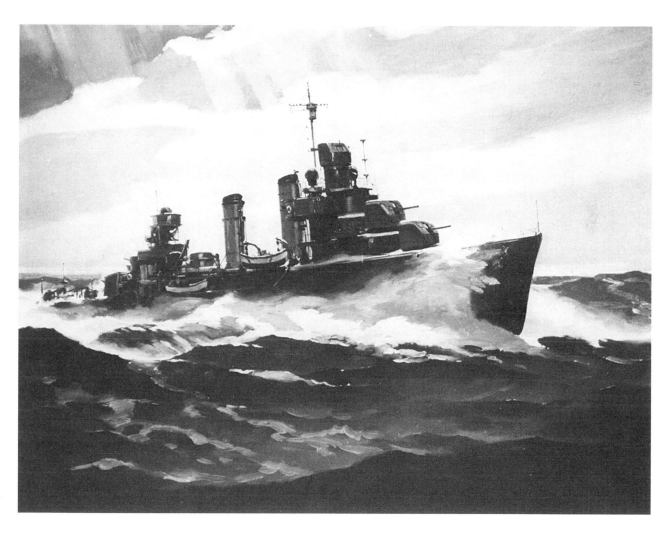

Oil U.S. Destroyer *Gleaves* *22x30"*

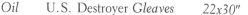

A shaft of sunlight bursting out of gray clouds spotlights this World War II Benson-class destroyer. Coupled with a heavy sea, this made a dramatic canvas. I have painted many modern warships and because in themselves they are seldom things of beauty I try to put them in settings which emphasize their speed and power. The water was kept dark to contrast with the spray and foam. Accuracy is essential in this type of painting and while I have painted contemporary vessels from blueprints I work from photographs when available, preferably ones shot from the correct angle. A ship painted gray needs all the color you can give it and I work in as many variations and reflections from sky, decks, and so forth, as possible.

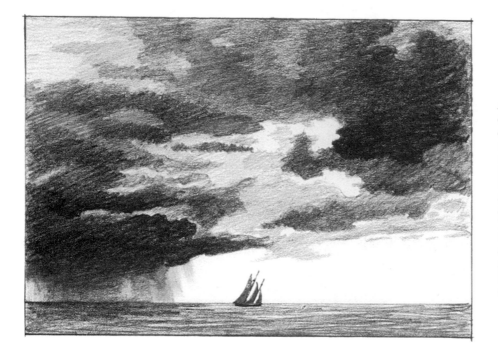

A stormy back-lit sky can be made dramatic and colorful. The light area at the horizon and above might be quite brilliant contrasting with the darks of the clouds and trailing rain. The progressively lighter clouds behind give distance and a chance to introduce warm colors to offset the darker grays. The cloud patterns in a sky like this can be complicated or simple as long as the gradations are kept subtle and the edges soft. The ship is small to emphasize the menace of the sky and expanse of sea.

Distance is the key here—cloud formations one behind the other to the horizon. The towering light cumulus clouds rolling upward are set far in the background by the streaks and patches of darker clouds in front and above. Don't make the light clouds too light or the darks too black or the effect will be jumpy and overpowering. Clouds are only vapor, and even the boldest and darkest should be handled with restraint. The same is true of the clear parts. Too intense a blue may spoil the atmospheric quality and cohesion of your painting.

deal to a composition. The cloud patterns are often quite strong, and the light gives the opportunity of introducing warm colors into an area that might otherwise tend to be cool. When you look at a sunset (or sunrise), the cloud patterns silhouetted against the light may appear quite dark. Once again, check your values against some dark object in the foreground. You will find the clouds are not so dark, after all, and may turn out to be a light pearly gray, which only seems dark by contrast.

When painting the light which often appears

around the edges of a cloud seen against the sun, be sure to keep the edges soft. These light edges may appear lighter in tone than the sky behind. This is especially true when painting areas of broken cloud in a generally gray sky lit by occasional patches of sunshine. These days also produce the ray effect, with beams of light spraying out dramatically through rifts in the clouds—what my wife calls an "And the Lord spake unto Moses" sky. If not overdone these skies can be very effective but can also be a bit overpowering.

(1)

(2)

The amount and direction of light striking clouds at various heights and distances depend on the size and density of other clouds between them and the sun. This lighting is arbitrary and constantly changing, and within reason can be arranged by the artist to suit the painting. The simple formations in (1), (2), and (3) are the same, but light from the sun (in this case, coming over the viewer's right shoulder) has been blocked in different ways, much as scenery flats on stage are in light or shadow depending on the arrangement of the spots. In (4) the light is behind the clouds and depending on atmospherics there may be a sunburst effect. In any case the edges of the darkish clouds against the light will probably have light edges where the solid mass of the cloud thins out. The same is true of (5) but here the blue of the sky is darker than the shadow side of the cloud, while some clouds are in full sunlight. These light fleecy clouds are typical of bright sunny days.

(3)

(4)

(5)

89

Usually only very heavy rain can be seen hanging from a cloud as in the sketch to the left. It is more typical of the tropics—or the plains—and can be very local. Standing in brilliant sunshine on a rise on a northwestern prairie I once counted a dozen such rain squalls, each with its thunderhead and trailing downpour and each surrounded by miles of sunlit country. The same effect can be seen in the waters of the Caribbean. These skies are dramatic, but don't overdo them. In temperate zones the rain has a more misty quality—one object after another being blotted out as the rain comes closer. The wind effect helps dramatize a stormy setting—tree branches bending, people leaning into the blast, lines blown in curves, signs blowing, and canvas flapping. Besides overall grays, stormy days often produce fairly strong light effects, which can be used to effect on wet surfaces.

Rain storms are beloved by watercolorists, because if you know the tricks of the trade, it is easy to show the rain falling convincingly out of the underside of a nice, fat, juicy cloud. In oil don't paint the trailing rain too heavily or with hard edges. Most rainy days are just dull, with edges and distant features blurred and almost lost. Dull doesn't mean dirty, though. Such days can produce some lovely grays, accented by light hitting puddles, tin roofs, and other reflective surfaces.

Oil on canvas Wind Fair, Sea Moderate *24x30"*

From the collection of Mr. and Mrs. Lewis J. McCoy.

The sunset glow is behind and to the right of the vessel, but the sky to the east is still so bright that the sails of this three-masted iron bark are quite light, though technically in shadow. The ship's rust-streaked sides and patched sails suggest she is homeward bound—and riding a bit light. Had she been heavy laden she would have been showing a little less freeboard.

The sky has been kept simple, and the cloud patterns unobtrusive. These sunset skies which fade from blue to warm orangey-yellows are tricky to paint, and the gradations must be subtle. I handled this one by blending wet in wet with horizontal strokes of a big brush. This works well in a fairly slick treatment. For more rugged results the same general effect can be had by careful gradation and juxtaposition of brushloads of broken color. These strokes should be close enough to their neighbors in color and value that they do not jump, while retaining enough variation to make an interesting area.

The rigging is sufficient, without giving a blueprint effect. With plain sail set the old ship is ploughing comfortably along, and we can well believe the log entry echoed in the picture's title.

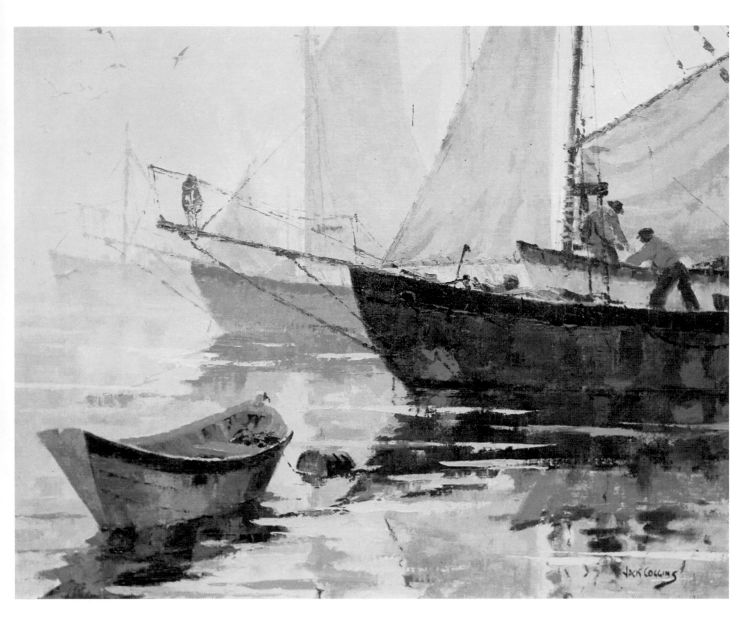

Oil on canvas Swordfishermen 24x30"

From the collection of Mr. and Mrs. B.L. Dietrich.

Above: Knife work can give the artist a great feeling of freedom and spontaneity as well as a chance to play colors one atop another without losing clarity. Directions of the dory and the pulpit draw attention to the figures, while the eye also centers on the mooring buoy—one spot of red among the blues and grays.

Oil on canvas Among the Rocks 20x30"

Left, above: I sat for quite a while watching the water boil around in this little inlet, made a rough sketch, took a few photos, and later made this fairly careful study. Nothing very dramatic, but typical, and I have always liked it.

Watercolor on rough paper The Seine Boat 12¾x17"

From the collection of Mr. and Mrs. E. Kenneth Nyce.

Left, below: Every time I do a watercolor I am impressed with the crispness and clarity of the medium and the possibilities for fluid transitions in color and value. Clear washes over white paper give sparkle and brilliance unattainable in oil.

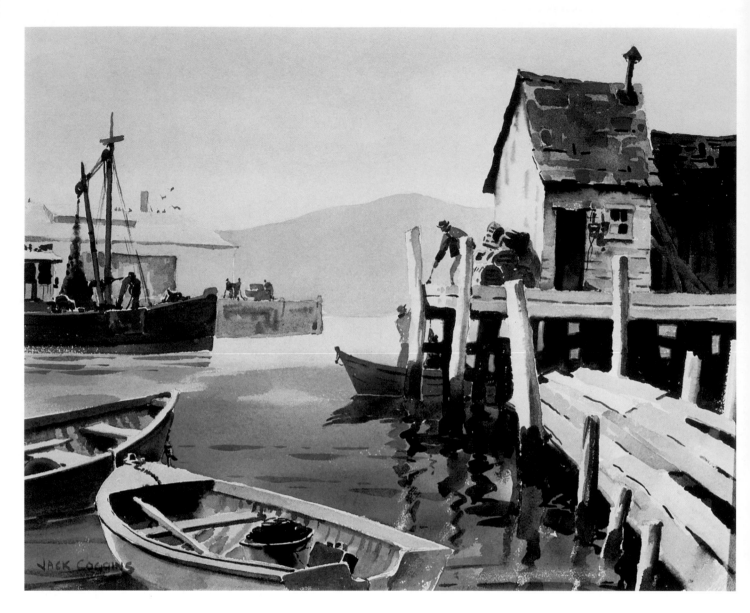

Watercolor on board Fishing Village—Nova Scotia *14x18"*

Above: This little scene was "cooked up" from a couple of sketches, a photo or two, and a lot of knowledge of the subject matter. In pattern pieces like this I work out the composition carefully via a good many trial pencil roughs.

Oil on Masonite Still Water *16x22"*

Right, above: This tranquil scene—also in Nova Scotia—seemed so right that I painted it almost as is from the slide. It doesn't often happen, but if the scene composes well there is no point in monkeying around with it, so I concentrated on the painting, forcing the color a little here and there and simplifying it in places.

Oil on canvas board Maine Coast *12x16"*

Right, below: This little sketch, done mainly with a knife, came out quite well, so I framed it. Though small, it has a "big painting" feel and the knife work has the boldness that often comes with speed and directness of execution.

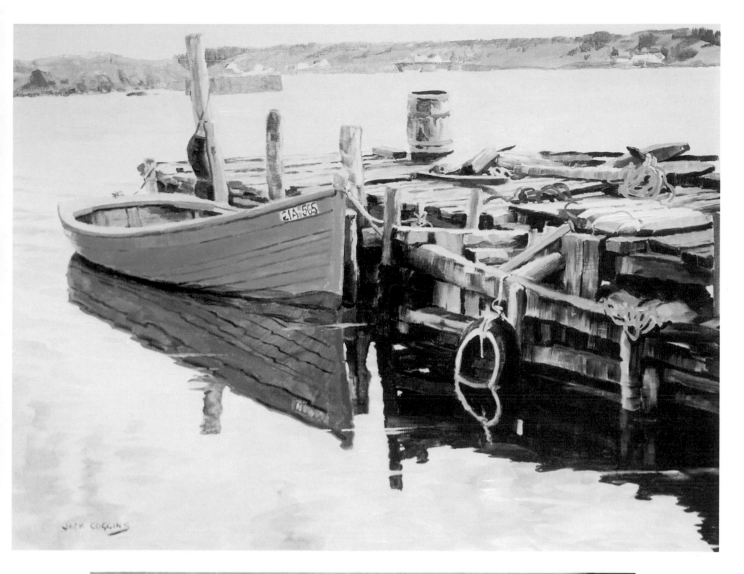

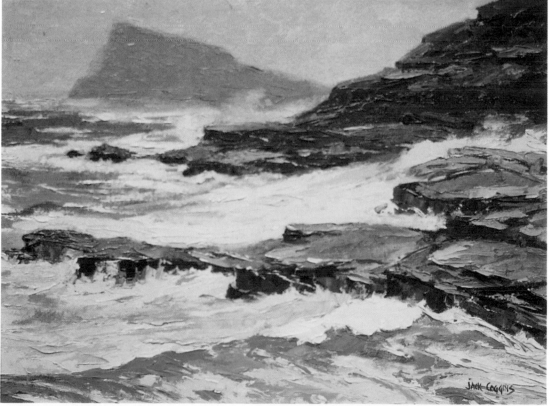

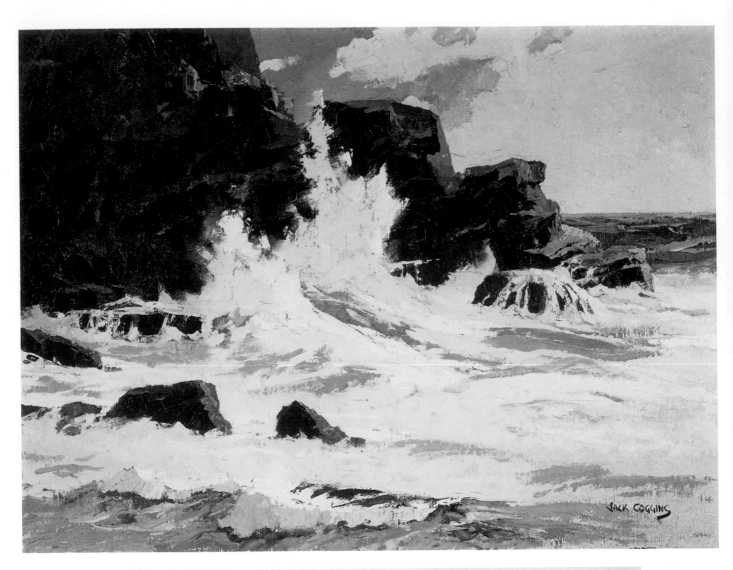

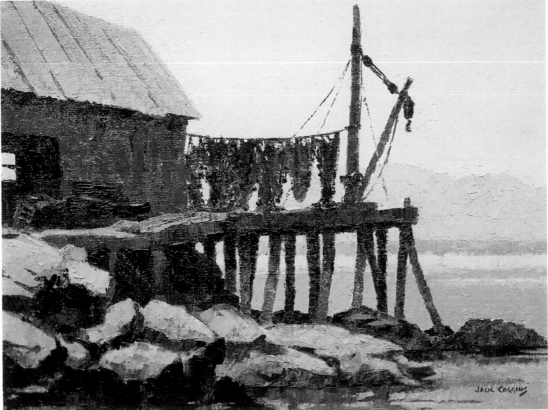

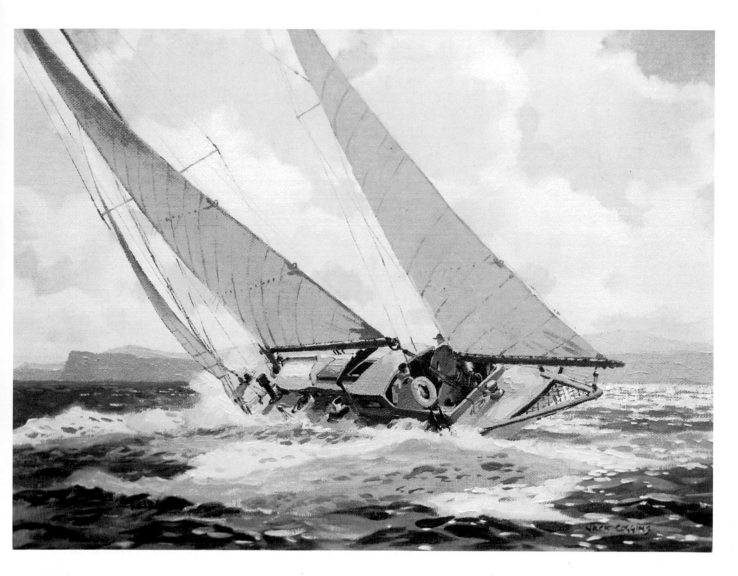

Oil on canvas Close Hauled *11x15"*

From the collection of Mr. and Mrs. James K. Boyer.

Above: Yachting pictures are always fun. I have done many, mostly commissions, including some covers for Yachting magazine.
Watch your details. Owners know every lovely expensive inch of their boats and like them painted accordingly. My interest here, besides the angle of hull and "set" in the water, was the dazzle effect and the way the sun lit the cloud edges.

Oil on canvas Sea Surge *22x30"*

Left, above: A good example of a painting done almost entirely with a knife. Rocks and surf seem to lend themselves to this technique. The rocks were underpainted flat with a warm brown and the water area with a light gray green. The rock formations were then modeled with bold strokes of the knife and the sea and surf treated the same way.

Oil on canvas Drying Nets *18x24"*

Left, below: Another knife painting, done with smaller strokes and using broken color. Unobtrusive "surprises" of color contrasts give a snap to otherwise dull areas. By doing this you can make your shadows glow.

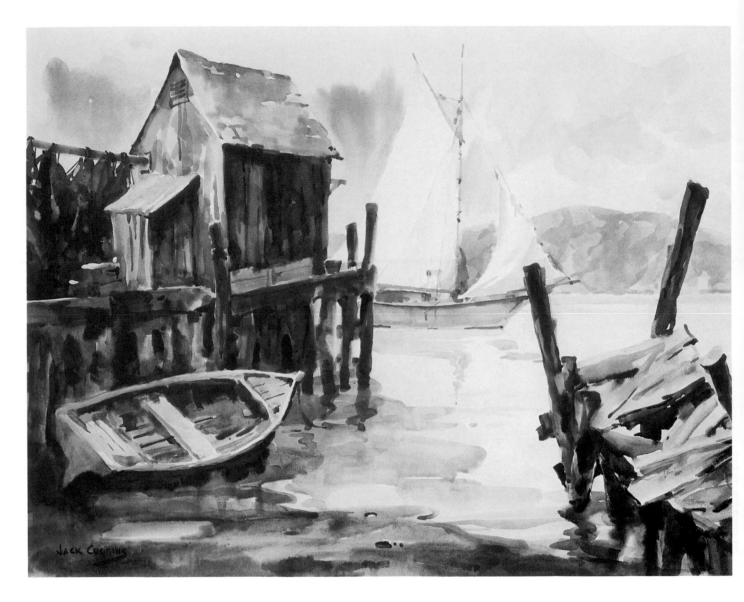

Watercolor on hot press board The Sloop 19½x25½″

Here the tones are built up in places, wash on wash: purples are overlaid with blues, burnt sienna with viridian, and so forth. The smooth board can present problems, especially in sky areas, but by judicious use of wet areas and the quick application of a clean sponge when a wash shows signs of getting out of hand, this can be kept under control. Lights can be left out, or painted with Maskoid or some similar substance and then removed.

I believe a watercolor, even of a desert scene, should have a fluid, wet effect. In my opinion this is what watercolor painting is all about, and overworked dry brushed, "every knothole showing" paintings usually leave me cold. True—watercolor also facilitates rendering of detail, but much of this can be suggested, with satisfactory results, and the fluid character of the medium retained.

Oil Fog 18½x22¼″

This impression was painted quickly with a knife on a board manufactured with a pronounced canvas tooth (one of those useful products which vanish from the market for one reason or another—at least, I haven't found any for years). The rigging and details of the schooner were kept at a minimum. The bell buoy was handled in the same manner, but the darks and lights were a little more pronounced.

In fog the light is different, somewhat brighter and yellower than on a rainy day. The blurring effect is more pronounced, and depending on the density of the fog, objects only a few yards away begin to fade. The fading away is quite rapid—an object, like the bow of a ship, may appear fairly clear, whereas the stern may be almost or quite invisible. Fog banks are often quite sharply defined, and it is possible for a vessel to sail out of fog into the clear almost as if breaking through a wall.

Watercolor Freighter Unloading on the Thames 22¼x16¼"

This was done years ago as an experiment. I had always used rough watercolor paper, occasionally cold pressed, but was curious to see how watercolor worked on a smooth surface. This was on kid-finished Bristol and while I found it a bit tricky I rather liked the effect. The washes will run and puddle freely but the surface lends itself to detail if you should need a little here and there. I have used smooth board often since and if I keep a little freedom in the washes, even in fairly technical subjects, I find it suits my way of working quite well. The addition of a small hair dryer to my kit has proved useful. Be cautious, though: the first time I used mine I blew a puddle of wash right across the sheet!

7

Freighters and Tugs

Freighters can be fun to draw. I've always found passenger ships, especially the big ones, a bit of a bore; but a rusty old tramp steamer, from half a century or more ago, still tempts me once in a while. The more modern boats may intrigue you—they are a bit too streamlined for me—and naturally fit into a modern port scene very well. If you can't sketch or photograph them yourself, use one of the types below.

By the method shown on pages 26 and 27 you can draw a hull at any angle providing you have a profile. From the profile you can estimate a rough plan (lacking a real one), and between profile and plan you can reconstruct the hull and superstructure accurately enough for most paintings. Just another trick of the trade, but it can come in handy sometimes.

I have always handled my port scenes rather broadly. There is a tendency to get involved in a vast amount of mechanical detail: railings, cargo booms and rigging, lifeboats and davits, ventilators, not to speak of cranes and whatnot on docks and shore. Even when very professionally done, I find this a bit overwhelming when painted in detail. Using a more impressionistic technique, this minutiae can be suggested rather than blueprinted. Distance lends enchantment, they say—across a picture gallery a detailed painting often gets "lost", but a boldly handled one often looks quite "finished."

Whatever you may feel about freighters, tugboats are quite delightful. They have a jaunty air about them, especially the smaller ones. They are a useful adjunct to a painting of a large port, either towing, pushing, or proceeding about their busi-ness. The larger, oceangoing variety are at home in any weather and are capable of delivering a tow to the Mediterranean or the Far East.

In the days of sail tugs could often be seen miles offshore waiting to pick up homing vessels held up by headwinds. They almost always took the big sailing ships out of port and frequently, if the breeze was contrary, quite a distance out to sea. Young sailors on their first voyage have written that when the tug finally cast off and turned for land, they really felt irrevocably cut off from home and family.

Many European tugs were side-wheelers (and some still are). Although without the traction power of screw tugs, side-wheelers could, by disengaging one paddle wheel and going ahead on the other, turn on a dime—a useful trick in a narrow, crowded harbor. I like to paint the British fishing vessels of eighty or one hundred years ago—husky ketches with long bowsprits and tanned reddish brown sails. If wind and tide were foul, they were usually towed out of the narrow entrances of ports like Yarmouth and Lowestoft by venerable paddle wheelers, black smoke pouring out of their tall funnels, water churning, and clouds of gulls in attendance. If tugs really send you, there are good plastic kits to be had, easy to assemble, and fun to draw.

Once more—watch your scale. Be sure that the tug in the foreground of your picture doesn't actually dwarf the big freighter in the middle distance. If you are not sure, project the stem of the tug to a VP on eye level and see how it compares in size.

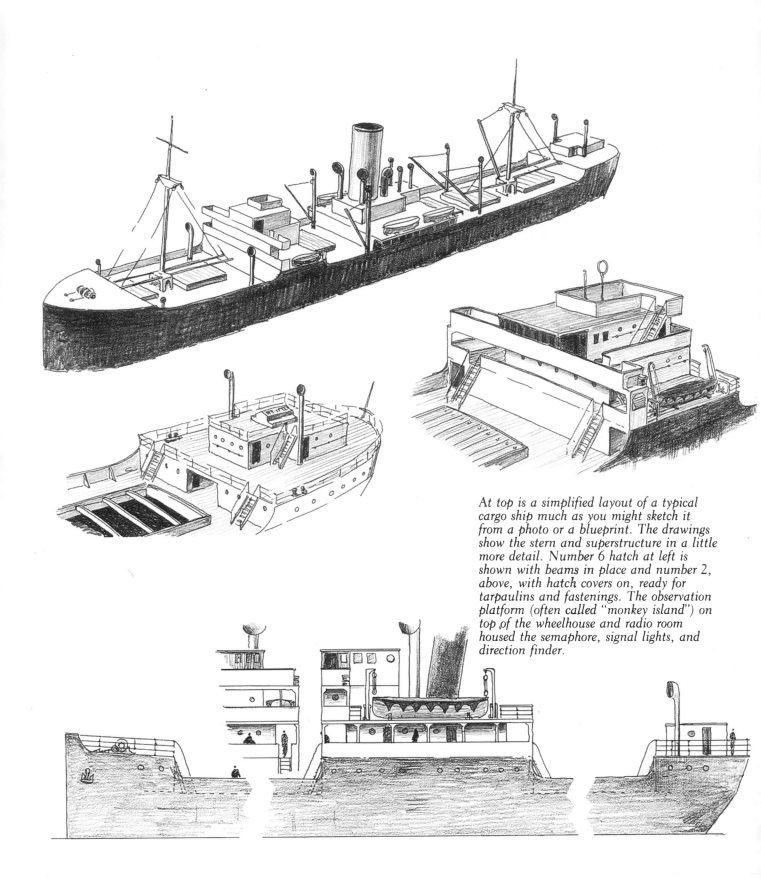

At top is a simplified layout of a typical cargo ship much as you might sketch it from a photo or a blueprint. The drawings show the stern and superstructure in a little more detail. Number 6 hatch at left is shown with beams in place and number 2, above, with hatch covers on, ready for tarpaulins and fastenings. The observation platform (often called "monkey island") on top of the wheelhouse and radio room housed the semaphore, signal lights, and direction finder.

This little ship is not to scale lengthwise, but the heights are about right. Bulwarks and railings will be approximately the same, perhaps 40 inches no matter what the size of the ship. I figure deckhouse heights at about 7 feet—lengths of course depending on size and layout of the ship. Lifeboats might be 24 to 28 feet long. If you make them three and a half times the deckhouse height, you won't be far wrong. Ladders as at A, B, and so on might have nine treads. Passenger liners have several decks and many lifeboats. The central superstructure is long in proportion as little deck space is taken for hatches, winches, and the like. Just as some of the nineteenth-century clippers carried a few passengers, so some cargo steamers were built with accommodations for people who disdained the Grand Hotel atmosphere of the great liners. Vessels of this sort could be recognized from the all-cargo types by their longer superstructures and larger number of boats.

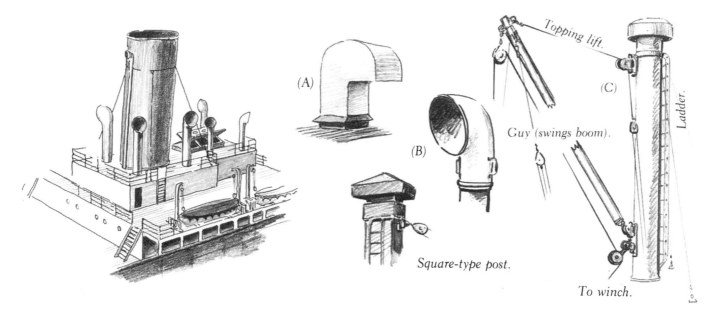

(A)

(B)

(C)

Topping lift.

Guy (swings boom).

Square-type post.

Ladder.

To winch.

Sketch, above left, shows funnel area of vessel on opposite page. Ventilators in older ships were of the cowl type (B). These were of varying heights and sizes—the largest for the stokeholds and engine rooms—and most were made to turn. In more modern ships, powerful electric blowers and fans supplement the old cowl intakes and vents; (A) is one such type. Cargo booms or derricks are mounted on masts or on tables as in D and on Sampson or King posts (C). Being hollow, these also serve as ventilators, with mushroom or cowl tops. They were nearly always mounted in pairs. In (E) you see a masthead crosstree with topping lift blocks.

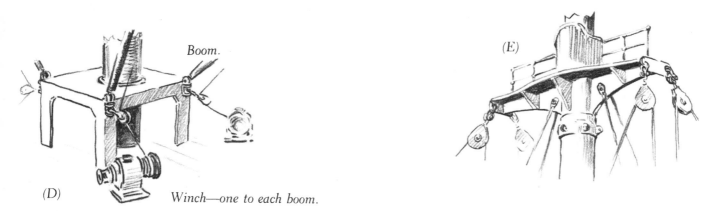

Boom.

(D)

Winch—one to each boom.

(E)

Below are diagrams of two kinds of davits found on modern vessels. Left is gravity-operated davit, in which boat and cradle are let down parallel tracks and the boat is then lowered to loading position and down to water. It can be operated by one man and gives more deck space. A quadrant davit is shown at right. Davit arms are swung out by crank and worm gear. The boat is lowered by falls in the usual manner.

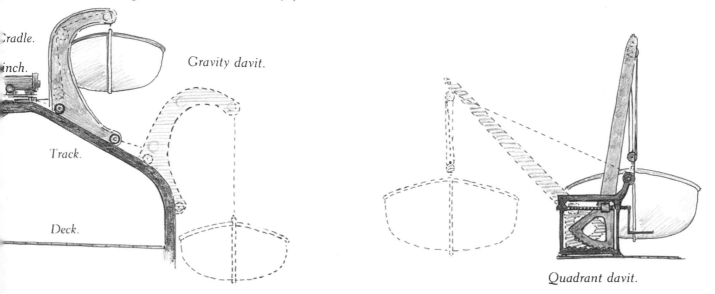

Cradle.

Winch.

Gravity davit.

Track.

Deck.

Quadrant davit.

(1)

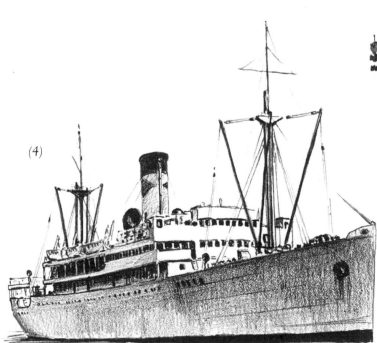

(2)

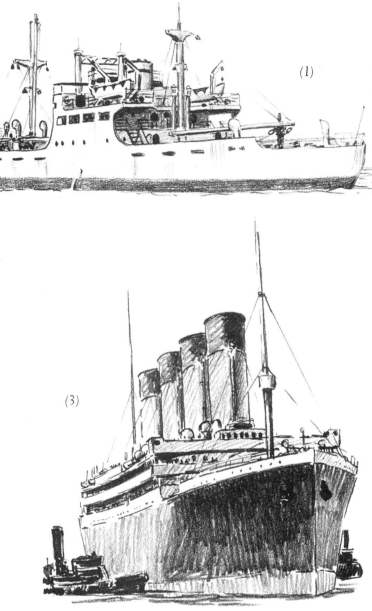

(3)

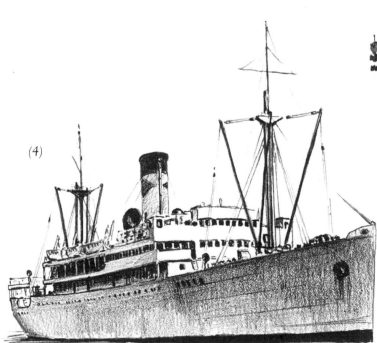

(4)

Number (1) is a small diesel-driven freighter, big enough for ocean voyages yet able to navigate many rivers and inland waterways. Note the scale of ladders, rails, and such in comparison with a larger cargo-passenger ship (4). Booms in (1) are lowered and in rests, ready for sea. Booms may be shown as in (4) in port, about to work cargo, but not on the open sea. The strain on guys and other gear would be too great. The head-on view in (2) is not a good angle for a painting. I included it to show the hull shape and the way in which the upper bridge of some large passenger ships projected to give a better view for docking. Number (3) is a real old-timer, circa 1912, from the days when such liners plied the Atlantic with the regularity of clockwork. The huge funnels (they were coal-burners) were characteristic.

Right is a freighter (about 1940) in ballast on her way to pick up cargo. When loaded, the light part of the hull (usually red) would be submerged. Nearing port, her booms are up and ready for loading. A ship has a good many discharging pipes and vents and there is usually at least one stream of water pumping overside.

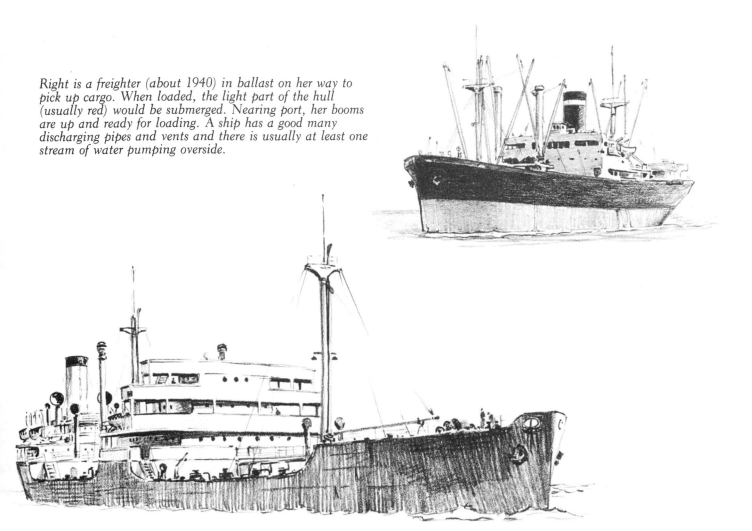

Above is a tanker of the 1930 period, about 525 feet long and 65 feet broad with raised forecastle and poop deck, bridge amidship, and engines aft. Vessels such as these carried the bulk of the fuel in World War II and dozens met fiery ends as torpedoes exploded in their flammable cargos. Ships like this were considered large in their day but are dwarfed by today's supertankers, some of which are well over 1,200 feet long and more than 200 feet in beam.

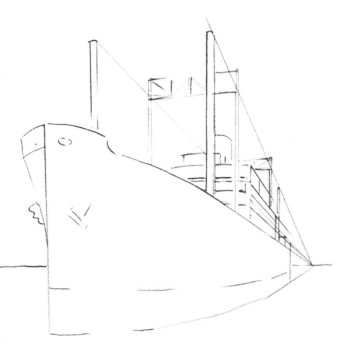

When working from photographs, avoid distortion due to too close a camera angle, such as in the diagram at left. Such an angle might be useful if you want to emphasize the huge bow of a liner looming over a little tug, but in general it is better to use a picture taken from farther away. Decks, deck structures, railings, and the like will follow the law of perspective, but you must make allowances for sheer—the slight curve or sag in the line from bow to stern. When laying in a hull with superstructures and so on, I usually lightly draw my deck and rail lines in perspective as though the hull were perfectly straight. This ensures continuity of deck levels and correct heights. I then compensate for sheer, allowing for the slight curve of the sheer line by eye. It is not much of a curve but a vessel drawn perfectly straight looks stiff and lacking in grace.

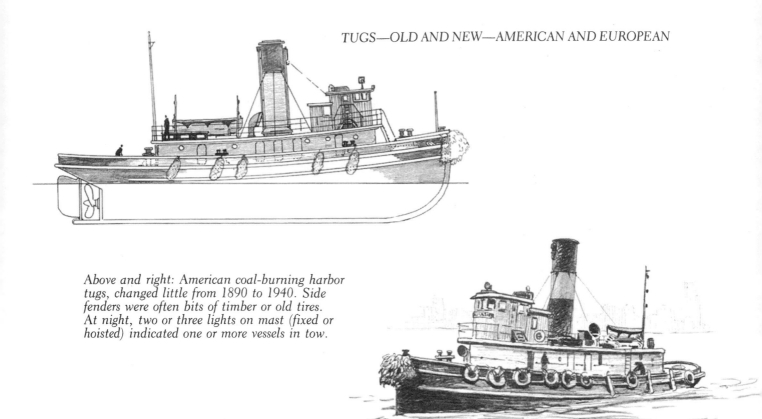

Above and right: American coal-burning harbor tugs, changed little from 1890 to 1940. Side fenders were often bits of timber or old tires. At night, two or three lights on mast (fixed or hoisted) indicated one or more vessels in tow.

American harbor tugs are used as much for pushing as for towing and can be recognized by the large rope fenders at the bow and along the sides. The two above are coal-burning steamers, with the characteristic tall stacks. Today's tugs are mostly diesel engined, and stacks are lower or have disappeared altogether. Beyond that, the type has not altered much.

The river tugs below are designed for pushing. In winding rivers, often with strong currents, greater control can be maintained over a tow when the power source is at the rear of and linked firm to the barge or barges. Some "pushers" have tunnel drive, like the model at left. This not only protects propellers from snags and logs but gives more thrust and maneuverability.

Some tugs are oceangoers and can tow large pieces of equipment (drilling rigs, for example) half-way around the world. The 170-foot European oceangoing tug is of this type. Paddle wheel tugs were common in Britain in the middle and late nineteenth century and often cruised down the Channel looking for a tow. Few square-riggers left port without one and tugs were used to tow fishing vessels out of narrow harbor entrances against wind or tide. The heavy arcs on the sterns of the European tugs are tow bows and serve to allow the towing hawser (which in these craft fastened farther forward than in their American counterparts) to move from side to side without fouling anything on the after deck. On the opposite page, the pen-and-ink drawing of the three American tugs shows how tugs team up on a big tow. The sketch also shows how you can draw with the shadows—letting the viewer's eye fill in the omitted outlines. The diesel tug has her well-padded stem against the freighter's stern and is giving her a gentle shove.

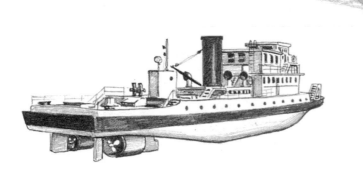

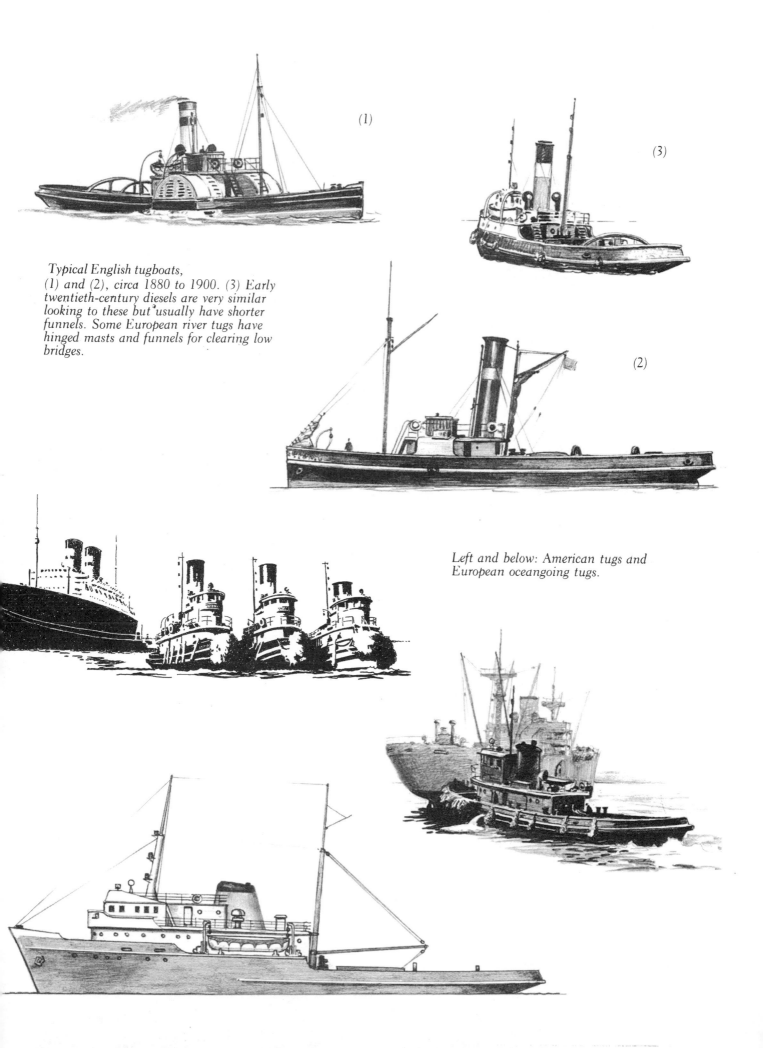

(1)

(3)

Typical English tugboats, (1) and (2), circa 1880 to 1900. (3) Early twentieth-century diesels are very similar looking to these but usually have shorter funnels. Some European river tugs have hinged masts and funnels for clearing low bridges.

(2)

Left and below: American tugs and European oceangoing tugs.

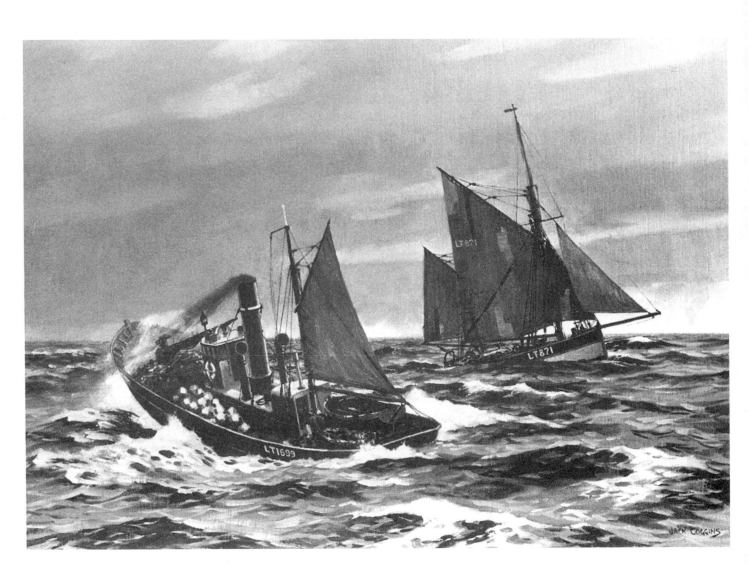

Oil on canvas Gray North Sea Morning *22x30"*

This painting showing two typical but quite different fishing vessels seemed a natural to head this chapter. It could have been titled The Old and the New *but both types, a British sailing trawler and steam drifter, are now museum pieces. The painting is fairly tightly done. I was interested more in combining accuracy and motion in a sea-sky setting than in creating a mere impression. This is a choice most ship painters have to make, and the results depend on the artist's skill at compromising between realism and impressionism. The "story," if you can call it that, did not seem to demand a bright, sunny approach, and grays and subdued lighting felt more appropriate to the cold, hard work of the fishing fleets.*

8

Fishing—Vessels, Methods, and Men

As I have mentioned, sail has all but disappeared from the commercial scene, but the United States and Canada support a thriving fishing industry, which employs a great variety of vessels of all sizes. These boats are the source of much material for contemporary marine artists, either as additions to harbor scenes or as the focal point of a work. A painting involving a fishing vessel will convey a greater feeling of authenticity if the artist knows a little about the type and what it is supposed to do.

Vessels vary a great deal in shape and size, and many are equipped to carry out several different fishing operations. Styles are changing, too, and the familiar dragger which filled ports like Gloucester will soon be as obsolete as the schooners of yesterday, supplanted by the more modern stern trawlers.

Let's start with the old-timers first. Years ago the biggest business in American offshore fishing was the cod fishery. For centuries, even before Columbus stumbled on the West Indies, thinking he'd reached China, hardy fishermen had crossed the North Atlantic to fish the teeming waters of the Grand Banks off Newfoundland. The reason: before the days of refrigeration the cod was one of the few protein-rich foods that, split, salted, and later sun dried, could be preserved for a considerable length of time. Haddock, pollock—both of the cod family—ocean perch or redfish, and halibut were also fished in quantity, but cod was the largest and most important catch. Cod are ground fish, generally living and feeding on or near the bottom, and are found in quantity on the relatively shallow waters of the Continental Shelf, especially in the

shallowest parts or banks, such as the Grand, the George's, and the Labrador banks.

Fishing was originally carried out from the decks of the fishing vessels using hand lines some fifty to one hundred feet long, weighted and with two hooks. Bait was clams or bits of mackerel or herring. Early in the nineteenth century fishing boats began to carry dories, small boats of Portuguese origin. A number of these, with one or two men, could cover a greater fishing area. In mid-century began the system of laying and hauling trawls from dories, a practice that ended in America—the Portuguese still do it—a few years ago. Dory fishing was hard and dangerous work, and fishermen now prefer to ship in the newer trawlers and long-liners.

A trawl was a long, stout, tarred line (the ground line), made up of series of shots fifty fathoms (three hundred feet) long. At about three-foot intervals lighter lines (snoods or gangens) two- or three-feet long with a hook at the end were fastened to the ground line. Seven shots fastened together made up a trawl tub (about six hundred seventy-five gangens and hooks). A dory might carry four tubs and when these were fastened together they made a trawl line about one and a half miles long with some twenty-seven hundred hooks. A good-sized schooner might easily carry a dozen dories. When they were all out, that meant over thirty-two thousand hooks on the bottom!

Because their seats (thwarts) were removable, dories could be carried nested one inside the other like piled saucers.

When the fishing ground was reached and the skipper thought he had found a likely spot, the ship

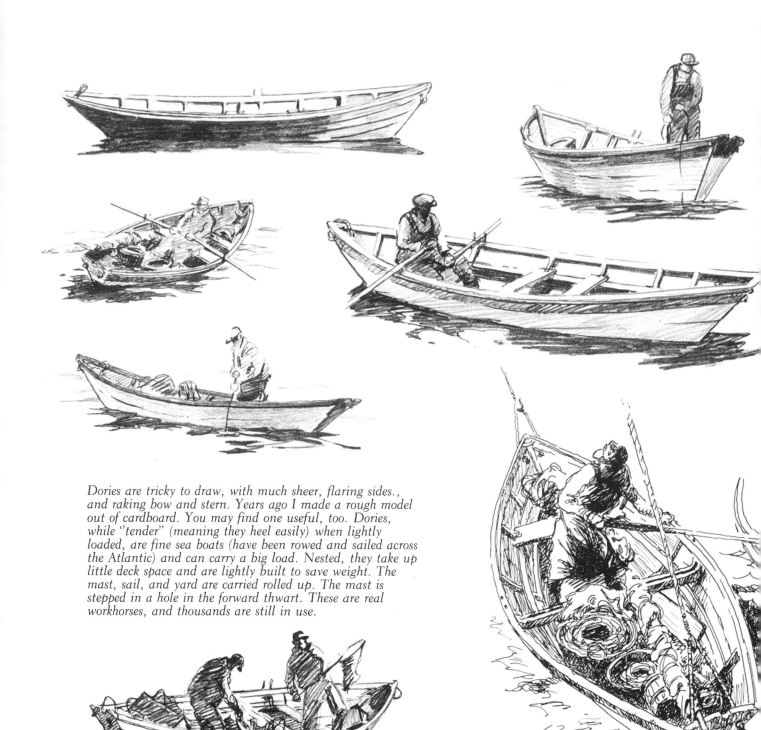

Dories are tricky to draw, with much sheer, flaring sides., and raking bow and stern. Years ago I made a rough model out of cardboard. You may find one useful, too. Dories, while ''tender'' (meaning they heel easily) when lightly loaded, are fine sea boats (have been rowed and sailed across the Atlantic) and can carry a big load. Nested, they take up little deck space and are lightly built to save weight. The mast, sail, and yard are carried rolled up. The mast is stepped in a hole in the forward thwart. These are real workhorses, and thousands are still in use.

anchored and the dories were readied and got overboard. Tackles, from fore and main spreaders, were hooked onto the rope beckets at a dory's bow and stern, and it was heaved up and overside. The dorymen then dropped aboard—no mean feat in itself in a choppy sea. There were usually two men to a boat, but some vessels carried smaller, single-crew dories. The boats pulled or sailed away from the anchored vessel, fanning out in all directions.

To lay the trawl, a marker buoy was dropped, the end of the ground line was fastened (bent) to a trawl anchor, and the anchor let go. One man rowed while the other paid out the earlier baited trawl from the tubs. A second marker was often

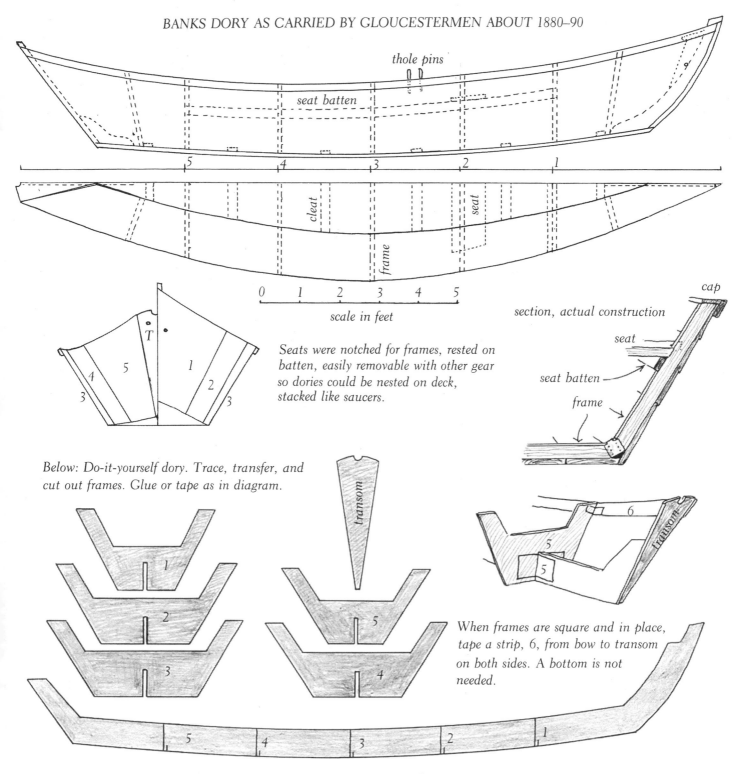

BANKS DORY AS CARRIED BY GLOUCESTERMEN ABOUT 1880-90

thole pins

seat batten

5 4 3 2 1

cleat

seat

frame

0 1 2 3 4 5

scale in feet

T

4 5 1

3 2 3

cap

section, actual construction

seat

seat batten

frame

Seats were notched for frames, rested on batten, easily removable with other gear so dories could be nested on deck, stacked like saucers.

Below: Do-it-yourself dory. Trace, transfer, and cut out frames. Glue or tape as in diagram.

1

2

3

transom

5

4

6

5

5

transom

When frames are square and in place, tape a strip, 6, from bow to transom on both sides. A bottom is not needed.

5 4 3 2 1

Not fancy but enough to sketch from

dropped halfway along the trawl and a third, plus the second anchor, at the end. There was a two or three hour wait. Then beginning at one end the ground line was hauled in over one side of the dory. Any fish were gaffed and brought aboard, the hooks rebaited, and the line paid out on the other side. The dory thus went down the whole length of the trawl. This was called underrunning the trawl and was done three of four times a day or until the dory was fully loaded. Usually the bowman gaffed the fish and the sternman rebaited. A hand winch, called a gurdy, was often fitted at the bow and used to wind the trawl in over the gunwale.

103

Some dory sail rigs.

Steering done with oar.

A two-man dory
would carry:
two to four trawl tubs
bait tub
two pairs of oars
mast and sail
two trawl anchors
two or three keg buoys
bailer and compass
gaff and club
kerosene flare
pen boards (fitted across boat to contain catch)
water jug and food
and, when loaded, about 1,700 pounds of fish.

Keg buoy.

*One (each end) of ground line
maybe one in the middle.*

Ground line.

3'

When loaded—and the average dory could hold sixteen hundred to seventeen hundred pounds of fish—the dory returned to the schooner and the catch was tossed aboard with two-tined pitchforks. Cod average about five pounds—anything over fifty is rare—but halibut run from five to over one hundred twenty pounds—(the record is seven hundred pounds)—and the big ones had to be brought aboard with block and tackle. Cod don't fight—the first cod I caught came up so quietly that I never realized I had him until he was at the surface—but halibut are lively and often have to be clubbed.

If the fishing was good, two or three trips back to the schooner might be made, but don't think the day's work was done when the dory was finally hoisted aboard. Trestle tables were set up, and the catch was cleaned, split, and passed down to the hold where each layer of fish was well salted. Treated like this, cod could be kept two or three months. Cleaning and salting a big catch might take half the night, and on the fishing grounds sleep was a rare commodity. Bear in mind that this activity did not take place in a quiet shed, but on a rolling, heaving deck, often lashed with spray, hail, or sleet. It was a hell of a way to make a living, and often a very poor one.

To follow the saga of the cod to its conclusion: when the catch was finally landed, the split and salted fish were spread on wooden racks, called flakes, on which the fish were dried for several days in the sun and wind. They had to be turned frequently and taken in if rain or fog threatened. Hard work and time consuming, but that's the way it was done until recently—and that's the way it had been for centuries.

This rather lengthy description of trawl fishing is included, first, because it affords good picture material relating to a historic era and, second, because trawl fishing, though not from schooner-launched dories, still accounts for a considerable proportion of the annual catch. Trawl fishing is carried on now in a variety of craft.

Many fishermen today vary their catch according to the season and what is available and marketable. A typical boat, such as can be seen on the coasts of New England and the Canadian Maritime Provinces, may be used for lobstering (she will probably have a pulley or power block slung on the underside of the wheelhouse); for mackerel fishing, using gill nets; for trawling cod and halibut; for seining, and for dragging for scallops. Larger vessels tend to be more specialized. Salting and drying have been made obsolete by modern methods of refrigeration, quick freezing, canning, and packaging. In the inshore fishery, using boats such as that shown in the drawing, fish are usually landed within forty-eight hours or so after they are caught. Once alongside the dock the fish are pitchforked into metal buckets, hauled up by a power-driven derrick, dumped into large wooden boxes, iced, and taken off to the processing sheds.

Such dock scenes can be fun, with figures in action pitching fish, dumping the buckets, shoveling ice, and in olden days winding up the buckets by a geared windlass at the foot of the derrick. These derricks are a feature of all docks where fish are unloaded and are also used for unloading nets and other gear.

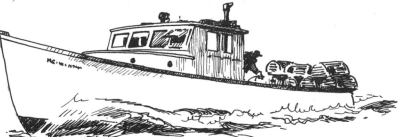

Work boats go from about 25 to 50 feet, with flaring bows, broad beams, and shallow drafts. Depending on size they can be adapted for lobstering, gill netting, long lining, seining, or dragging. Fast and seaworthy.

Thirty-five foot diesel-powered fiber-glass work boat. Note the powered block on the davit and the Radome (Radar dome).

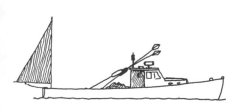

WORK BOATS

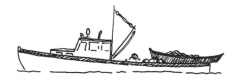

Boats like these are common in many harbors. They are often used for seasonal fishing with gear varied to suit (drums for gill or seine nets, frames aft for dragging, and so on) Many carry a small steadying sail and long liners, and seiners often carry a dory perched aft. Today Radar domes and direction-finder loops are common. And most boats have a tall antenna for two-way radio. Netbuoys, floats, and markers (often with radar reflectors instead of flags) are seen on many boats. Buoys today are mostly of synthetics— fluorescent reds and oranges for visibility. With all the modern gear, a lot of inshore fishing is still done from small open skiffs or dories, powered by oars alone or at best an outboard motor.

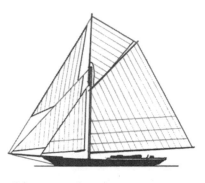

Gloucester sloop Circa 1880 50'

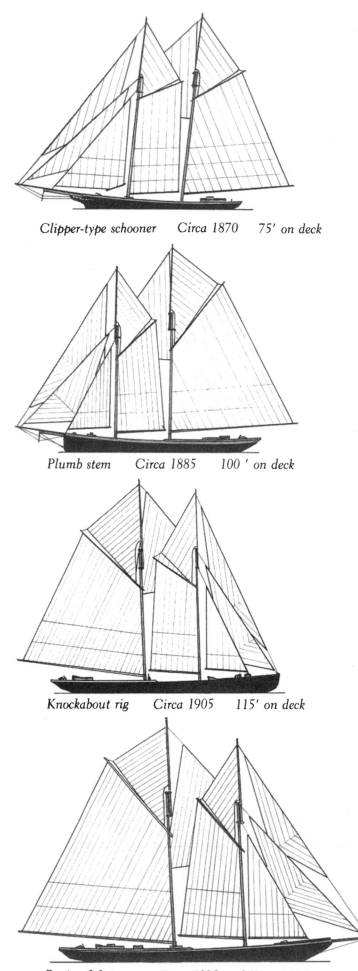

Clipper-type schooner Circa 1870 75' on deck

Plumb stem Circa 1885 100' on deck

Knockabout rig Circa 1905 115' on deck

Racing fisherman Circa 1920 140' on deck

SOME NORTH AMERICAN FISHERMEN

These vessels represent a few of the types which fished the great banks off the shores of New England and eastern Canada. These banks are shallow (50 to 400 feet) parts of the Continental Shelf, are rich in plankton, and so are the feeding grounds for a great number and variety of fish. Most are some distance off shore—the Grand Bank of Newfoundland is over 1,000 miles from Gloucester and Georges Bank, 200. The vessels had to be seaworthy, then, and, because often a quick return meant better prices (and fish, even when packed in ice, didn't stay fresh long) they had to be fast. The early clipper-type schooners often sacrificed safety to speed and losses were frequent.

In the years 1882 to 1886, some eighty-three schooners and six hundred twenty-five men were lost from Gloucester alone. In winter some boats sent their fore topmasts and jib-booms ashore and some smaller boats never carried either. The trend was for larger, safer vessels (no vessel was ever safe on the Banks in bad weather) and later the bowsprit (known with reason as the "widow maker") was dispensed with and the so-called knockabout hull became popular.

The big racing type came almost at the end of the sailing era and reflected more chauvinism than economic good sense. To this period of the International Fishing Schooner Races belong the famous Nova Scotian Bluenose and her American rivals Elsie, Columbia, and Gertrude L. Thebaud. The vessels are shown with all sails set. At sea the sail area would of course be modified according to weather, desired speed, and so on. Not all fishing boats were schooners, however, and the Gloucester sloop was typical of many single-masted vessels. Lack of space forbids portrayal of many local type small boats of various rigs. Finally, the sad end of the sailing fleet—topmasts gone, rig cut down, and the boat relying mostly on power.

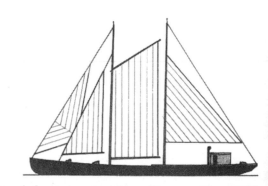

Knockabout rigged with auxiliary Circa 1930

Steam trawler Circa 1900

Diesel trawler Circa 1940

Stern trawler Circa 1980

Drum seiner Circa 1980

There are about as many designs of fishing boats as there are builders—and many more specialized types than we have space for here. Labor costs have forced designers to replace muscle-power with machines—drums, winches, blocks, and so on. Today's boats are super-efficient, though not to my mind as much fun to paint. Remember, you can put an older boat with recent ones (some old boats have been in service for years) but don't put a 1980 model in a 1930 harbor scene. Sketches on the following pages will give you an idea of how boats like these operate and some of the situations which might lend themselves to paintings. Some color hints: deckhouses and the like are usually painted white or light gray, hulls often black or a dark color. An exception are shrimpers whose owners seem to favor light colors or white. And don't forget that steel hulls rust, so some occasional light red streaks are in order.

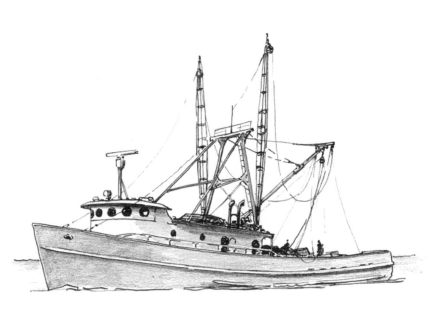

Shrimp boat Circa 1975

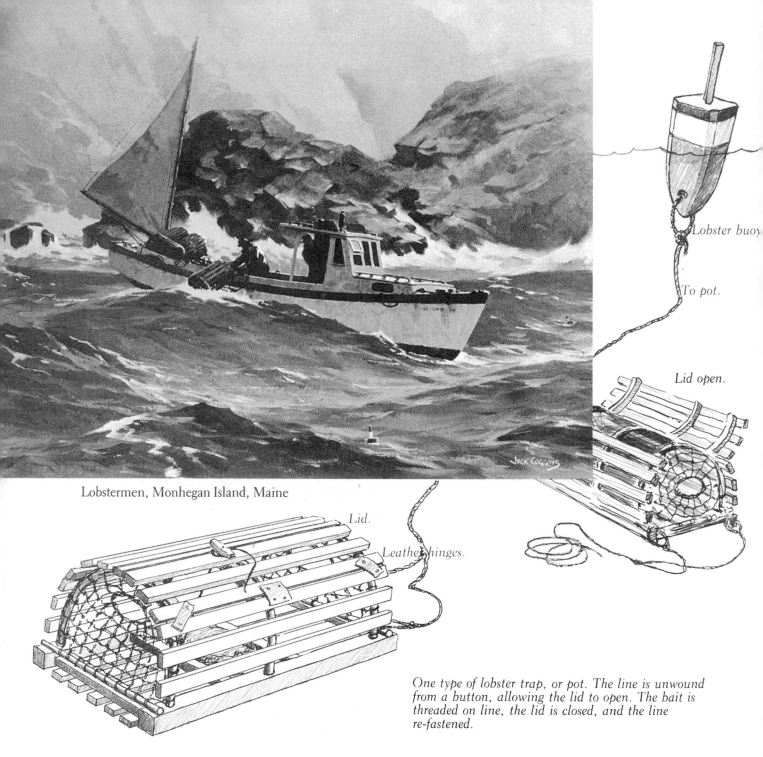

Lobster buoy

To pot.

Lid open.

Lobstermen, Monhegan Island, Maine

Lid.

Leather hinges.

One type of lobster trap, or pot. The line is unwound from a button, allowing the lid to open. The bait is threaded on line, the lid is closed, and the line re-fastened.

JACK COGGINS

The lobster industry has been a great boon to marine artists for many years, and the familiar lobster trap, singly, stacked in dozens, or in process of being hauled, has graced many a painting. The fishing process is simple and carried on in a time-honored fashion from a variety of craft. The internal combustion engine and powered winches, radio, radar, and loran have made the industry as a whole safer, less laborious, and more efficient; but a lot of traps are still laid and hauled the old way, by hand from dories or other small boats.

There are many variations of the lobster trap—square ones, wire ones, and pots that have entry on one end, both ends, or on the sides—but the principle is the same. The trap, weighted with a slab of rock and baited with a chunk of fish (cod's head or such), is lowered to the bottom. The lobster, it is hoped, crawls through the hole in the mesh and cannot manage to crawl out. Each pot is marked with its buoy and painted with its owner's colors or number. Many traps are set close to shore and boats often work within a few yards of the surf.

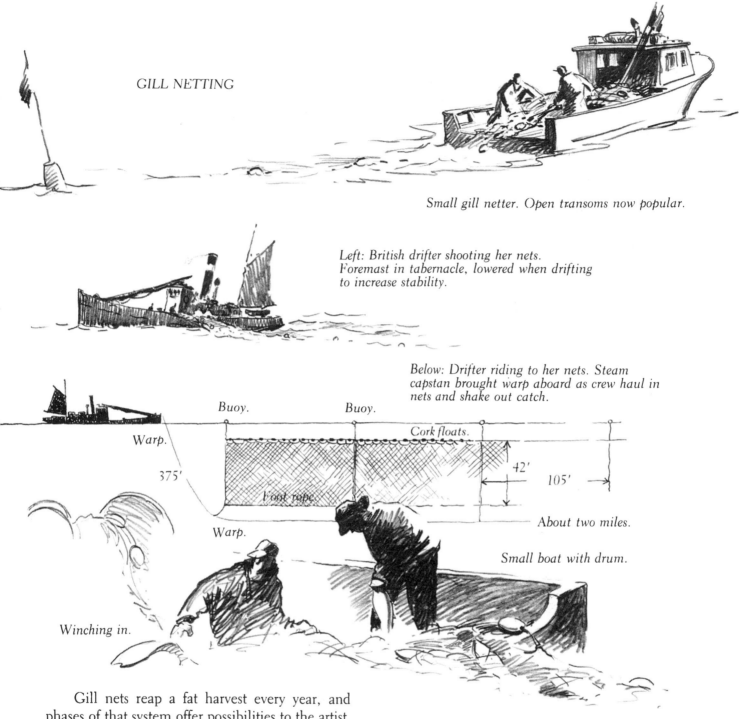

GILL NETTING

Small gill netter. Open transoms now popular.

Left: British drifter shooting her nets. Foremast in tabernacle, lowered when drifting to increase stability.

Below: Drifter riding to her nets. Steam capstan brought warp aboard as crew haul in nets and shake out catch.

Buoy.

Buoy.

Warp.

Cork floats.

375'

42'

105'

Foot rope

About two miles.

Warp.

Small boat with drum.

Winching in.

Gill nets reap a fat harvest every year, and phases of that system offer possibilities to the artist. Gill nets have a large enough mesh to allow a fish's head and gills to pass through but not the rest of the body. When the fish tries to withdraw, its gills catch in the mesh. Basically a gill net is a long net buoyed at close intervals at the top and weighted at the bottom. Anchors and marker floats or buoys are attached to either end. Such nets are usually carefully stowed in folds at the stern. When the fishing ground is reached a marker buoy and anchor are heaved overboard and the net paid out behind the boat until the second buoy and anchor mark the end of the set. More nets may be laid in series or in other locations. Either the nets are underrun by the boat and the fish removed or the buoy and anchor are hoisted aboard, followed by the end of the net, which is cleared of fish as it comes aboard. Large vessels shoot miles of nets, drifting downwind at one end and so stretching the net out to windward. Recovery is aided by power winches, but there is much handwork involved, too.

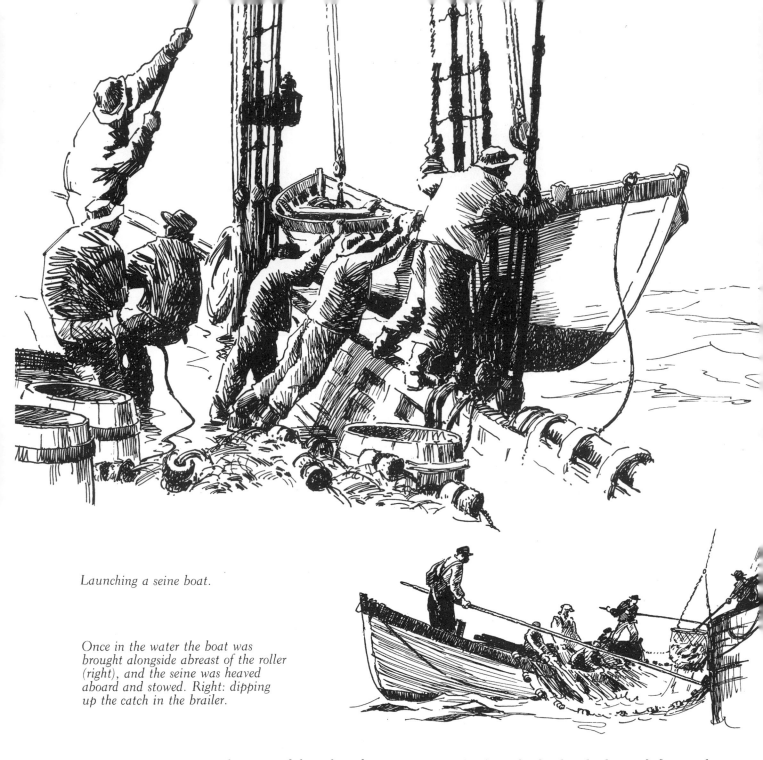

Launching a seine boat.

Once in the water the boat was brought alongside abreast of the roller (right), and the seine was heaved aboard and stowed. Right: dipping up the catch in the brailer.

Seine nets are used to trap fish rather than entangle them. These nets, too, are buoyed at the top and weighted at the bottom. This ancient method of fishing ranges all the way from deepwater seining to seines drawn around shoals of fish in shallow water and where the ends are then dragged ashore by fishermen, sometimes aided by horses. Much seining is purse seining, in which after a school of fish is surrounded by the net, lines running through rings at the bottom of the net are pulled up gradually until the bottom of the net is closed, thus trapping the fish.

In the days of sail, when lookouts aloft spotted a school of fish, usually mackerel, the seine boat, a heavily built double-ended boat some forty feet long and weighing about two tons, was got overboard and the seine off-loaded from the schooner and neatly stowed in folds aboard. When the schooner had approached as close as possible, the seine boat's crew, some dozen men, tumbled aboard, manned the oars, and she was off. The school area encircled, the crew began to gather in the net, while the vessel came alongside. The fish were now in a pocket between the vessel and the seine boat. While a man

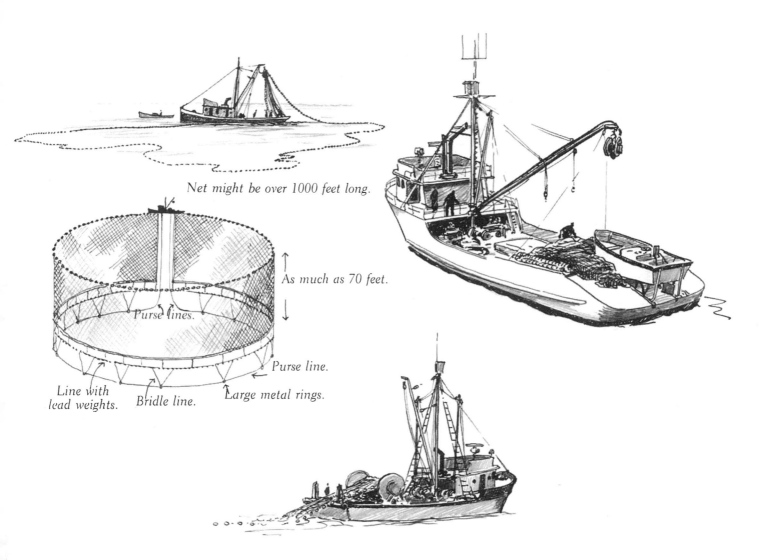

Net might be over 1000 feet long.

As much as 70 feet.

Purse lines.

Purse line.

Line with lead weights.

Bridle line.

Large metal rings.

Top left: A seiner winching in her net with a hydraulic power block. The hundreds of feet of floats—cork, plastic, aluminum, or glass—make interesting patterns. Nets used to be hauled in by hand. Power blocks and/or drums make life easier for today's fishermen.

Above right: The skiff used to carry out one end of the net, once a rowed boat or dory, is now a powered craft, often with built-on skegs which keep the boat on an even keel when slid off the stern. After the purse seine has been brought alongside and emptied with the brailer (operated from the small boom) or, in case of small fish like herring, sucked up by a pump, the net is flaked down on deck with floats on one side and weights on the other, or it may be wound on huge drums. The diagram shows how a purse-seine works, and in the sketch above a drum-seiner lets her net go over the stern roller, towed by her skiff (not shown).

at the bow and one at the stern fended the seine boat off with their oars, the long-handled dip net, or brailer, was dipped into the squirming silvery mass and hoisted aboard by a tackle.

This is all great picture material, as many artists have realized, and now that you know how the fishing was done, you can build your own compositions around the central theme. Today the schooner has been replaced by a power boat, some of them large, carrying the net piled on her stern or wound on a huge drum. A powered skiff now takes one end of the net as it is set or shot over the stern and the seiner completes the circle. On the West Coast much salmon is taken this way as well as tuna. Tuna used to be caught by men fishing from platforms slung over the rail and heaving the fish in as fast as rod, short line, and baitless hook could lift them out of the water. This is also good picture material.

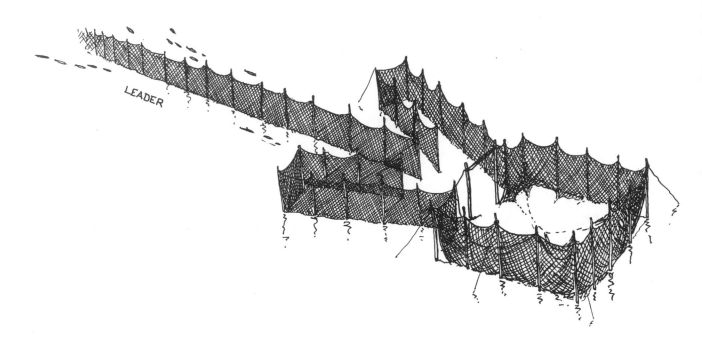

LEADER

In the diagram above, fish follow along leader, which may be a mile long with one end anchored close to shore. They then become caught in the pockets and finish up in the trap, which has a net floor. Many leaders are made of brush and stakes—cheaper than nets and more easily replaced when damaged by storm. Instead of being strung on stakes, some fish-trap nets hang from floats and are anchored in place while the trap may have a purse-string arrangement. The framework of fish traps and weirs is made out of local materials and has a rough and ready quality. Pilings are of all shapes and sizes and often lean at odd angles. In the sketch below, boats are hauling in the net floor of the trap. When the fish are bagged in a small area they are scooped aboard with dipnets.

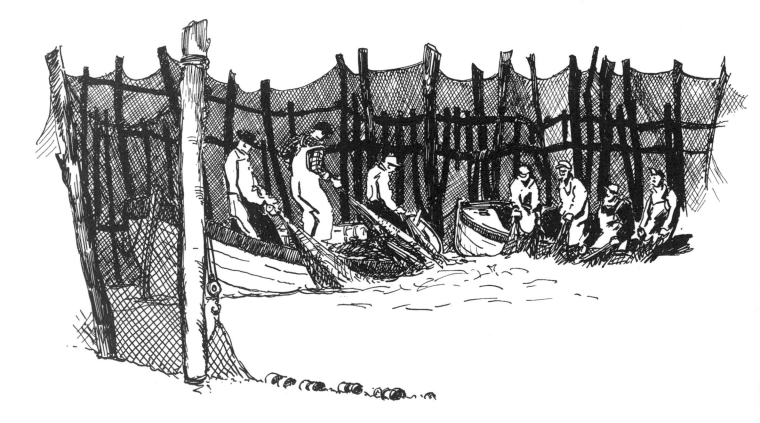

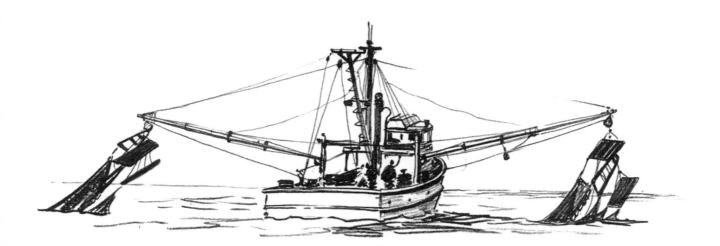

Shrimp boats are trawlers, but their gear is a bit different from those on the following pages. Their trawls are usually spread from big outriggers, as in the sketch above. Even with power blocks and winches, getting the trawl doors (otter boards) in and out (right) is a tricky business.

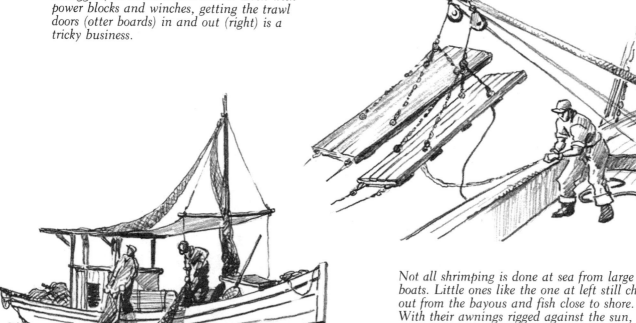

Not all shrimping is done at sea from large boats. Little ones like the one at left still chug out from the bayous and fish close to shore. With their awnings rigged against the sun, small craft like this—sometimes a bit ratty looking—make good pictures.

If your travels have taken you along the shores of bays or estuaries, you may have noticed closely spaced lines of poles sticking up out of the water or rather complicated patterns of floats bobbing on the tide. These mark fish traps, also called weirs. This is also a very ancient method of fishing suitable to relatively shallow and sheltered waters. These traps vary greatly in construction and complexity, but the basic idea is that the fish are steered by the outlying wing or wings of the nets through a narrow opening from which, fish not being very bright, they do not escape. In most cases the trap part of the weir has a net bottom or a purse arrangement. Boats go into the trap portion, and as the net is heaved aboard one boat, the trapped fish are scooped up into another. There are variations, but this is the general idea. Almost any kind of open boat may be used— dories, seine boats, or any local craft available. Picture possibilities are good, with men heaving nets up, boats heeling under the weight, nets and ropes festooned from poles, and the brailers busy dipping out fish from the squirming mass struggling to escape.

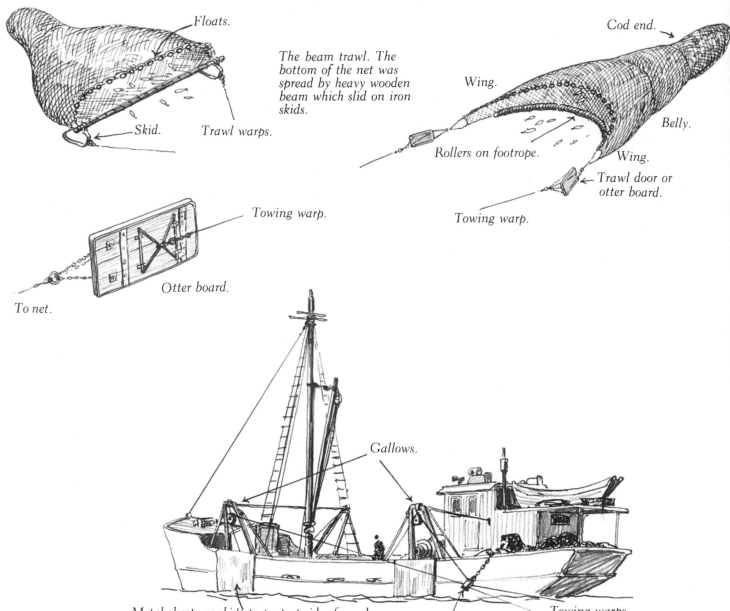

Floats.

The beam trawl. The bottom of the net was spread by heavy wooden beam which slid on iron skids.

Skid. *Trawl warps.*

Cod end.

Wing.

Rollers on footrope.

Belly.

Wing.

Trawl door or otter board.

Towing warp.

Towing warp.

Otter board.

To net.

Gallows.

Metal sheets or skids to protect sides from doors.

Towing block.

Towing warps.

Not all had mizzenmast. The towing warps led from the winches through sheaves on deck to the block on the gallows and so to the otter boards. Smaller draggers had one pair of gallows—larger ones two, port and starboard. Not all had booms on the mast. In some the tackle for hauling up the net was fastened to a heavy cable running from the crosstrees down to the deck or superstructure aft. The winches were usually mounted on deck just forward of the wheelhouse.

One of the most effective methods of fishing is with the trawl net. This is in effect a large conical net, something like a huge butterfly net, which is put overside and dragged along the bottom behind the fishing vessel. When it is judged that enough fish have found their way through the net's wide mouth to the strongly meshed tip, called the cod end, the trawl is then winched in. The cod end, packed with fish, is hauled up over the rail with a derrick; the cod line, which closes the end of the cod end, is released; and the catch is spilled into the pens on deck where it is sorted and sent down to be iced and stored.

In the days of sail the bottom of the trawl was spread by means of a stout beam of wood. When steam began to appear in the fishing fleets, a better way was found to spread the mouth of the net. The increase in speed and power made it possible to tow

Here a large trawler is hauling her trawl. The boards have been hauled up to the gallows and the net is coming in over the side.

When the wings and belly are in, the bulging cod end is hoisted inboard, the draw-rope or codline—which kept the cod end closed—is released, and the catch pours out into the sorting pens on deck.

Gallows come in various forms but essentially they are heavy steel frames, projecting slightly outboard, from which is suspended the large block or pulley used to handle the steel-shod doors.

It is easier and more efficient to haul the net over a sloped ramp at the stern rather than over the side as before. Here, an early type of stern trawler hauls her net. Her gallows are both aft and the boom will raise the cod end for opening when it is hauled aboard.

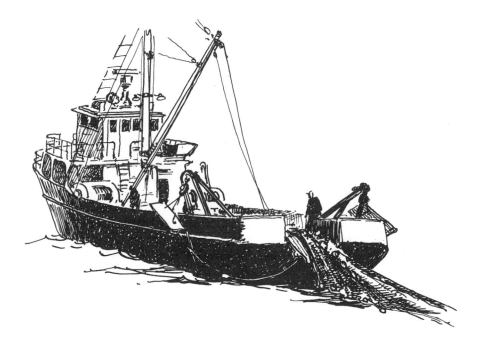

two trawl doors, or otter boards, as they are called, which, like underwater kites, surged apart and held open the mouth of the trawl. The warps by which these boards were towed ran to the gallows, which are a feature of many of the draggers found in our fishing ports. You can see these boards made of heavy timber and reinforced with iron resting inboard of the gallows. Many draggers, especially the wooden ones, have plates, usually battered and rusty, fastened on the sides outboard of the gallows to help withstand the battering of the heavy boards as they are hauled. Draggers vary in size, the larger usually used on distant fishing ground. Latterly, the side trawler is being displaced by the more efficient stern trawler and one day will probably go the way of the schooner.

Nets themselves are featured in many marine pictures. When not in use nets have to be cleaned, dried, and frequently repaired. They are racked on a variety of frames and, with their many colors and fringes of often gaily colored floats and buoys, add a nice touch to a composition. I use them a good deal and have long since run out of titles—"Men Mending Nets," "Drying Nets," "Nets Drying, Gloucester," etcetera, etcetera, etcetera.

Despite the hazards of over-fishing and pollu-

Nets are hung up to dry on frames of many shapes and sizes. These frames are usually pretty roughly made so, knowing the general idea, you can dream up your own construction to fit your picture. Nets are easily torn and a figure or two at work mending always adds a nice touch. On fishing vessels, nets were usually hoisted on masts or booms. In port they are often spread on any available area of dock. Buoys and floats come in many forms and materials; the old ones are almost invariably a series of short cylinders of cork strung on the headropes.

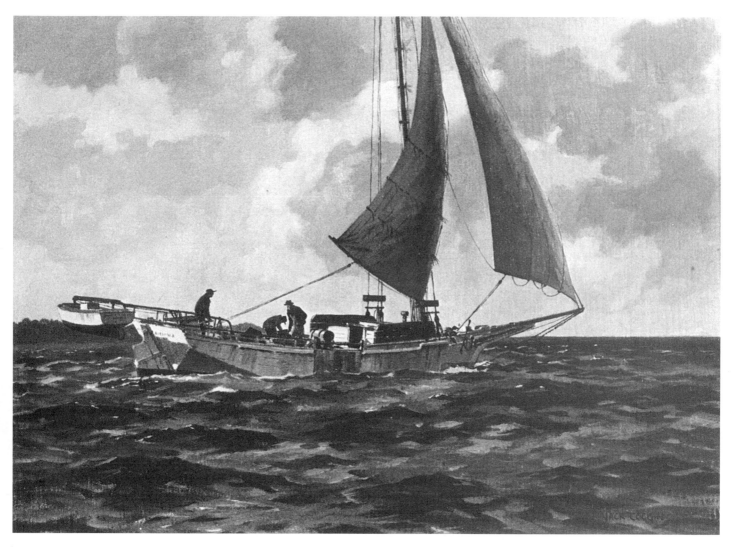

Oil on canvas Off the Choptank *20x26"*

tion, the delicious but, alas, increasingly expensive oyster manages to survive, and oystering still supports a large number of boats and men. Oysters grow in a good many places, but the shallow waters of Chesapeake Bay provide the largest oyster harvest of any state—or country, for that matter—with the added advantage to the artist that a few of the boats still use sail. There are only a dozen or so working sailers left—in 1900 there were two thousand or more—but they are distinctive craft and have been the subject of countless paintings, including several of mine.

Fishing from these boats is done with gear very similar to that used by scallopers, though not so large. Since engines are not permitted on these sailing dredgers, they use a small but powerfully engined yale boat, as it is called, to push or tow them when the wind doesn't serve. When not in use, these yale boats are carried or hauled-up to the stern davits. Oysters are dumped from the dredge onto the deck, where they are separated from the assorted marine junk that is brought up with each haul. When oystering is good, a boat will come home dangerously low in the water and literally heaped with shellfish from bow to stern.

The dredgers may be photogenic, but the bulk of oystering is done from small power boats using grabs or rakes, which operate somewhat like the old ice tongs. Some of these tongs are now hydraulically operated. In shallow beds hand tongs with long wooden handles, looking a bit like garden rakes, are used.

Besides oysters, the Chesapeake is noted for its crabs, most of which are taken in traps much in the same way lobsters are.

117

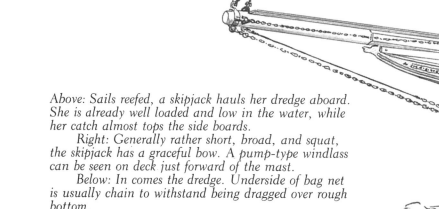

Above: Sails reefed, a skipjack hauls her dredge aboard. She is already well loaded and low in the water, while her catch almost tops the side boards.

Right: Generally rather short, broad, and squat, the skipjack has a graceful bow. A pump-type windlass can be seen on deck just forward of the mast.

Below: In comes the dredge. Underside of bag net is usually chain to withstand being dragged over rough bottom.

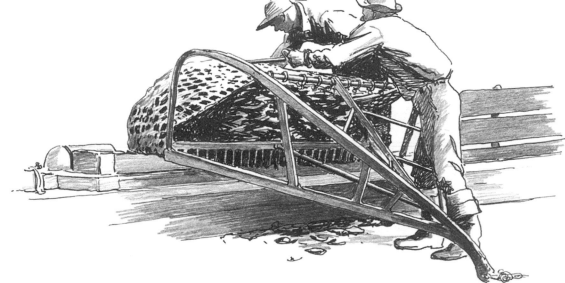

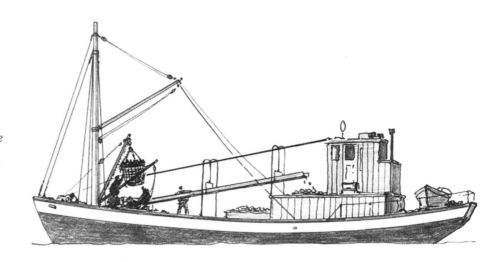

Right: Atlantic-coast type of large oyster dredge. Endless belt moves catch up to storage bins. Dredges are towed and hauled at ends of short booms.

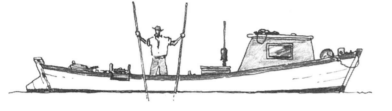

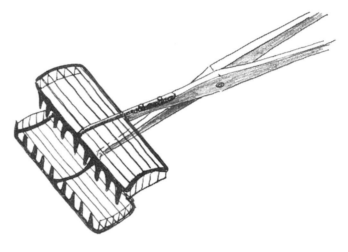

Above: Tonging for oysters. In shallow water this is a common way to take oysters. Smaller boats are rowed or driven by outboards.
 Right: Oyster tongs—the handles may be 20 feet or more long.

Left: Long-handled (up to 35 feet) bull rake.
 Below: This boat, typical of the Chesapeake, uses large hydraulically operated tongs, in this case raised and lowered by power blocks. A feature of every oyster boat large or small is the culling or sorting board, a shallow wooden or metal trough extending across the hull on which the catch is separated from the debris from the bottom and illegal (less than 3-inch) oysters are rejected.

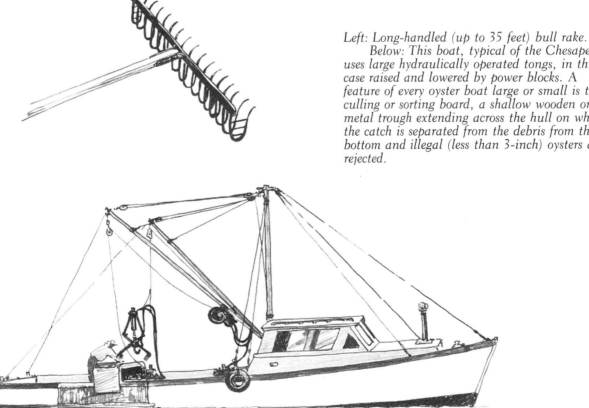

119

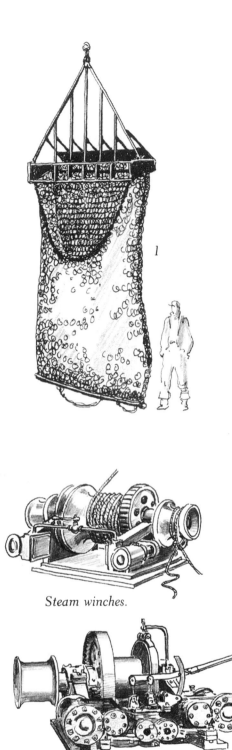

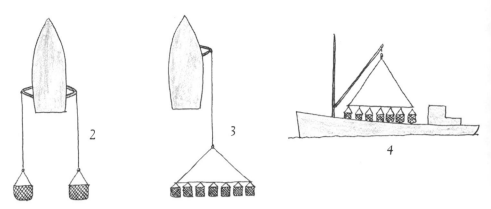

Above: (1) Deep-sea scallop drag, or rake. Towed from blocks on gallows port and starboard (2). Inshore rakes towed in gangs (3), and hoisted on boom to be emptied (4). Nearly all of the heavy work of hoisting and hauling trawls, drags, and so on is done by power, usually winches. These used to be steam-operated and were seldom seen on sailing vessels, but now every modern vessel, even comparatively small fishing boats, carry an array of electrically or hydraulically operated winches and power blocks. In deck views winches and their operators can be logically incorporated in compositions, if not made the focal point.

Basically, a winch, however operated, applies power to a drum or wheel used to wind in or let out a load-bearing line. They are seen in a variety of designs and sizes. There is usually a clutch—often a lever—and some kind of throttle or method of applying or reducing power.

From the winch, the line usually passes through fair leads or swivel blocks to the point of operation. As long as it is recognizable as a winch, small details are unnecessary. And if you're not too sure about a piece of equipment, arrange your composition so that you can at least partially screen it with a figure.

Steam winches.

Hydraulic trawl winch. The gadget in front moves back and forth and correctly feeds the line to the drum.

Hydraulic winch.

You may have a taste for scallops. If so, the next time you see a vessel with what looks like an oversized purse made up mostly of heavy steel links hanging from gallows or stern frame, you'll know that's what brings those tasty little morsels of shellfish muscle to your table.

Inshore scallopers tow gangs of up to seven thirty-inch drags attached side by side to a long metal bar. Deep-sea scallops are taken with larger drags some ten to fifteen feet wide and weighing some fourteen hundred pounds empty. With a full catch they may weigh four tons. Usually the dragger will tow two of these, one on each side. When the loaded drag is hauled up to the gallows, the catch is hoisted up aboard by derrick and the bottom opened. The scallops and other debris cascade onto the deck. There they are shelled, or shucked, cleaned, and iced.

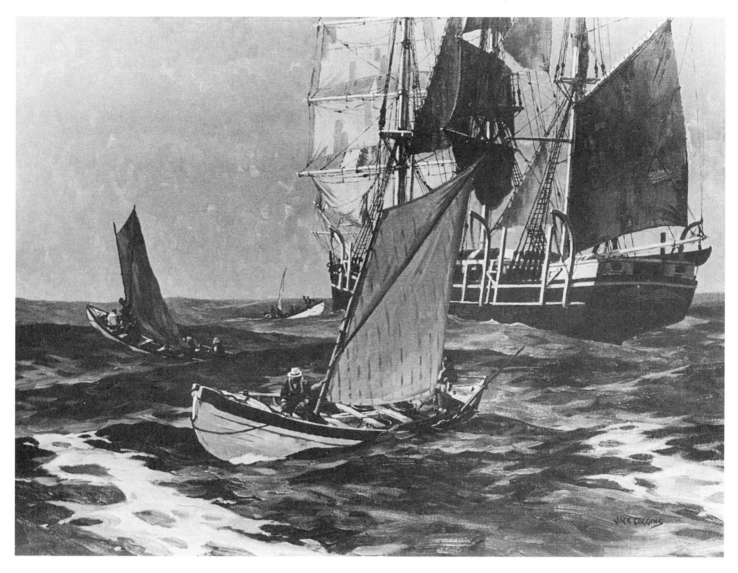

Oil on canvas Larboard Boats Away *22x30"*

The quarry is some distance off—far enough to warrant stepping the masts and setting sail. The whaler is hove-to, mainmast yards aback. Whaleboat rigs differed but the spritsail shown here was common. The long steering oar was used when closing the whale under oars. When not in use, the rudder was unshipped and hung over the port side at the stern.

Whaling is a dirty word today, at least among the conservation-minded, and the whaler with its harpoon gun and the whale factory ship may not have much appeal as marine subjects. In the heyday of the sailing whaleships, though, some hundred and fifty years ago, whaling was a respected if dangerous profession and the catching of the whale a dramatic and pictorially satisfying theme for artist and author alike. For those who might fancy a fling at such a subject, the following may be of some interest and assistance.

First, the typical whaling ship. She was a bluff-bowed chunky vessel, usually ship or bark rigged, perhaps one hundred twenty feet long. She was easily recognizable by the prominent fixed wooden davits and cranes from which her whaleboats were suspended. These graceful craft were some twenty-eight to thirty feet long and five and a half to six and a half feet in beam and were pulled by five oars. A rudder was carried and could be shipped when under sail. But normally the steering was done with an oar about twenty-three feet long. The whale line was kept coiled in two tubs, which together held some three hundred fifty fathoms of line about three-quarters of an inch in diameter. The drawings show the gear used.

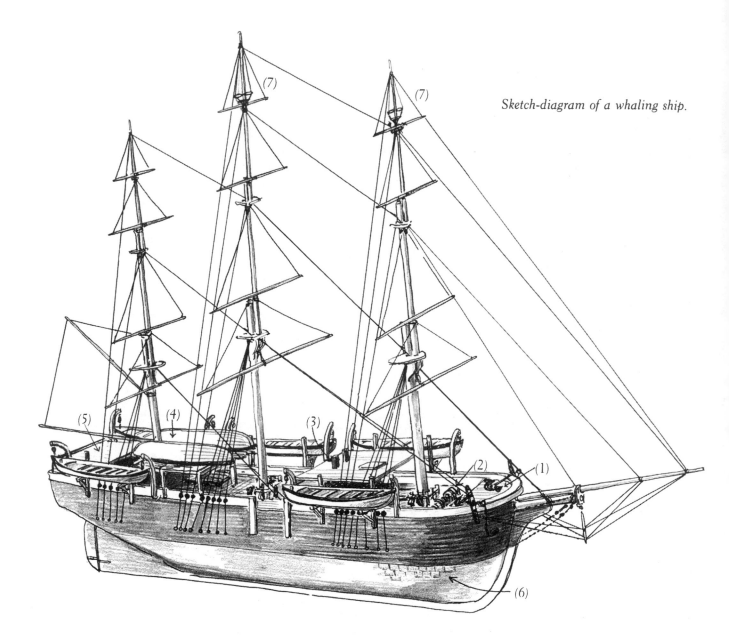

Sketch-diagram of a whaling ship.

This drawing gives an idea of the bluff bows and generally tubby appearance of most of these ships. Number (1) is the short anchor deck with typical wooden-stocked anchors. Just aft of this is the windlass (2) and between the fore and main masts is the covered-in tryworks. The tryworks were built of brick over a shallow watertight tank (called the goose pen) which could be filled with water to prevent the deck beneath being scorched. This brick oven enclosed two large iron kettles in which the fat or blubber was cooked. The chimneys (3) can be seen projecting over the covering deck. Spare boats (4) were carried on skids aft of the main mast. The boxlike after house (5) characteristic of whaling ships was divided by an alley way cutting fore-and-aft through the center. The starboard side of this structure was usually taken up by the galley and storeroom. On the larboard side was more storage room and the companionway leading below. For some reason whaling men still used the old term larboard (which to avoid confusion had long since given way to the word port). To no practical use to a painter but as a matter of interest the three whaleboats on the larboard side were, from forward, the bow boat, the waist boat, and the larboard boat.

On the starboard were the starboard bow boat and the starboard boat. There was no waist boat as that was where, when a section of bulwark had been removed, the cutting stage was rigged and the blubber dragged on deck and cut up. Below the water line wooden hulls were sheathed with sheets of copper (6) to defy the ravages of the toredo or ships worm, which bored holes with destructive effect. And copper deterred to some extent the growth of barnacles and marine growth. These latter could cut down a ship's speed drastically.

Hulls were usually black, with white trim, although false gun ports, painted black on a white strake, were also common. Yards were usually painted white, as were lower masts, bowsprits, and doublings. So were the steam-bent davits (often of white oak, 8 inches square) and the hinged cranes on which the whale boats rested. Whaling ships were sometimes rigged as schooners, brigs, and barkentines, but most were ship-rigged (as above) or rigged as three-masted barks (the masts and yards in the sketch are in true proportion but, obviously, the rigging is only partially indicated).

Last but not least, the hoops at fore and main royals were for the lookouts (7), who constantly searched the horizon for the telltale vapor spouts which raised up as the whale breathed.

The fishing method was generally as follows. When the whaling grounds, often thousands of miles from the whaler's home port, were reached and the lookout had spotted spouts, the well-known "Thar she blows!" sent the crew into action. Boats were lowered, the crews swarmed down the falls—the tackle by which the boats were lowered—and the long chase began. If the whales were to windward, this often meant hours of back-breaking labor at the oars; otherwise the mast was stepped, the rudder shipped, and the whaleboat sailed as close to the quarry as practicable. The mast was then unstepped, the rudder unshipped, and the final approach made under oar. Boats were sometimes sailed in until the harpooner made his strike. Oars, however, would be manned, as the boat would have to be ready to back off when the iron struck home. The bow oar, who was also the harpooner, then shipped his oar and took his stance, harpoon in hand, in the bow. A second harpoon, or iron, was also bent to the line and was also planted if possible. If not, it had to be tossed overboard. The boat was steered as close as possible, sometimes "wood to blackskin," then the harpooner lunged and darted his iron into the whale. This was the signal for all hell to break loose. "Stern all!" yelled the steersman, who was usually one of the mates, and the crew backed their oars frantically. The startled whale—he might have been asleep on the surface—most often dived in a flurry of foam and smash of flukes. The line, well fast, began to whiz out of the after tub, around the stout round post (the loggerhead) set in the little afterdeck, and down the length of the boat to a sheave in the deeply chocked stem. The oarsmen—each sat on the side opposite his oarlock to balance the seventeen or eighteen-foot length of his oar—peaked their oars (put the handles of their oars down) affording a channel over which the line ran. At the same time the mate clambered forward, relieving the harpooner, who took the steering oar. The mate's job was to kill the whale—the harpoon was not intended to do this—with the lance, which had a razor-sharp, petal-shaped blade with a five or six-foot shank set on a six-foot wooden pole.

The whale was played like a huge game fish. Whenever possible the line was hauled in and a couple of turns taken round the loggerhead. At times, when the whale sounded and went deep, for instance, the line had to be let run, while a hand doused the line with seawater out of his hat as it ran smoking round the loggerhead. Sometimes, if the whale took off on the surface, the boat towed behind at a great pace, throwing sheets of spray and leaving a white wake behind. This Nantucket sleigh ride, as it was called, often took the whaleboat out of sight of the whaler altogether, the crew bailing like mad. Whenever the whale tired and slowed a little, a few fathoms of line might be gained—and sometimes lost again as the whale tried some new trick.

At last the boat was brought close alongside—the vicious slap of a massive fluke smashed many a whaleboat at this stage—and the mate plunged his lance again and again into the whale's vitals. If the crew was lucky, this might finish the monster.

Lance—11 or 12 feet long.

Used for killing once the boat was hauled alongside the whale. A line was attached to an eye at the end of the lance for recovery.

Harpoon, or "iron" as whalemen called it, with toggle head.

Line fastened around iron at the socket was stopped two or three times down the pole and ended in an eye to which the whale line was made fast. The pole was 6 or 7 feet long, usually oak or hickory and often with the bark still on. The iron part was about 3 feet.

Cutting spade, perhaps 15 feet long, used from stage to slice blubber in strips.

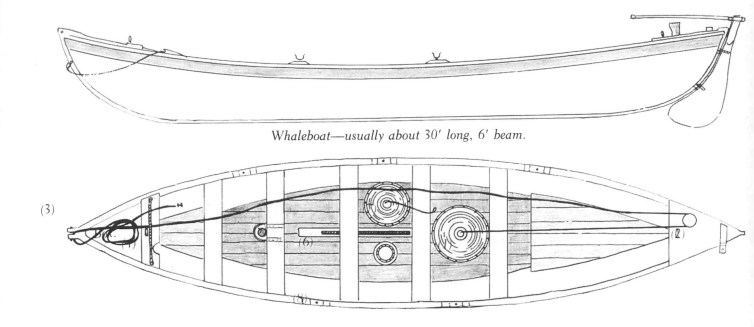

Whaleboat—usually about 30' long, 6' beam.

The boat is shown with its rudder shipped. When not in use the tiller was removed and the rudder slung from two lines from the stern on the port side. The whale line passed from main line tub (1) around loggerhead (2) up under rope "kicking strap," through bow chock (3) back to the shallow "box" where 25 or 30 feet were coiled, then end was bent to harpoon. Number (4) is the "clumsy cleat" with notch for harpooner's left thigh, (5) is the mast step, (6) the center board trunk, (7) the spare line tub, and (8) the oarlock. The five rowers sat on opposite sides to their oarlocks to get more leverage from the long oars. Among the gear carried: water keg (shown), oars, mast and sail, buckets, bailers, harpoons, lances, boat spade, "waif" (small flagstaff for marking a dead whale), lantern, grapnel and line, a drogue or sea anchor, and a box compass. With six men, quite a load.

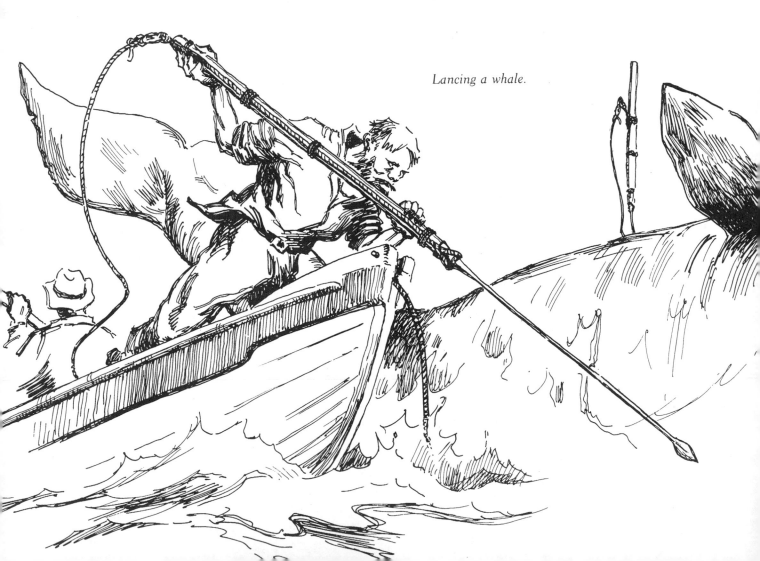

Lancing a whale.

Of the four whales most commonly taken by Yankee whalemen—the right, the bowhead, the humpback and the sperm—the first three were relatively peaceful feeders on minute marine animals. The sperm whale which, unlike the others, had a mouthful of teeth, battled with and fed on the great squid who inhabit the ocean depths. Naturally pugnacious, the sperm whale was a dangerous adversary. Any whale could demolish a boat with a flick of its tail, but a sperm whale would often grab a boat in his jaws, reducing it to splinters in his fury.

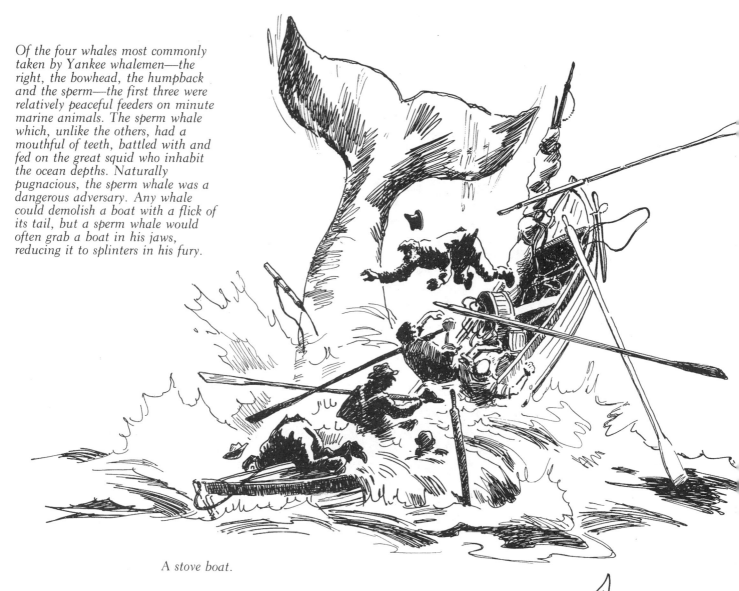

A stove boat.

65-foot sperm whale, a 30-foot whaleboat, and a man—to scale.

Because of its combativeness, the sperm whale figures most often in whaling prints and paintings. A whale such as this shown was about average and might yield 90 barrels, although 90-foot, 137 barrel sperm have been taken. A whale breathes through two small spout-holes on his head (sperm have only one). The moist air is atomized as it is forced out and is visible for some distance. The cry, "Blows—thar she blows" from the two pair of lookouts carried at fore and main tells that at least one plume of vapor has been spotted.

125

Often, though, the dying beast, spouting blood, might take off once more, with the back-breaking hauling and dangerous lancing all to do over.

It was a gory business, far from ended when the leviathan finally went into its death flurry. When at last, after much labor, the whale was secured alongside the whaling ship, a platform, or cutting stage, was lowered and boomed out from the whaler's starboard side (where the cutting in always took place). Two massive tackles were rigged to the maintop, each with a huge blubber hook attached. One of the hooks was then secured through a hole in the whale's outer layer of fatty tissue, the blubber. From the cutting stage, which had a handrail, men armed with sharp cutting spades cut vertically through the blubber to the flesh beneath. These cuts were continued in a spiral line as the blubber hook was hauled up. The blubber pulled away from the flesh in a long strip, the whale revolving as the blubber was torn away. When the first tackle was two-blocked—hauled up as far as it could go, so that the two great blocks were almost touching—two holes were made in the suspended strip near the deck through which a chain was rove. The second hook was fastened to this. The strip above was severed and swung inboard down to the blubber room below, while the second tackle began the stripping process anew. All this, the men with their cutting spades, the slowly revolving carcass, and the great strips of blubber hoisted aloft, was dramatic enough without the usual added presence of hordes of sharks, maddened by the scent of blood, tearing at the flesh and blubber. A well-aimed blow from a spade often sufficed to turn attacker into victim, as the injured shark was speedily torn to pieces by his brethren.

When the carcass had been stripped, the head or as much of it as could be got aboard—the front end of a sperm whale might weigh twenty tons—was cut off and hoisted on deck. This part, the case of spermaceti, was where the whale stored its reserve nourishment, like a camel's hump. It was filled with a white fatty substance and might yield thirty barrels of pure spermaceti, which was bailed out and barreled. Another feature of a whaler was the brick oven or try-outs, built on deck just aft of the foremast. In the top of the ovens were the try-pots, huge iron pots in which the blubber was rendered or tried out. While fires were being lit under the pots, the long strips of blubber—which is about 75 percent oil—were cut up on boards into manageable sizes, called books, and minced with knives about thirty inches long with a handle at each end. These pieces were forked into the pots, the cooked scrap being used to feed the fire. A whaler trying out at night was a spectacle—greasy black smoke pouring from the oven stacks, the lower sails lit by the lurid glow from the fires, and the crew laboring with bailers and pitchforks like so many devils.

A good-sized sperm whale might yield seventy-five barrels of oil, a really big one one hundred (a barrel was a unit of measure equalling thirty-one and a half gallons). Oil was stored in casks of varying sizes, the largest holding some fourteen barrels. Whalers, of course, differed greatly in size as well as rig, but the average vessel might hold some twenty-four hundred barrels when loaded, or over seventy-five thousand gallons. As whales grew scarcer, voyages became longer. Four years was not considered unusual—the longest on record lasted nearly eleven!

Some great paintings and drawings have been made of the whale fishery. Author-artist Clifford Ashley's book *The Yankee Whaler** is a classic on the subject, illustrated with many of his fine paintings and sketches. If some pictures or prints may seem to you to exaggerate the dangers of whale fishing—yes! a bull sperm whale is quite capable of splintering a boat with his huge jaws or smashing it to pieces with a blow of his tail. Many boats were so lost—three whalers once had seven boats chewed by one whale. And the whalers themselves sometimes fell victim, rammed by an infuriated bull sperm whale, like Captain Ahab's *Pequod*. The last one so sunk was in 1902. Butted only once, she sank in five minutes.

Perhaps I have made the planning of a painting to do with fishing too long and complicated. Actually, I have only scratched the surface. Each country has its own vessels, often differing from one district to another. A little research—a pile of old *National Geographics* is a help—and you can concoct a fishing scene from anywhere in the world. Just apply what you have already learned about drawing hulls, and be sure your fishing figures are properly costumed and doing their thing with the correct gear.

* *The Yankee Whaler* is available as a Dover reprint (0-486-26854-3).

"Cutting in."

The cutting stage has been rigged, and men with long handled cutting spades are slicing the thick blubber into a long strip. As it is hauled aloft the body of the whale revolves. Sharks tear at the carcass and are occasionally dispatched with a blow from one of the razor-sharp spades.

Below right: The tryworks, with its brick oven and metal cauldrons. Cut into slices, the blubber is then forked into the cauldrons. When cooked, the crisp remains are fished out and tossed into the furnace for fuel. When the pots began to fill, the hot oil was ladled into cooling tanks alongside the furnace and later transferred to barrels for storage in the hold.

"Trying out."

Blubber knife.

Blubber fork and bailer.

127

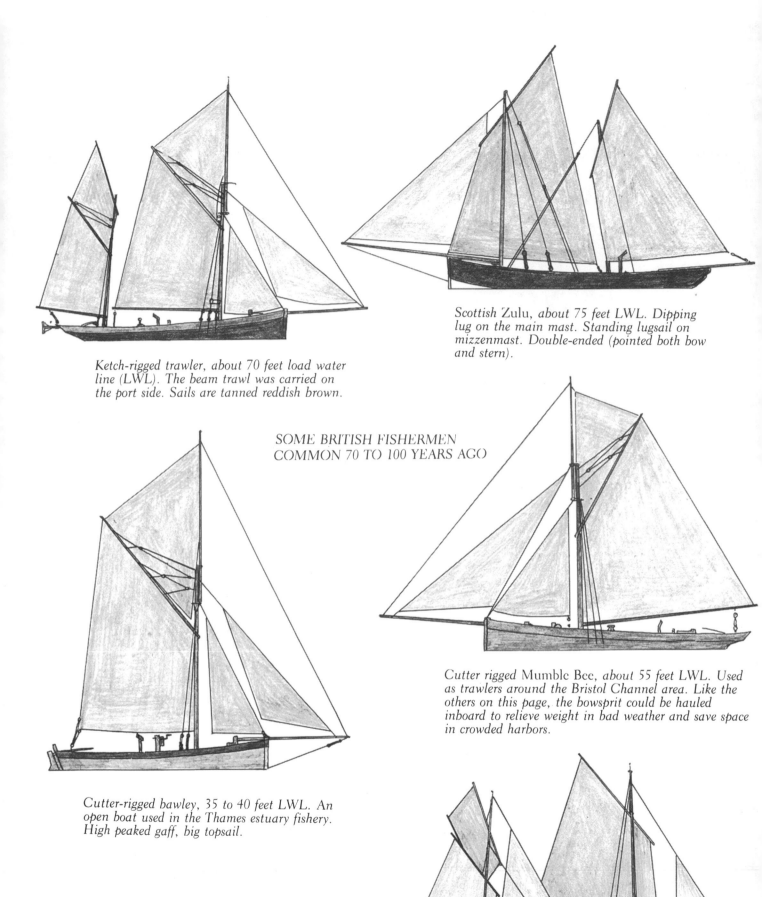

Ketch-rigged trawler, about 70 feet load water line (LWL). The beam trawl was carried on the port side. Sails are tanned reddish brown.

Scottish Zulu, about 75 feet LWL. Dipping lug on the main mast. Standing lugsail on mizzenmast. Double-ended (pointed both bow and stern).

SOME BRITISH FISHERMEN
COMMON 70 TO 100 YEARS AGO

Cutter rigged Mumble Bee, about 55 feet LWL. Used as trawlers around the Bristol Channel area. Like the others on this page, the bowsprit could be hauled inboard to relieve weight in bad weather and save space in crowded harbors.

Cutter-rigged bawley, 35 to 40 feet LWL. An open boat used in the Thames estuary fishery. High peaked gaff, big topsail.

Right: Hastings lugger, 30 to 35 feet LWL. Sturdy, bluff-bowed fishing boats. Were customarily beached stern first by horse-worked capstan. Flattish bottoms helped in beaching.

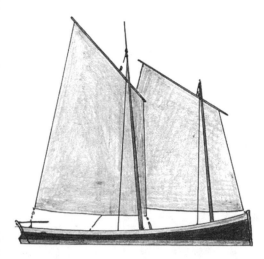

Sardine-fishing lugger on the coast of Brittany, about 35 feet LWL.

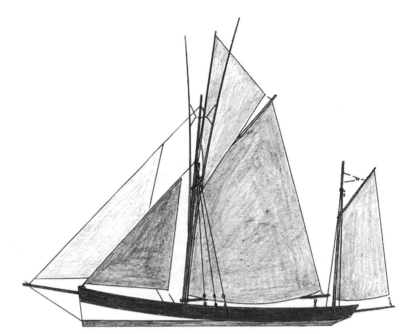

Yawl-rigged (the mizzen is stepped aft of the rudder post) tunny (tuna) fisherman from Concarneau, in Brittany. In port the long fishing poles are topped up alongside the mast. When fishing they were let out at an angle of 45°. Each trailed seven lines, with a few more from a pole fastened to the top of the mizzen. The hulls, about 65 feet LWL, were usually brightly painted; the staysail might have been white, the main a deep red, mizzen and jib a tan, and the topsail perhaps a bright blue.

SOME OTHER EUROPEAN FISHING VESSELS

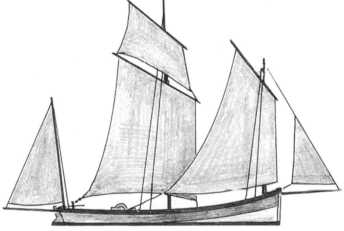

Belgian lugger, about 45 feet LWL. A common sight off Dunkirk 90 or 100 years ago.

Below: a Spanish tartane. Some are quite large but this open fishing vessel might be some 35 feet LWL. Note lateen sail yard made of two spars lashed together.

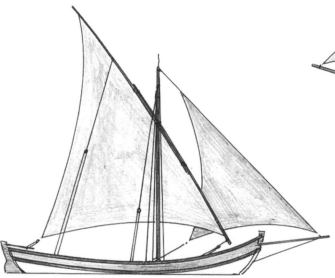

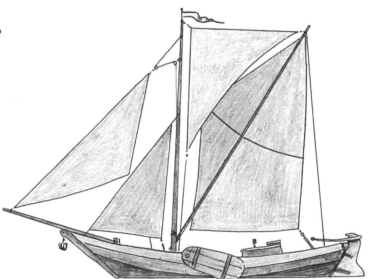

Dutch Hoogart from the island of Walcheren. Typical are the raking bow, flat bottom, leeboards (the leeboard was lowered to prevent drift—the Dutch seldom used the center board for this purpose), and sprit rig, a heavy curved rudder and weather vane. Average length about 30 feet LWL.

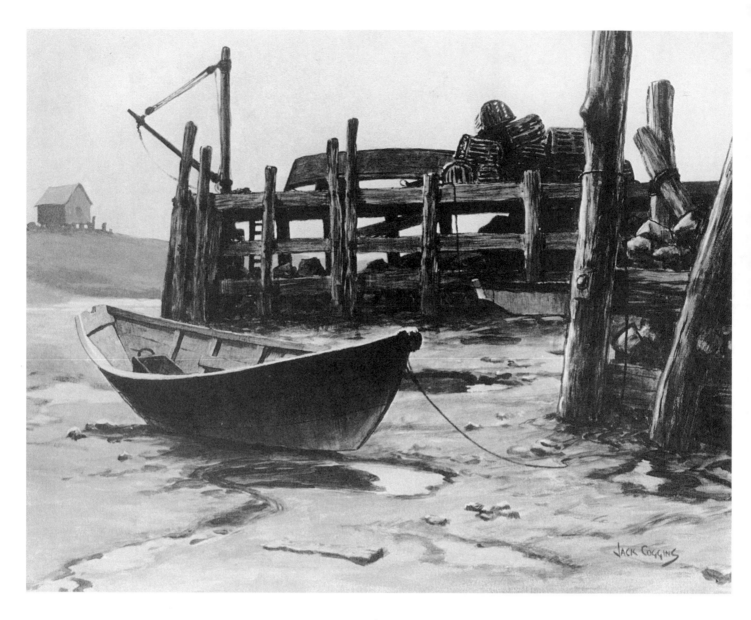

Acrylic on Masonite Low Tide 24x30"

If you've messed around with boats much, a scene like this will bring back the unforgettable smell of drying sand and mud, seaweed, some long-dead marine life, decaying piling, and wet rope. The bottom is cut into pockets and channels, some of which will retain water and furnish excuses for reflections and nice contrasts of lights and darks. There will usually be some rocks and other debris, possibly a rusty anchor from a mooring buoy. Pilings are commonly made partly of unfinished logs and the squared timbers are roughly hewn.

Below the high-water mark there will usually be a growth of seaweed and barnacles. This area shows up darker than the dry timbers above and often has a definite greenish tinge. Some pilings are lashed together with wire rope, others are bolted. A small derrick may often be seen at the end of a dock.

9

Docks, Piers, and Pilings

Docks are almost as useful to marine painters as to the fishermen who use them. Weathered to beautiful many-hued grays, often crowned with delightfully ramshackle buildings clad in pastel shades of ancient paint, and constructed in a variety of shapes and sizes guaranteed to fit any composition, old docks are an artist's delight. I love them, and in search of them my wife claims to have been made to explore every byroad heading to the water from Florida to Cape Breton. They show up in one way or another in a good many of my pictures, and while I realize that paintings with docks are as numerous, and often as bad, as paintings with old barns, I still can't resist them.

One of the useful things about docks is the opportunity they afford for an almost endless variety of different compositions. Docks high up on pilings, docks of stone, docks with buildings, docks with floats, docks with cranes and gangways, docks with boats. You name it, docks have it!

As the sketches show, docks, piers, wharfs, or whatever you want to call them, are sometimes all of stone, stone and pilings, or all on pilings. Where the wharf is exposed to rough water and also does duty as a seawall, then it is almost always of stone, dressed and laid-up in some cases, in others formed of huge blocks dumped to make a breakwater, with a wall or maybe just a roadway on top.

Common in many places are ramps, sometimes of stone, but in many cases logs laid horizontally onto which boats are hauled for repair or storage or to get them out of the water in bad weather. In the old days a wooden capstan, man powered, was used, or perhaps a team of husky horses. Today a gasoline or diesel engine usually does the job.

Newer docks tend to be neater and more symmetrical, with pilings evenly spaced and plumb, but older ones (more fun to do) are often built haphazardly, with crooked timbers at odd angles, in places obviously repaired or added onto. Where stone is available, it is often used in conjunction with pilings as a base or built solid partway out from the shore. Old docks are often rickety structures, with uneven boarded decks sloping dangerously and with gaping holes where planks have rotted away and not been replaced.

Buildings on older wharfs are usually a bit the worse for wear, as well, a little out of plumb, perhaps, with sagging rooftrees and patched shingle, tar paper, or corrugated iron roofs. Covering may be anything—sheathing, (vertical or horizontal) shingles, tar paper, or a combination. The neater ones will have painted trim around the doors and windows. When painted at all, barn red, faded to shades of pink and purply gray, seems to be a favorite. The larger structures were usually for cleaning and salting fish. They are often at the end of the wharf, with a simple derrick for hoisting up buckets of fish from vessels alongside.

Buildings were often added next to each other. As these seldom were the same height, the different roof levels show interesting lines. Lean-tos are common, and roof pitches vary from very steep to almost flat, offering a variety of roof angles.

Wharfs are not always straight-line affairs but were often built with one or more angles. A slight difference in height is not uncommon, either, with

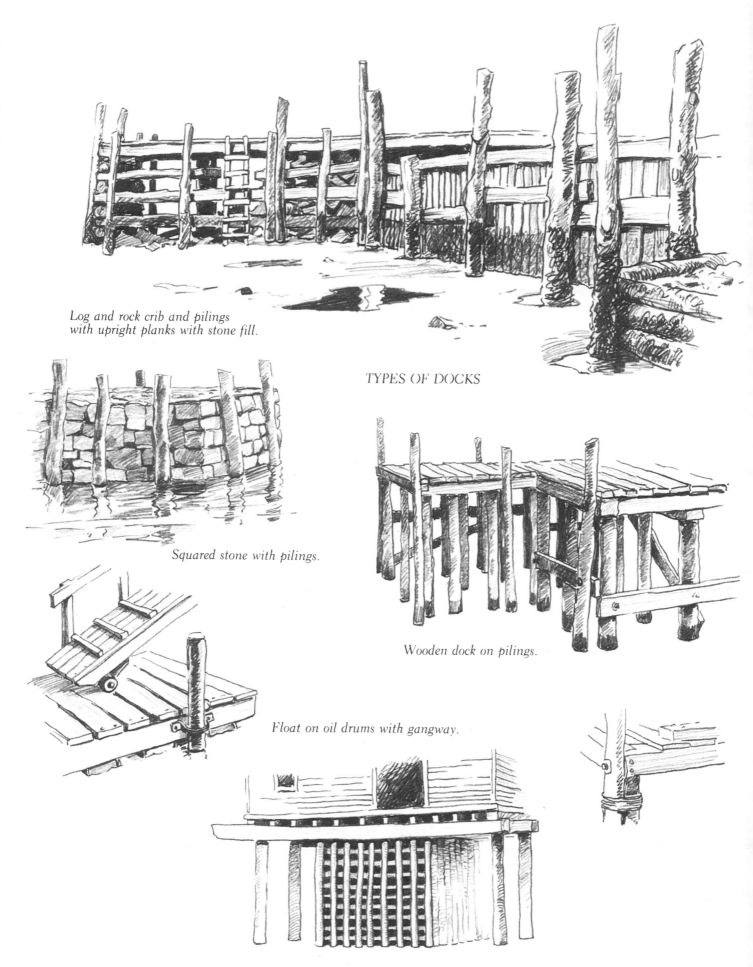

Log and rock crib and pilings
with upright planks with stone fill.

TYPES OF DOCKS

Squared stone with pilings.

Wooden dock on pilings.

Float on oil drums with gangway.

Pilings with log and rock crib.

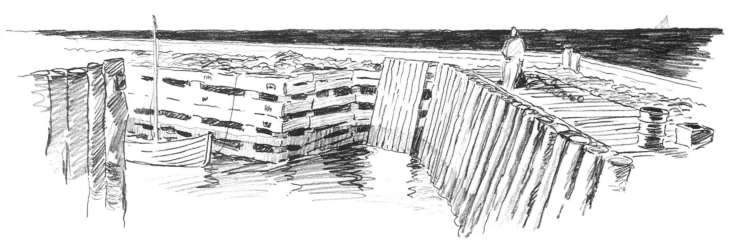

Above: Wooden piers and anchorages at eastern end of Gaspe Peninsula, Quebec. Narrow entrances often surmounted by a large wooden cross. Below left and bottom: In the British Isles and Western Europe, such structures are usually solidly built of stone. As the tide rises, foundations of buildings constructed at water's edge are covered, as in this scene in the Shetland Islands.

Lower right: Boardwalks are seldom straight, and often curve and dip alarmingly. Draw the curved lines for your planking in perspective and then "break" them into straight sections.

a planked incline or gangway between the two levels. Major differences in height, though, would have posed problems. Ease of loading and unloading and level access to the shore mean that in the same area wharfs would be much the same height. Seen at low tide, they exhibit a large amount of seaweed and barnacle-encrusted pilings, but at high water some in more sheltered spots are not many feet over water level. Those in more exposed locations may be built on higher pilings.

Many docks, especially where there is a lot of small-boat traffic, have a float, usually buoyed up with empty oil drums. Iron hoops around a couple of pilings allow the float to rise and fall with the tide, and a gangway with rollers gives access to the dock.

I'm mentioning these things because if you want to concoct your own compositions, you can add some of these components in almost any logical combination.

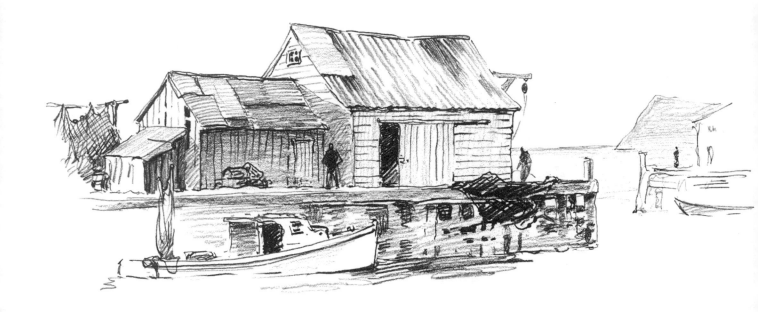

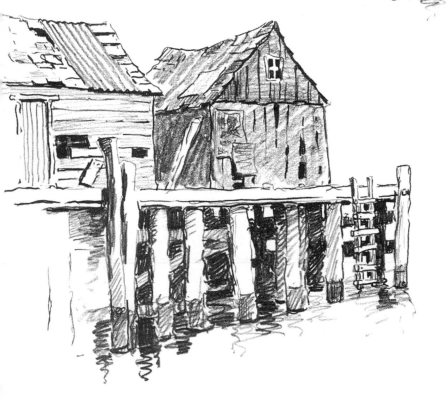

Buildings on docks are often a hodgepodge of old and new, additions tacked on to older structures, many in various stages of disrepair. In the sketch at left, I have bulged the walls, loosened up a board or two, patched a bit (old tin signs are often used), and put a piece of corrugated iron roofing over a badly holed shingle roof. Most docks have at least one rough ladder. Keep the pilings at the back under the dock simple. Note that the high-water mark is in perspective. A long length of dock can be monotonous, so break it with a boat and/or nets or a drying sail as in the drawing at the top. Note heads of figures on eye-level line. Dormers can be fun, but watch your perspective.

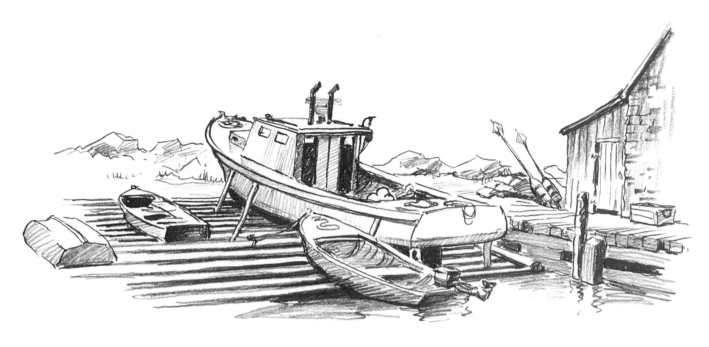

Log hauling ramp, Nova Scotia. Small boats are heaved up by hand, larger ones by power winch or tractor. If you paint a scene like this don't forget the props which hold the big boat upright. The horse- or man-powered windlass is, or was, typical of those used to haul boats up the pebble beaches of the north shore of the Gaspe Peninsula. In places, horses (in southern Europe, often oxen) were hitched directly to the bows as in the somewhat cropped reproduction of my Beaching the Boat.

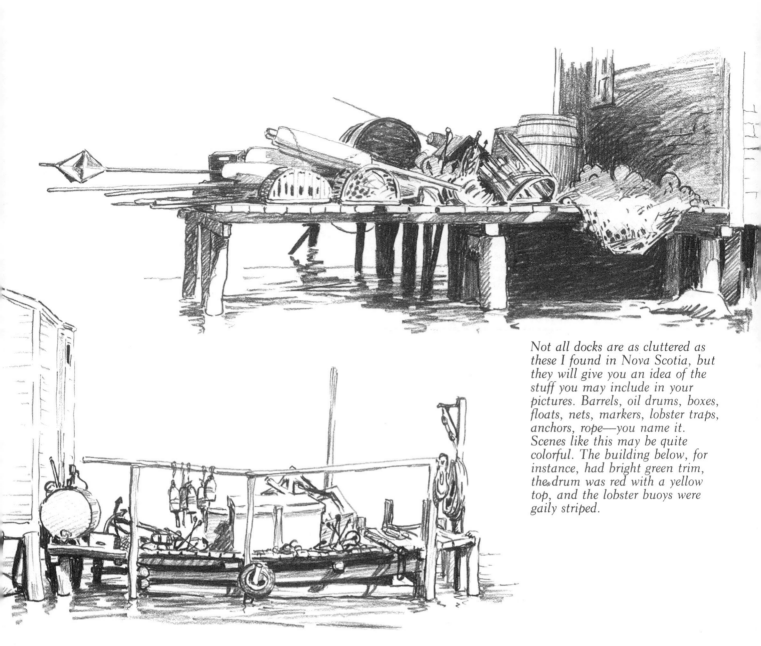

Not all docks are as cluttered as these I found in Nova Scotia, but they will give you an idea of the stuff you may include in your pictures. Barrels, oil drums, boxes, floats, nets, markers, lobster traps, anchors, rope—you name it. Scenes like this may be quite colorful. The building below, for instance, had bright green trim, the drum was red with a yellow top, and the lobster buoys were gaily striped.

A dock, even with the most fascinating structural details, would be naked and barren indeed without the normal clutter that endows it with life and a feeling of bustle and activity. Here is a partial list of things one can expect to find on an average working wharf. Nets: heaped up or partially spread out to be repaired or to dry on a comparatively unused section of dock and some hung up on frames or wound up on big creellike affairs. When painting nets don't forget the floats and net buoys. The former are mostly cork; the latter sometimes kegs or spheres of metal, wood, glass, or in recent times plastic or fiberglass, often in bright orange for visibility. Along with the nets there would most likely be tubs of line for trawl fishing.

Barrels and boxes: barrels are not much in evidence these days, but in the period before refrigeration wharfs would have been stacked with them—barrels for salt (they used vast quantities), barrels for fish, barrels for pickling, barrels for ships' food (flour, salt pork or beef, biscuits, molasses), barrels for fish oil, barrels for kerosene, barrels and kegs for just about everything. Coopers, the men who made them, were busy men in those days. There are still wooden boxes around, for fish and other things, but aluminum and fiberglass are becoming common, while the empty fifty-five-gallon steel oil drum is now a part of every dock scene.

Lobster traps: few docks in lobster country are without a stack of traps somewhere, piled up against a building, arranged in tiers on parts of the dock or on shore close by, or, damaged beyond repair, tossed aside in some corner along with old rope,

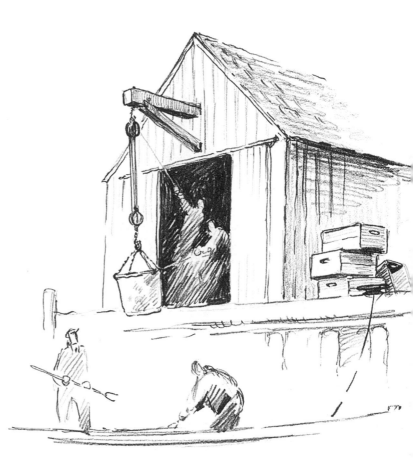

The cranes you see along the fish wharves are often small, and usually have a "homemade" look — a couple of bits of timber and ironwork by the local blacksmith. They used to be hand-powered but today a gasoline, Diesel, or electric motor does the job. Hoists as above right are often built into the end of a fish shed. These are made of heavy timbers well secured inside the framework. The small electrically powered crane at left is typical. Sturdily built, it has no guy wires to brace it, as a larger one might need. The boom swings freely but does not raise or lower as do the derrick booms on a freighter.

broken oars and boxes, and other marine junk. And don't forget lobster buoys, hanging on shed walls or festooned over rails, with their gay colors making a welcome spot of color against weathered wood.

Anchors: these come in various shapes and sizes, and with their ropes or rusty chains are usually to be found somewhere on the average wharf.

Spars and timber: there is usually some repair work to be done, ashore or afloat, and a few assorted balks of timber are often to be seen stacked somewhere handy. A spare mast or spar of some sort lying along a wharf is not out of place.

Rope: odds and ends of cordage, coiled or untidily heaped, are usually to be found, along with assorted blocks. Many larger wharfs, especially the

stone or concrete ones, have heavy mooring bits for securing vessels alongside. Others tie up to pilings or cleats. In any case, there are likely to be coils of mooring line nearby. For larger vessels these might be heavy, with loops spliced in one end. Wire rope and heavy cable seldom lie flat but tend to hoop up here and there.

Cranes: Derricks or cranes are used on many docks. These vary from fairly sophisticated affairs to a heavy timber frame projecting over the water from a fish house. The sketches show a few, but almost anything sturdy enough to support a block and tackle and a load has been used. Old ones used a manually powered winch. Some of these are still in use, although most now use gasoline or electrical power to do the hauling.

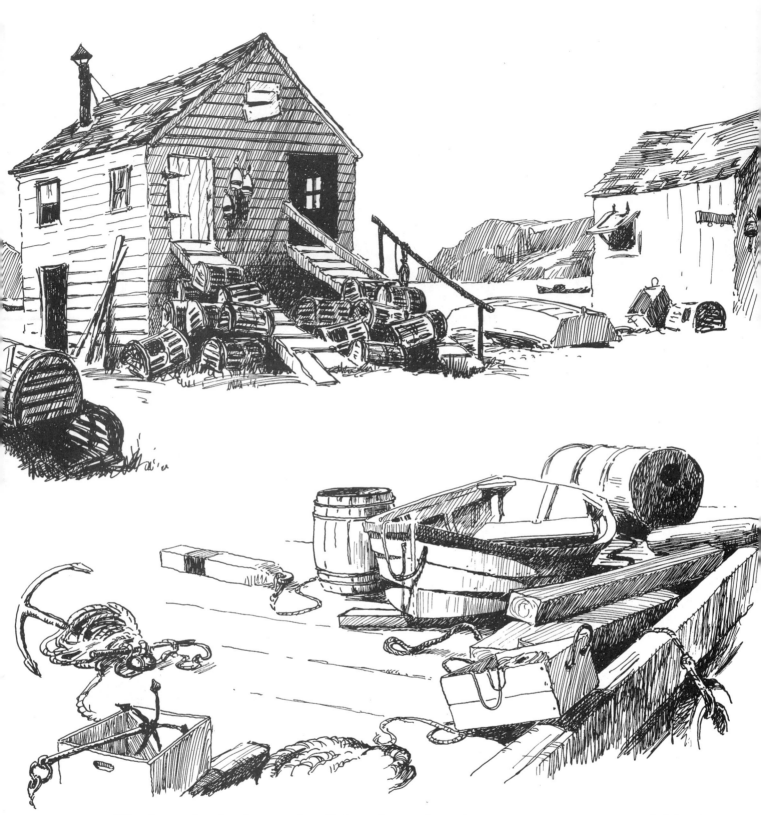

Wharfs were handy places to do a little work on a boat or dory that needed repair or a coat of paint. So a small craft, sometimes upside down on a pair of sawhorses or resting on a couple of timbers, could well add a touch to your dock scene.

Oars or small spars, things which needed to be stored but were in the way lying on the dock, were usually leaned against the corner of a building where they serve a purpose not intended by their owners, namely, making it possible for an artist to break the vertical planes of a structure with some angles, lines, and shadows.

All of this may suggest some of the objects which you can introduce to add realism to your paintings. A trip to a fishing port will add some more.

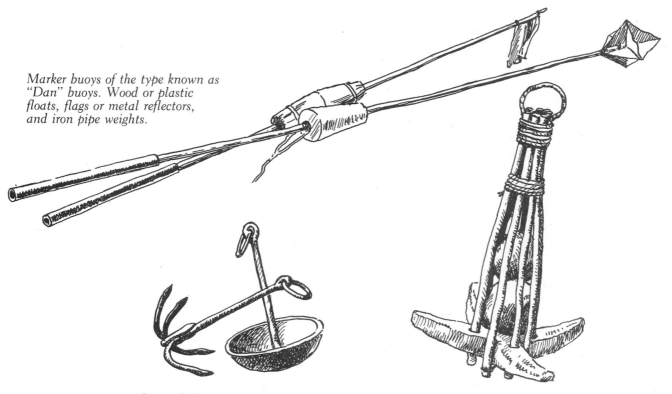

Marker buoys of the type known as "Dan" buoys. Wood or plastic floats, flags or metal reflectors, and iron pipe weights.

Grapnel, left, and a mushroom anchor.

Wooden anchor weighted with stones.

If you are painting a scene in lobster country (above left), the traps and the buoys are part of the landscape. And the ramps up to the upper floors are also a feature of many fishhouses in the northeastern United States and Canada. When a dock features in your canvas, don't forget, marker buoys often have red or orange stripes and the ever-present oil drum is also painted or is a nice rusty color. Buoys like the ones above are carried on many boats, several of them sticking out over the stern or resting up against the wheel house. Walking along docks or quays you'll see most of the boats from above, while vessels beached and propped can add a nice touch. Of the ones below, the center two are typically British—the rest of them Maine or Nova Scotian.

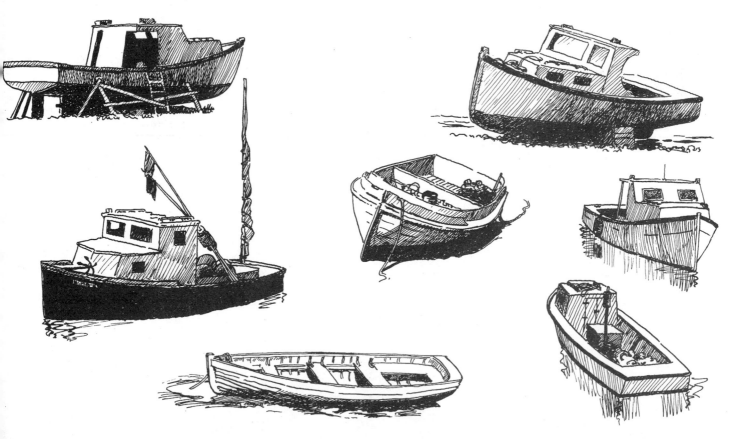

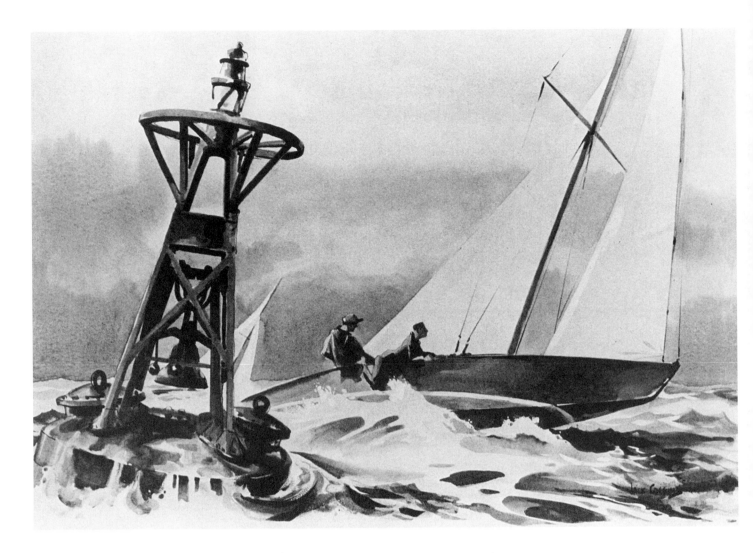

Watercolor on Whatman board First Around the Buoy *14x20"*

The board this was painted on was fairly smooth—which I like if I am going to do some detail—and I made some use of opaque white and a little thin ink in a few places. The buoy is obviously the dominant feature. Color, size, tone, and shape ensure this as well as the diagonal line of the sail pointing to it. I tried to show the mechanics of the buoy and still keep some freshness of handling. The angle and thrust of the hull, the position of the figures, and the fact that the bow is close to the edge of the picture help give the boat motion. Notice that in this type of buoy the bell does not move—only the clappers swing. The tanks, the tops of which show, are for fuel for the lamp.

10

Signposts of the Sea

Lighthouses have been around since ancient times (Ptolemy II's famous Pharos at Alexandria was one of the Seven Wonders of the World). They have evolved from wood-fired beacons atop stone towers into the multicandle-powered structures of today. As you will see on the following pages, lighthouses and their attendant buildings are constructed to suit their individual locations and differ greatly in design.

Some wave-swept towers stand by themselves on rocky reefs, often some distance from the mainland. These are almost always of masonry, usually with a cylindrical base firmly anchored in the rock below and with a circular tower, either with a uniform batter or slope or with a continuous curve. The light is placed high enough to prevent it from being obscured by spray or broken water. Even so, lights are occasionally damaged by wind-tossed stones, and in rare cases towers are completely destroyed by enormous waves. The force of such gale-swept seas are tremendous, and to be in a tower in a great storm must be an unnerving experience for a novice.

Another reason for placing the light high up is visibility. The curvature of the earth limits the distance to the horizon. When you stand at the water's edge, your horizon is just over 2.5 miles. At a height of 30 feet—a ship's bridge, perhaps—you can see 6.28 miles. A light in a tower 150 feet high—on the other side of the curve—would be visible from the ship at a distance of 20.3 miles (30 feet to horizon equals 6.28 plus 150 feet, light to horizon, equals 14.02 miles). In case you are interested, a formula with diagram on the following page will enable you to do your own calculations.

In more sheltered waters lighthouses are sometimes built on stilts. One which used to stand in Chesapeake Bay has been re-erected at the Maritime Museum at St. Michaels, Maryland.

A bit of extraneous information—a steady light on the horizon might be mistaken for a house light or even a star and certainly could not be told apart from any other navigational light; thus lights flash on and off at set intervals (a flash every 10 seconds, say) so they can be identified from a chart.

Whatever the method of construction, the lighthouse has for many years been a favorite subject for the marine painter, either as the primary focus for a canvas or as an adjunct. They make fine subjects or additions for any painting. Be sure, though, you know which of the two categories you want. A fifty-fifty split between the two can be confusing, and your viewer will never know whether you are painting a boat with a lighthouse or a lighthouse with a boat.

When depth of water makes the building of a lighthouse impractical, a lightship is used. These have developed from small wooden ships carrying an oil lantern to sturdy steel vessels some one hundred eighty feet long or more, built to withstand very heavy seas and anchored in position by huge mushroom anchors weighing three or four tons. Besides powerful lights, lightships carry foghorns and radio beacons. Crews are relieved every six weeks or so. A monotonous job and one calling for good sea legs and a strong stomach, as those of you who have spent only a few hours at anchor in a small boat in even a moderate swell can testify.

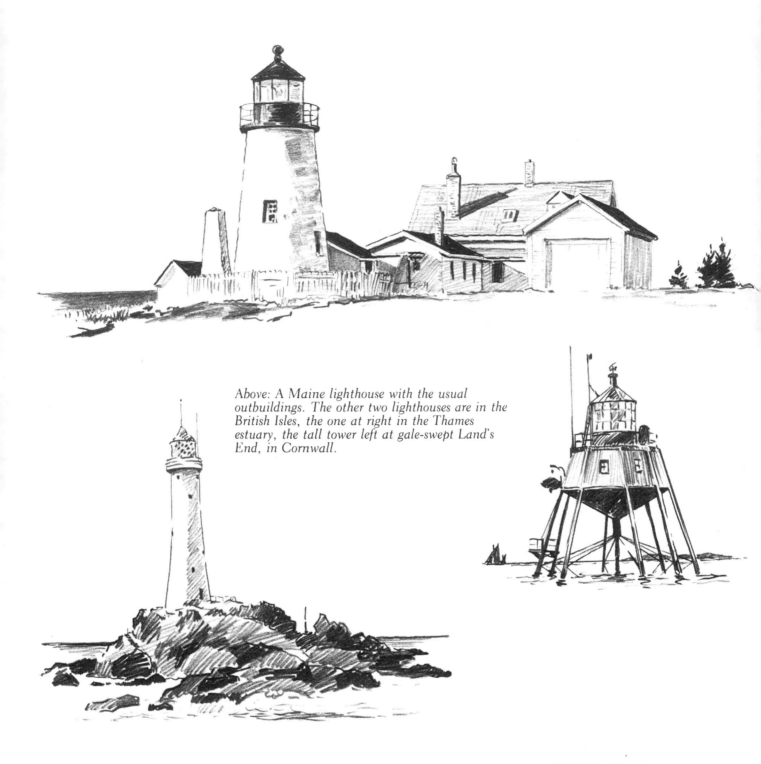

Above: A Maine lighthouse with the usual outbuildings. The other two lighthouses are in the British Isles, the one at right in the Thames estuary, the tall tower left at gale-swept Land's End, in Cornwall.

$$HL \text{ (miles)} = \tfrac{8}{7}\sqrt{\text{height of light (feet)}}$$

$$HE \text{ (miles)} = \tfrac{8}{7}\sqrt{\text{height of eye above sea level}}$$

$$HL + HE = \text{total range of visibility}$$

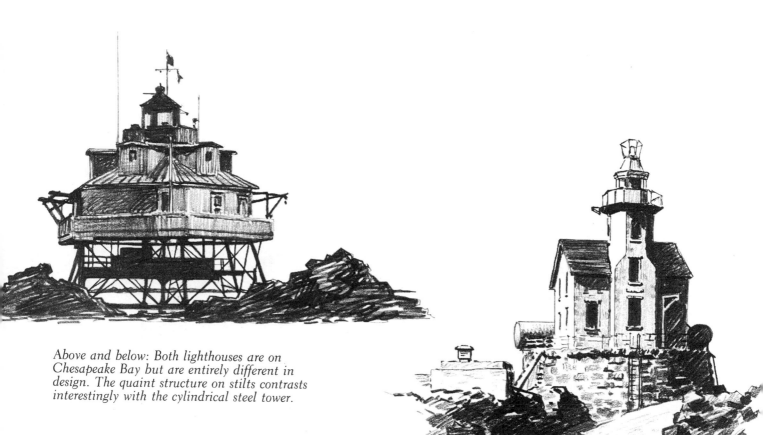

*Above and below: Both lighthouses are on
Chesapeake Bay but are entirely different in
design. The quaint structure on stilts contrasts
interestingly with the cylindrical steel tower.*

*This rather Victorian-looking light on its heavy
masonry base is one of the many located on Long
Island Sound. Below: one of the exposed lighthouses on
the West Coast being battered by raging Pacific seas.
Only when seas are calm can men and supplies be
landed safely. At other times, stores and personnel
must be hauled up from vessels standing as close in as
possible.*

Above: American lightship under way. Notice the heavy mushroom anchors, one on either bow and one in the stem at the waterline. Color notes: hull, red—superstructure, white—masts, funnels, ventilators, and so on, buff.

Left: A Swedish lightship with light mounted on a central tower. This was a logical development of the earlier movable light (see below). The lattice-type spheres at the mast head were for visibility and identification.

Right: A British lightship of about a century ago. The light, some 8 feet in diameter, surrounded the mast and was lowered to the deck during the day. The bilge keels (one shows at the bottom of the hull) were to check the rolling as was the steadying sail aft. The foghorn is at the front of the superstructure. Unlike the American ships, many of the European lightships were not self-propelled. The tiller and rudder were for control while being towed.

If lighthouses and lightships are the sea's beacons, the buoys and channel markers that line our harbor approaches and navigable rivers are the traffic signals. And handy additions to a marine painter they are, too. They come in various shapes and sizes. Because they often mark narrow channels, boats must steer quite close to them. Yacht races often use a convenient buoy as a marker for a leg of a race, and there have been many paintings—including some of mine—titled "Rounding the Buoy" or something similar. The proximity of vessel to buoy gives an opportunity for interesting compositions. But don't go painting vessels too close to lighthouses or lightships. These beacons usually warn of rocks, shoals, or reefs and are given healthy clearance, especially by deep-draught vessels.

Buoys with lights and whistles have to be tended occasionally, and some fine drawings and paintings have been made of small-boat crews alongside, with perhaps a man clambering up the structure. Some buoys, bell buoys, and some whistlers, as well as the numerous and familiar can buoys, need little or no such attention but occasionally have to be moved, painted, or inspected.

In shallow water and small rivers, where buoys are not needed, wooden channel markers are often used. These also come in a variety of forms, and all can be used by the artist with good effect. At least one such marker I have passed a number of times housed a nest of ospreys, and all make natural perches for gulls, pelicans, and cormorants.

Sketch diagram of one type of lighted whistle buoy. The height above water is about 20 feet. There are many designs. This one has a radar reflector at the top—many do not. Below the lantern (1) is the whistle and air pipe. As the waves move the buoy up and down, water is forced into the column at (2). This forces the air above it up through the pipe and whistle. Number (3) is a fin which helps keep the buoy from rotating. Number (4) is the mooring chain. Seen just behind two of the lifting rings are the tops of the tanks (5) which hold acetylene gas for the light. Number (6) is the buoyancy chamber and (7) the ballast. Numbers are painted on the four plates; the back of one is shown in (8). If the buoy is red the number will be even, if black, odd.

*Tall nun (red):
8, 10, and 12 feet.*

*Spar buoy.
7, 10, 13, and 16 feet.*

*Nun buoy mid-channel.
Spars and cans also used.*

*Tall can buoy.
7, 9, and 11 feet.*

*Unlighted bell buoy.
Red or black.*

*Lighted buoy.
One of several types.*

*Unlighted whistle buoy.
Red or black.*

The majority of buoys are all red or all black. The red ones (even numbers) mark the right-hand side of channels as seen from a vessel approaching the harbor from seaward. "Red, Right, Returning" is the time-honored way of remembering. Besides the plain reds and blacks there are mid-channel buoys with red and black bands. If the red band is at the top the preferred side to pass (from seaward) is left, if black, pass to right. These buoys usually mark a shoal or obstruction so are to be given a wide berth. Other mid-channel buoys, those which can be passed close either side are black and white, striped vertically. Some smaller channel markers are shown as well.

*Channel markers.
(Not what the Coast*

Despite such navigational aids as buoys and beacons, most ports require the services, for large vessels, of men familiar with local conditions. These are the pilots, and the pilot boat (sail in the old days) has also featured largely in marine art. "Dropping the Pilot" is a familiar title. Pilot boats, in places where local pilots were in competition with each other for the pilotage fees, often went far out into the shipping lanes to offer their services. Fine, fast craft many of these were—and seaworthy, too, for their trade took them to sea in all sorts of weather.

A large sailing vessel, with a pilot boat standing by, while her small boat carrying the pilot is rowed across a choppy sea to the larger ship, makes an exciting picture. Don't forget that both vessels would be hove-to (see chapter 4). The larger vessel would be flying the REQUIRE A PILOT signal (International Code "G" or "P" over "T").

Speaking of flags—ships sailing alone at sea seldom flew any. Why have a perfectly good piece of bunting blow itself to tatters with not another ship for miles? An ensign, however, at the peak of the gaff (national colors or, on a British ship, the familiar Red Duster, a red flag with the Union Jack in the upper left corner) adds a nice little touch of color and many painters include one. When encountering another ship, the ensign would be hoisted. The house flag of the line to which the vessel belonged also, might be raised at the main, and at the top of the foremast the flag of the country of destination might also be shown.

Signaling was done with flags using the International Code or private code signals. These add a touch of color as well, but unless you find out what combinations of flags to use, you had better resist the temptation. One signal is easy to remember—a vessel in distress hoists her ensign upside down.

Another warning—be sure your flag follows the direction of the wind. Don't show a sailing ship bowling along with a favorable breeze, the wind driving her one way and the flags flying the other.

Oil on board A Hard Wet Job *22x30"*

This painting, illustration, or however you wish to name it, was done on a smooth surface using thinned paint over most of the areas. This procedure gave a luminescent quality to the paint, something like a watercolor. The light areas were put in heavier. The darks were built up, glaze on glaze. This gives you a chance for deep, rich colors, but still clear and transparent. Shadows and dark areas should be painted thinly so they don't get heavy and dingy looking. Save the heavy impasto for the lights.

11

Peopling Your Pictures

A harbor scene with docks and vessels but without at least a few figures looks dead and deserted. Add a couple of men overhauling some nets or hauling on a rope and the place begins to come alive. Even if no one else is visible, you can imagine voices, the crash of boxes being stacked, the whine of a winch, or the rumble of a diesel. Or if you are competent to handle figures in a professional manner, you can make a group the center of interest. Then, instead of titling your picture "Nets Drying," you can call it "Men Drying Nets" or "Hauling the Nets" or "Landing the Catch." Heed an old pro's advice, though—if you are *not* too sure of your anatomy, it's best to relegate your workers to the background. Nothing but nothing shows an amateur up more quickly than a badly drawn figure. Better a few meaningful blobs in the distance than an awkward being performing an anatomically impossible task in center stage.

Actually, you don't need much. An impression of a seaman partially seen behind a lot of rigging and clutter will, as if by magic, people a ship with a whole but invisible crew. And keep your representation simple. A man indicated by three or four strokes, providing they are in the right place, will usually look a lot better than one carefully painted, complete with blue jacket and brass buttons.

The secret is in the action. However splashily you may portray your people, be sure that they appear to be doing the thing they are supposed to be doing—lifting, heaving, hauling. A scrap page of stick figures or, better yet, a few quick sketches of an obliging model will do wonders. After all, how

better can our loved ones show their devotion than by hauling on imaginary ropes or lifting equally imaginary lobster traps. The point is, if you have worked out the action and if you know what your figure is supposed to be doing, then you can better portray your figure and avoid fussy and possibly inaccurate details.

What should your figures be wearing? Well, it depends a good deal on what they are doing as well as the season and location. If they are aboard a fishing vessel or are helping to unload one, they would probably be wearing oilskins. Fish are wet and messy and there is much spraying from hoses and washing down with buckets of water, so waterproof clothing is almost a necessity. On the dock long waterproof aprons are often worn, but they are cumbersome for shipboard use and offer little all-around protection from rain and spray. Otherwise, any combination of shirts, skivvy shirts, sweaters, coats, even an occasional vest, is to be seen. One factor common to nearly all are boots—boots short or long, worn under oilskin pants or with trousers stuffed into them. A few are the old leather seaboot, well oiled and fairly water-resistant. Now most of them are rubber, hot in the summer and cold in winter, but leakproof.

Caps are the usual headgear, now mostly the baseball variety, often with long bills. In the days of sail, caps were usually of the flat-topped peaked sort, which are still common in many foreign ports. Felt hats in various stages of dilapidation were also common, while skippers, pilots, ship chandlers, fish buyers, and other important folk often sported high-crowned derbys or even straw boaters in warm

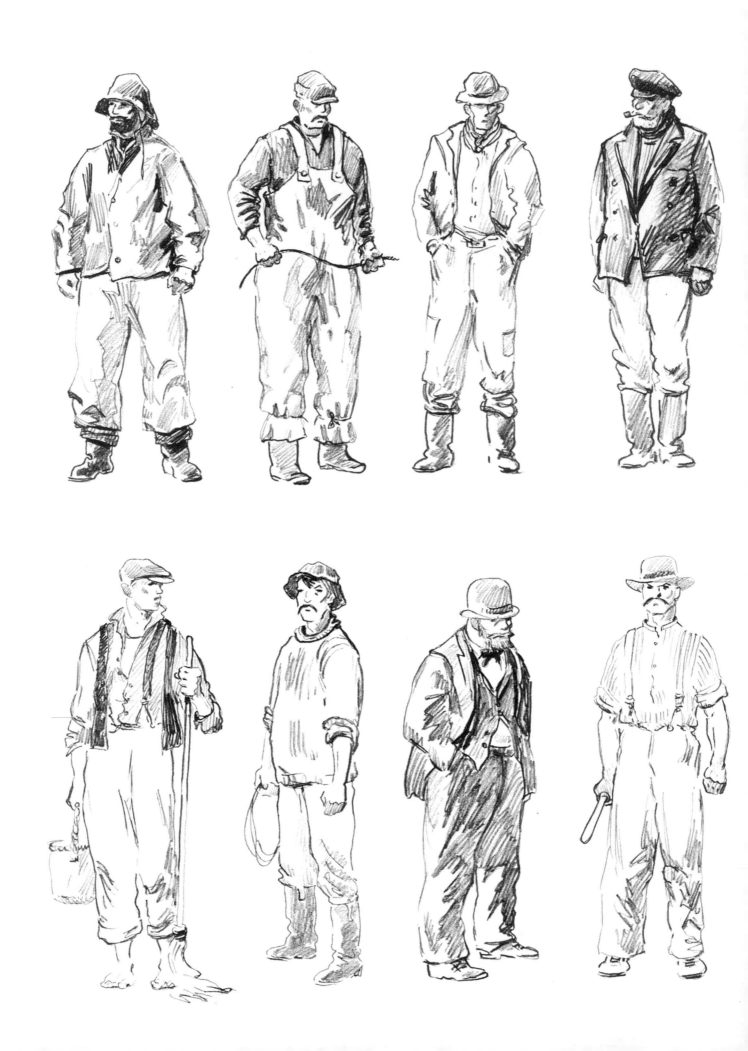

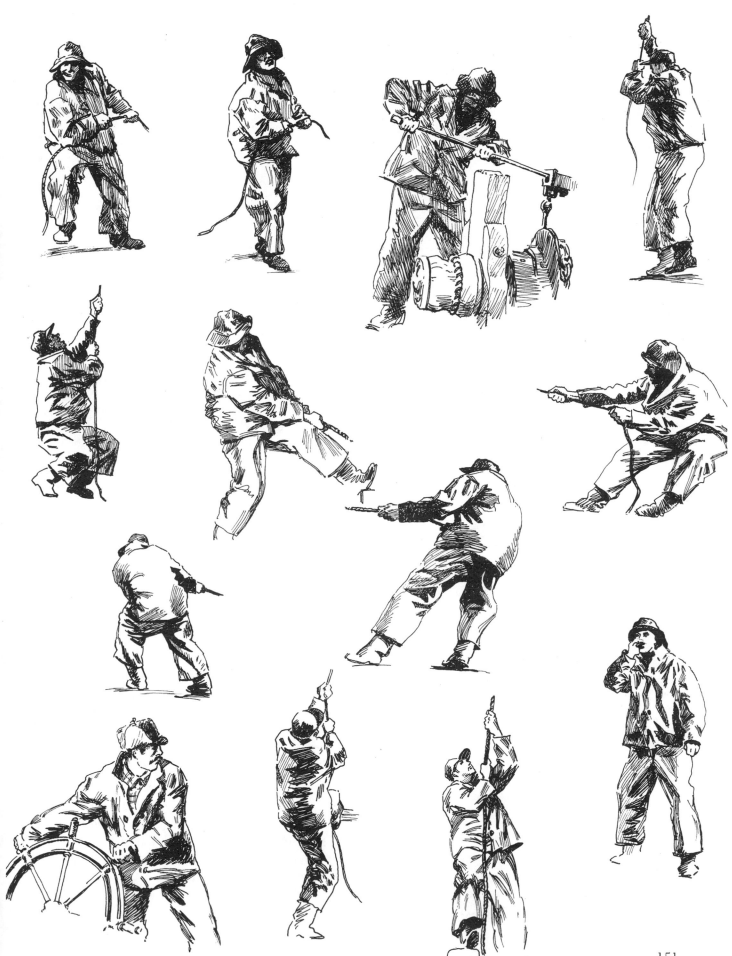

151

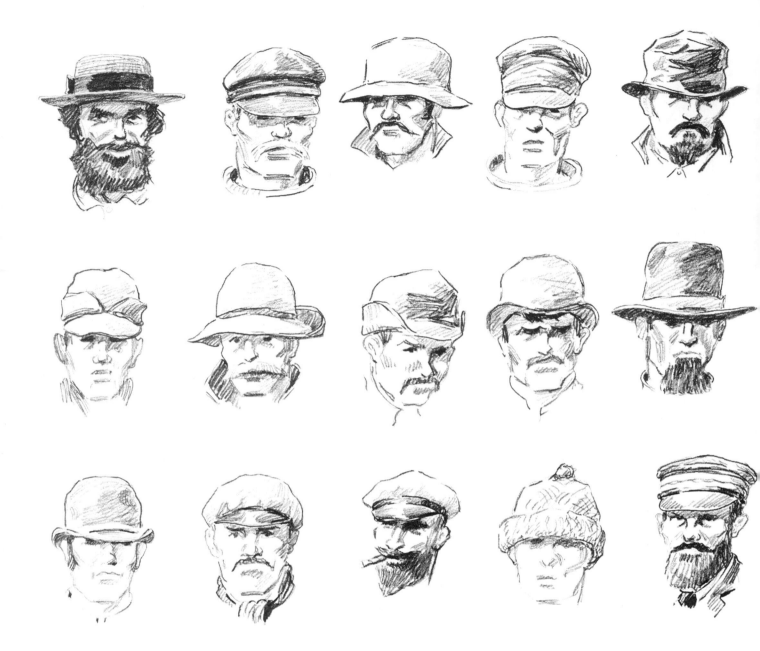

The behatted characters above could have been found on a variety of vessels in the golden age of sail. Common seamen and fishermen wore any headgear they happened to fancy. The felt hat, worn in many styles, was popular, as were peaked caps of many kinds. Straws were common in warm climates, while any seamen capable of plying a needle could turn out a passable hat from a bit of canvas—and he could waterproof it, too, with paint or linseed oil. From choice or because they happened to be wearing one when coming aboard, bowlers were sometimes to be seen, often much the worse for wear. Some skippers fancied them; others preferred something more nautical, sometimes with a bit of gold braid. Knitted caps were to be found (many sailors could knit) with or without tassels or pom-poms. Mustaches, mostly of the "walrus" variety, were sported by many.

weather. For foul weather the familiar sou'wester was—and still is—standard gear.

Be particularly careful to draw your figures in the correct proportions. The persons in your painting give it scale. We are people oriented, and the viewer tends to gauge the relative size of objects by comparing them to the average human figure. You may want to portray a sixteen-foot dory, but if you put an oversize figure in it, your dory will shrink to bathtub dimensions. The reverse is true as well. A pair of midgets will make a small boat appear twice its proper size.

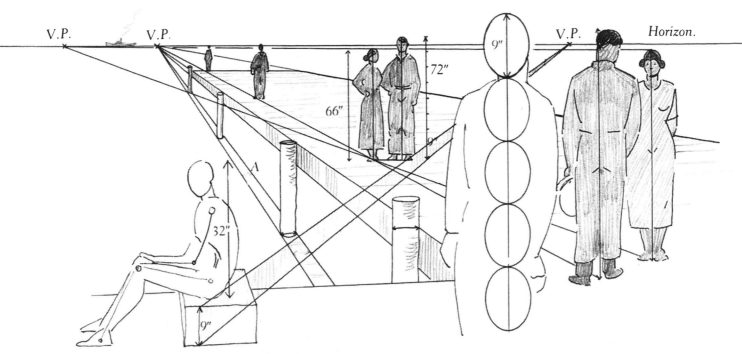

"Ideal" figures used (eight 9-inch heads, women, eight 8¼-inch heads). Note that once you have established one measurement as a "yardstick" you can find any others, and by using different V.P.s you can put your figures or objects anywhere in the picture you want. The top of a seated man's head is some 32 inches above his seat. The box could have been made any height. The horizontal triangle A helps keep the pilings about the same diameter. Below, left, your eye level when sitting. Middle, as you stand, the horizon seems to go up, too.

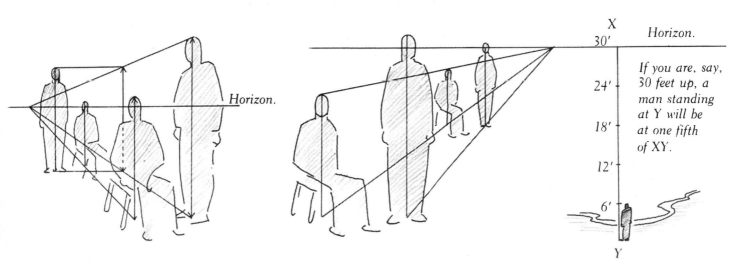

If you are, say, 30 feet up, a man standing at Y will be at one fifth of XY.

More modern headgear includes several peaked varieties and the hood, the lower part of which can be fastened across the throat. The type at the left is popular, while the one next to it is, or was, favored by seamen in the British Isles and Canada.

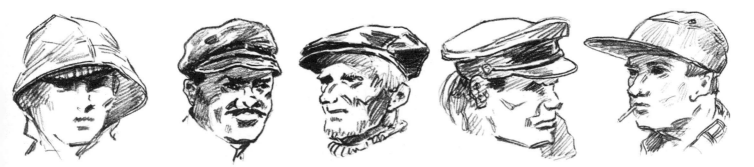

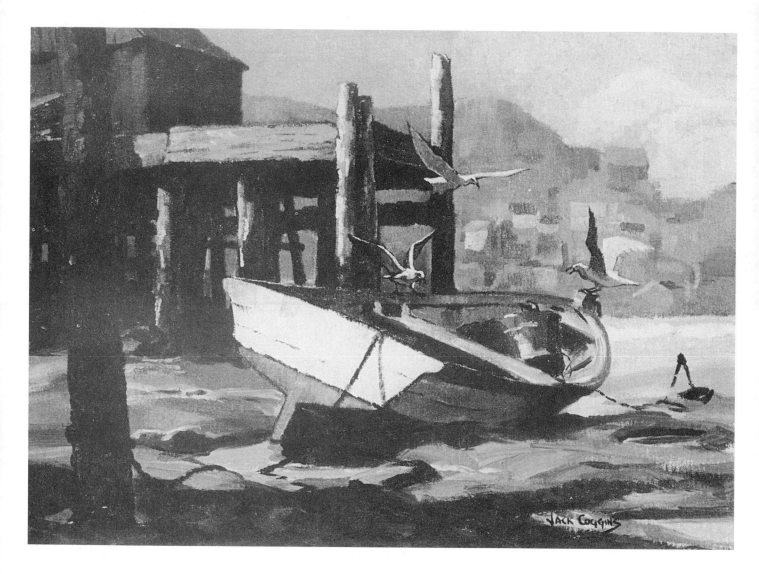

Oil on canvas Noisy Crew *18x24"*

Boldly painted on a rough canvas. Like a lot of my pictures it relies heavily on the contrast of light and dark. The strong patterns of the dark pilings offset the stark white of the boat's stern. Because of the definite design quality and because the gulls played an important part I outlined a couple of them. Notice that the gull at the bow breaks up the simply painted hill and houses and the others cut the uprights of the pilings and focus interest to the boat.

12

Gulls

Why not put in a few gulls? The thought occurs to countless marine painters every year. Is the canvas a bit empty on one side? Put in a few gulls. Does that area of sky need breaking up? Put in a few gulls. And so on. Why not indeed? Few fishing harbors are ever without gulls. Wherever there is anything edible, living or dead, there you will find the ever-hungry sea gull. When pickings are good, every piling will have its occupant, every roof ridge will be lined.

I had a studio once looking over the water. When I finally moved, I missed the flashes of white against the sky and the crazy mocking laughter more than anything else. And the occasional thump when a smart gull dropped a shellfish from on high onto my roof, to smash it open and devour it speedily before one of his thieving companions swooped down and beat him to it. There is nothing particularly lovable about a gull. In fact, seen close-up, they are predatory, with a mean eye and cruel beak, but I love them because gulls mean ocean, ships, fishing ports, beaches.

There are several species of gulls, but the large gull commonly seen on the Atlantic is the herring gull, with a length of twenty-three to twenty-six inches. Mature birds have gray wings and backs with black wing tips. Immature birds are a dull gray brown. The California gull is similar but smaller. Another Eastern gull is the great black-backed gull. Considerably larger than the herring gull, at twenty-eight to thirty-one inches in length, this gull is recognizable also by the dark slaty color of its back and wings. Much smaller, only fifteen to seventeen inches long, is the smart-looking laughing gull, with its black head—in the breeding season; in winter it is white with dark markings—gray mantle, and dark wing tips.

Gulls have a distinctive appearance while flying, which can be portrayed with a few well-placed strokes. In most cases the birds are in the background and detail is unnecessary. Practice drawing gulls from photographs until you can capture the motion, then simplify it so that a line or two and a touch of shadow will say gull, with no chance of mistaking it for a pigeon, duck, or other feathered friend. The page of sketches will show what I mean about the simplified yet recognizable shapes.

If you are going to add gulls to a painting, do it with some care and restraint. Don't dot them about at random or your composition will look as if it had the measles. Let your gulls make a pleasing design and, if there are enough of them, help carry the eye in and out of the picture. When you want your gulls to help with the "story," then don't hesitate to use enough of them. A fishing boat heading into port with the crew busy gutting and filleting will usually be surrounded by a cloud of gulls. Schools of small fish, driven to the surface by predators, will also attract swarms of gulls, many riding the surface, others hovering and swooping over head.

Depending on the light and their position in relation to it, gulls may appear as dark silhouettes or as silvery flashes against blue or gray sky. Or they may show a combination of white and shadow—one wing and part of the body catching the light, while one upraised wing might be in full shadow.

Used intelligently, as part of the design, gulls may be a great asset. Just don't get carried away.

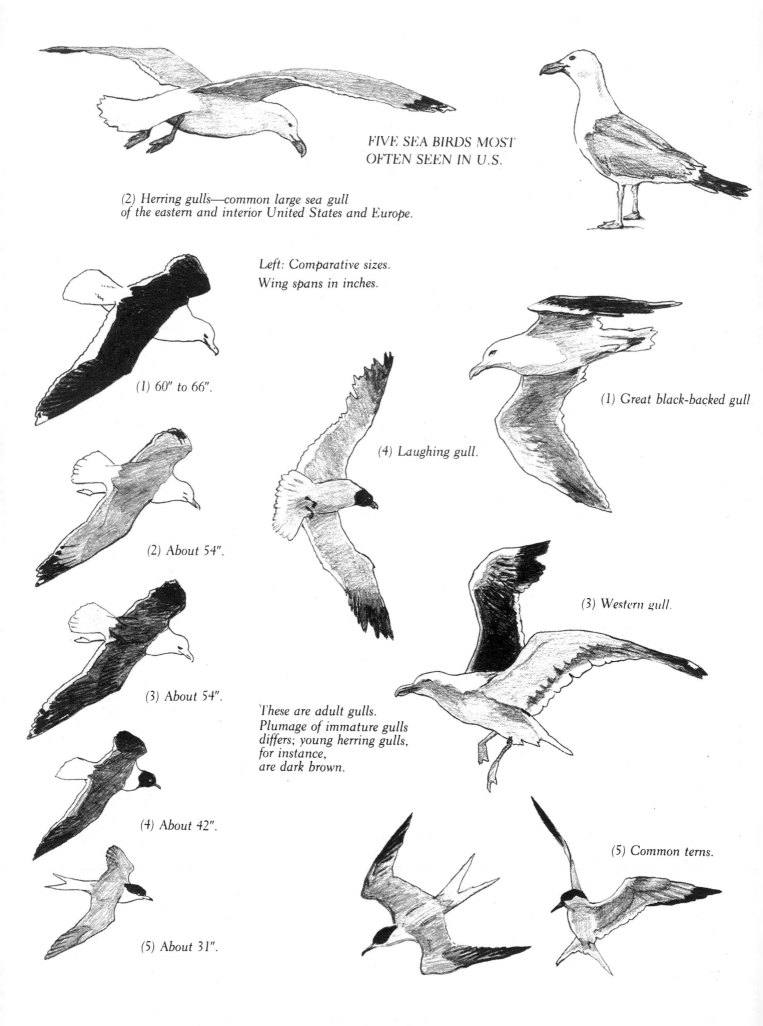

FIVE SEA BIRDS MOST
OFTEN SEEN IN U.S.

(2) Herring gulls—common large sea gull
of the eastern and interior United States and Europe.

Left: Comparative sizes.
Wing spans in inches.

(1) 60" to 66".

(2) About 54".

(3) About 54".

(4) About 42".

(5) About 31".

(4) Laughing gull.

(1) Great black-backed gull

(3) Western gull.

These are adult gulls.
Plumage of immature gulls
differs; young herring gulls,
for instance,
are dark brown.

(5) Common terns.

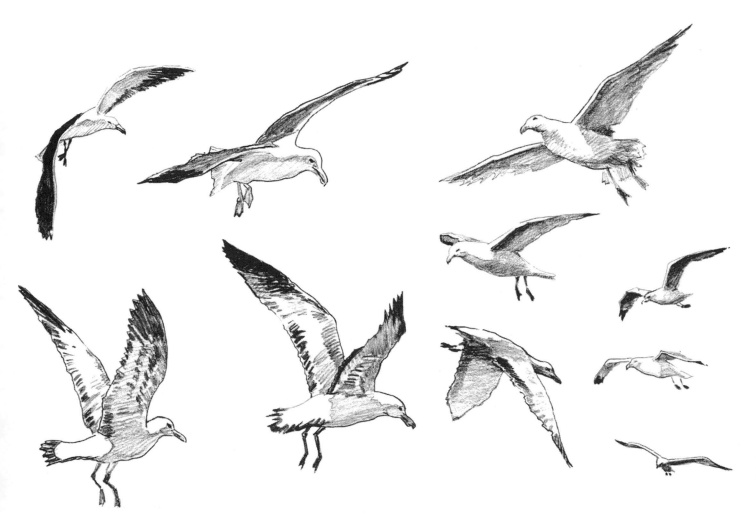

Every species of bird has its characteristic shape, and gulls are easily recognizable. The average marine painter, using sea birds as part of his design, need not be concerned about small differences between one kind of gull and another. All that is necessary is that the small flying object can be identified as a gull and not a pigeon or a turkey buzzard or a duck. Often your birds will be seen only as silhouettes, but if you study their shapes and the way they fly you won't have any trouble. The double arc which many artists use to denote a gull is familiar because it looks not unlike a gull gliding—and gulls spend a lot of time doing just that. But they do other things, too, and it's nice to vary a flock by seeing just what positions they assume when they fly, take off, and alight.

Being a large bird, the gull has wing movements that are comparatively slow (and therefore noticeable). You can notice, then, how high the wings may point when at the top of the up-beat and how low below the body at the farthest stroke of the down-beat. When maneuvering they can twist their wings, tilt them, and use them as brakes. So can the tail be open or closed like a fan, while the legs, which can be tucked up under the body so as to be almost invisible, are sometimes swung to one side to help balance a turn. They can be thrust almost straight forward as in landing, or left dangling.

Wings on gull at left appear to nearly touch. Flexibility is shown as birds fling themselves about in midair. Their chasing after scraps tossed off the stern of a ferry brought on this display of acrobatics.

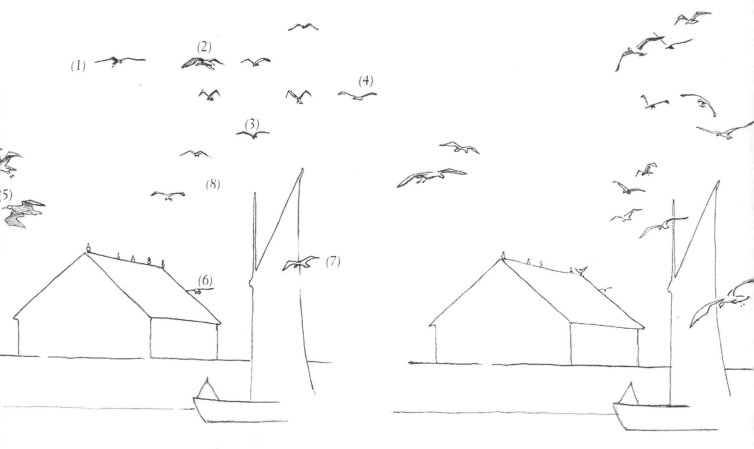

Not so good. Much better.

Above left: The arrangement of birds is too regular and there is not enough variation of size or shape. At (1) gulls are in a straight line. While gulls often fly in different directions, one going against traffic (2) is very noticeable. Don't put gull exactly on edge of canvas (4) or directly over an object like a mast (3). Gulls at (5) would look better entering than leaving the scene. The bird at (6) is too big (watch scale!) and the one at (7) is too small and is cut exactly in half by a sail. The group at (8) is too regular in spacing and shape.

At right, the pattern is more pleasing and the shapes and sizes more varied. Don't be afraid to put one bird behind another, and if you would like one near the edge of your picture either bring it well in or cut part of it off. Below left, you can often break a dark mass with light shapes, while gulls seen against a light sky often appear as silhouettes, rather dark. Gulls in a picture are often quite small, so simplify them as much as possible. Right, shadows will often suggest entire objects, but be sure your shadows are just right.

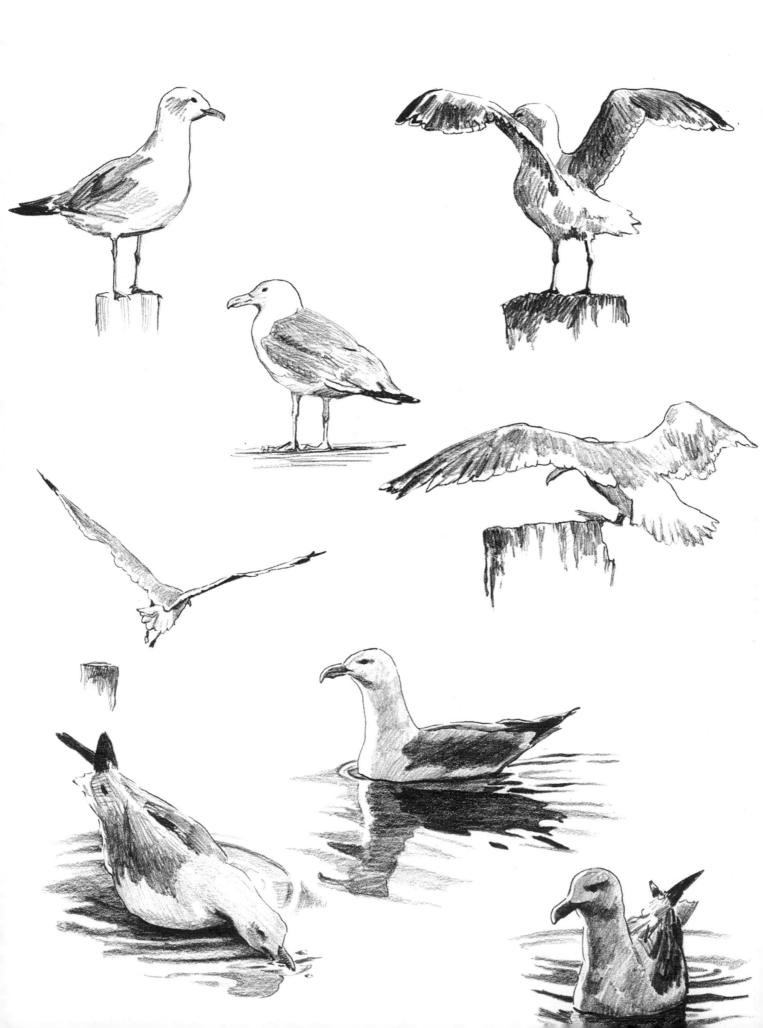

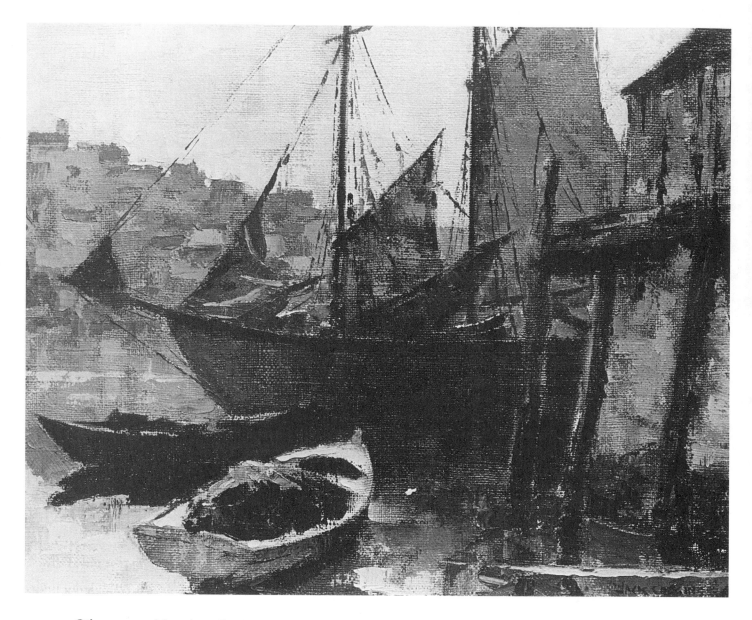

Oil on textured board Day's End *18x22"*

Thin oil stains followed by thicker paint laid on with a painting knife allowed me to finish this picture in a few hours, but the design sketches took as long or longer. The composition roughs are a most important part of any painting, and I work mine out very carefully before I start to paint. No amount of clever painting will cover up a poor composition, and the time invested in preliminary sketches is always amply repaid.

13

Picture Planning

This chapter was written under the assumption that the reader is making up his picture rather than actually painting the subject from nature. In the latter case the subject matter is chosen by sight, and while adjustments often have to be made—a telephone pole or a large oil storage tank removed or a building shifted slightly in the interests of composition—the artist paints what he sees. The studio painter, however, although he will probably use notes in the form of sketches or photographs, is faced with the task of creating a scene, as well as projecting a mood, more or less out of his head.

I suppose every individual goes about this differently. In my case the germ of the idea may come from something I've just read. A tale about a clipper ship may start a train of thought that results, in a roundabout way, in a picture of a pilot boat racing out to a square-rigger in the distance. Leafing through an old sketchbook may start a different chain of thought. Ultimately, I will see a picture in my mind, not clear and complete, perhaps, but enough to go on. Next follow rough sketches—very small because these are only ideas—succeeded in turn by more detailed ones as the idea begins to jell.

At this time I start to think about the composition: balance, lights and darks, pattern, and color. This last brings me to the color sketch or sketches, also small, perhaps four inches by six inches. I keep them small because detail at this point is undesirable; I am concentrating on the essentials. The painting has now evolved from a nebulous idea to something concrete and is ready to be transferred to canvas. This often is done by the time-honored squaring-up process or the use of proportional dividers. When laying in a small painting—I do a lot of nine by twelves—I often make the final composition sketch the same size as the finish and trace it through, using a graphite rubbing sheet.

While thinking up the picture, I am also concerned with how I am going to handle it. This may depend on what interested me in this particular composition. If it is a kind of boat which intrigues me—hull or rig, perhaps—then I may use a fairly tight treatment with considerable attention to detail. If the design, color, and atmosphere are the main features, then I use a broad brush treatment or a knife. This last is used in conjunction with some brushwork, which may amount to no more than a very thin under painting. There are certain things that I can do better with a brush, and I see no point in laboring with a knife over a passage better suited to the former (and vice versa). You don't get any medals for doing a painting entirely with either one or the other.

Planning for a picture is entirely a personal matter. It involves your own idea of the impression you want to give and the mood you wish to create. Beyond a few technical tips no one else can help you. As one piece of advice I would suggest that each painting is worth considerable thought and expenditure of time in preparatory research and sketches. Don't just start off with an object and try to build a finished painting around it. Too hasty a start usually means a scrubbed job or at best one that has had to be much changed and reworked.

This is a fairly complicated design and I worked it out with a good many sketches—some of which are shown here. I had the tones and colors pretty well thought out so the sketches were mainly for the final arrangement of sails and boats. The background presented no great problem, although at one time I considered making it a plain hill without a town on it. It had to be kept very simple because of the busy foreground. I played around with several groupings of boats and finally eliminated the one at the right (too many boats) and turned the one in the foreground so that it pointed into the center of the picture. The sail arrangement was important, because the ones silhouetted against the sky make a definite pattern and the shapes of the sky areas—the negative shapes—should be pleasing in design and balance. In the finish a few lights along the edges give form to the hulls and a little variation to the dark areas.

162

The errors above are obvious: the horizon bisects the picture one way and the cliff the other. Tones are too similar and the cliff too monotonous and flat. The arrangement below is better: tones in the cliff are varied and its shape more pleasing, and there is some contrast between cliff and sea.

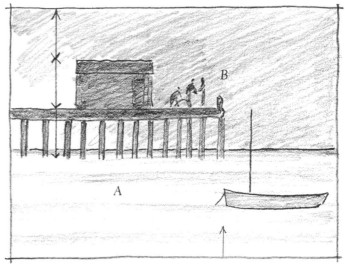

Above: The dock is uninteresting, the house square in the middle, and distances between water, dock, roof, and top of picture are the same. Also, the bow of the boat is in line with the end of dock. As space A is an uninteresting rectangle, the sole action is at B, but the area seems remote and nothing directs our eye there.

Here, clouds are the main feature. Whether a stormy sky or piles of cumulus, the sea and ships, if any, are of secondary interest. The design of the cloud patterns is going to be of greatest importance, other objects should be kept small to enhance the feeling of spaciousness.

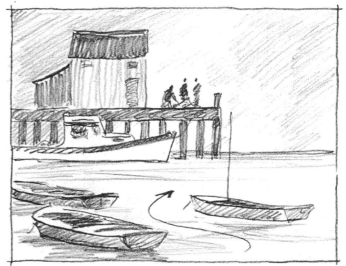

Above: The top sketch redesigned. A boat now hides much of repetitious piling; the hut is taller, a lean-to has been added and tones are varied. The sky is planned to bring out figures, and boats are added to fill A. Our eye should travel between the boats to point to B. Below: Definitely a sea picture, with sky subordinated.

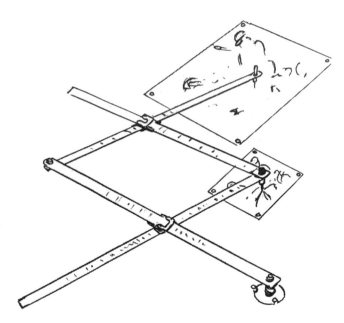

Once you have a satisfactory sketch, the next step is to transfer it, enlarged, to your canvas. Here are three methods:

Above: Squaring up. The more detail, the smaller your divisions should be. The sketch, of course, must be the same proportion as the finish. Draw the lines lightly on the canvas with hard charcoal or a soft pencil. Muralists use this method.

Left: Pantographs can be bought in most art stores, and they work quite well. Rather than work directly on a stretched canvas, I would enlarge my sketch on a piece of paper first and then transfer it to my canvas by a graphite rubbing (a soft pencil or graphite stick is rubbed over the back of a drawing or separate piece of paper) which is then used like a carbon paper.

Below: Proportional dividers are very handy gadgets. I made a pair for myself years ago, but you can buy them. The holes in mine correspond to various proportions—half-up, one third, and so on.

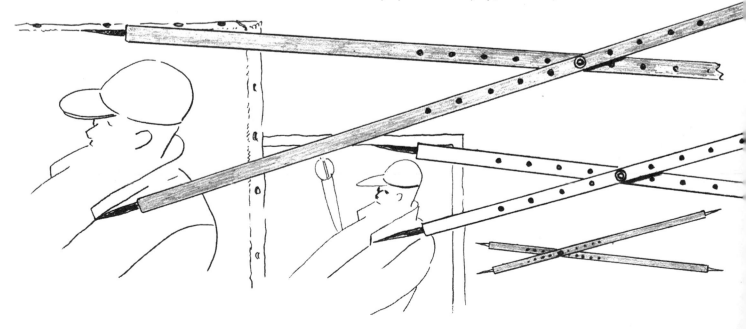

Paintings *can* be altered, and frequently are, but do your thinking on paper before you commit yourself to canvas.

If your picture calls for technical details, assemble any research material, sketches or photographs, beforehand so that you can work with it when you make your sketches. Otherwise it may happen that you draw up a carefully composed painting only to find that a technical detail makes nonsense of your plan.

If in your research you have found a sketch or photograph that is just what you want and are planning to use it as is, be careful that it is in proper perspective—and watch your scale. Say you want a dory in your painting; you have found a good photo of one; and you prepare to incorporate it in the composition. Be sure that the dory you are going to lift is in the right perspective to fit the plane of the water in your drawing. If it isn't, you must redraw, using the photo as a guide. As a matter of fact, few photos can be used directly. The chances of their being at the right angle or in the proper perspective are remote.

Let us assume, though, that you have photographed a whole scene and are going to use the print or slide as a basis for a painting. Presumably you have taken the shot from the desired viewpoint and no further adjustment is necessary. Your photo, however, may need considerable editing before you are satisfied that it meets requirements as the foundation for your painting.

For one thing, the camera is nonselective. It records everything in the viewfinder, including the power line in the foreground and the tall factory chimneys cutting the skyline. Eliminating undesirable objects is easy. You may have to do some filling in from your imagination where you have removed an unwanted building or trailer truck, but that is no great problem. Probably, the camera has also shown far more area than you intend to paint. Cut yourself two **L**-shaped pieces of matboard or heavy paper, lay them on the photo, and use them as an adjustable mat. Move them around—keeping approximately the same proportion as your canvas—until you find the best composition, which may comprise only a small area of the whole photograph. It may well be that one photograph will yield two or three good compositions (subject, of course, to the editing noted above).

Minor adjustments in arrangement may be made—a boat moved sideways slightly, perhaps (but be careful about moving it closer or further away—you may change the scale drastically). You may make any number of small changes but *don't* monkey around with the horizon (eye-level) line! Raising or lowering this arbitrarily will throw the perspective hopelessly out of whack.

A photograph if taken, as most of mine are, strictly for reference will have no nuances of tone, no mood nor atmosphere. It is only a record, to be treated as such—a foundation on which you will build your painting. Lighting may be changed, but be careful of your shadows. A sharp photo taken in bright sun might end up as a picture drenched in rain or hazy with fog. Use your material; don't let it use you!

If you usually record your material on slides, I suggest you put your blank canvas on an easel and project your slide on it. By moving the projector back and forth as well as vertically and horizontally you will attain the same effect as with the adjustable mat. Here again, treat your slide as an aid. I find color slides are often difficult to use *because* they are in color. It is sometimes easier to envisage a color scheme for a painting from neutral black and white than from a slide whose color may be totally different from what is planned.

Sometimes I take a color slide that in itself, including composition and color, is exactly what I want. (It happens very rarely.) Then I move the screen a little to the rear and to one side of the easel, put the projector beside or slightly behind me, make my drawing, and paint as if I was looking out my studio window. I try to paint as directly, and as quickly, as I would if I were working on the spot, putting down my impression of the scene rather than attempting to copy it. The trap to avoid is to become involved in all the detail the camera records indiscriminately, which the eye tends to ignore or filter out. If used intelligently, a color slide may be a valuable means of recording all or part of a scene that otherwise might have been impossible to put on canvas. Photography allows the recording of a far greater variety of scenes than is possible by sketching alone. Time and weather are both factors to consider in on-the-spot sketching, but the great advantage of the camera is that it enables the user to take pictures from vantage points

A photograph of a Cornish harbor such as this would furnish half a dozen good picture-composition possibilities.

Left: A tracing table is a mighty handy thing to have in your studio. I put all the working sketches for this book on mine and traced the drawings through onto the paper for the finishes. They come in various designs. Mine has a fluorescent tube mounted on each of two pieces of wood (which move in a slot so you can put the light where you need it).

Right: A most useful piece of equipment, this scene-framing device. I always ask my students to equip themselves with one, and some react as if I'd asked them to make a grandfather's clock! A piece of mat board and a razor blade is all you need. The one shown is about the right size. Cut the opening in proportion to the size canvas you prefer. Mark the halves—it helps. My wife glues two bits of black thread across hers, like the cross hairs in a telescopic lens. I use mine for everything—landscape, still life, and portrait.

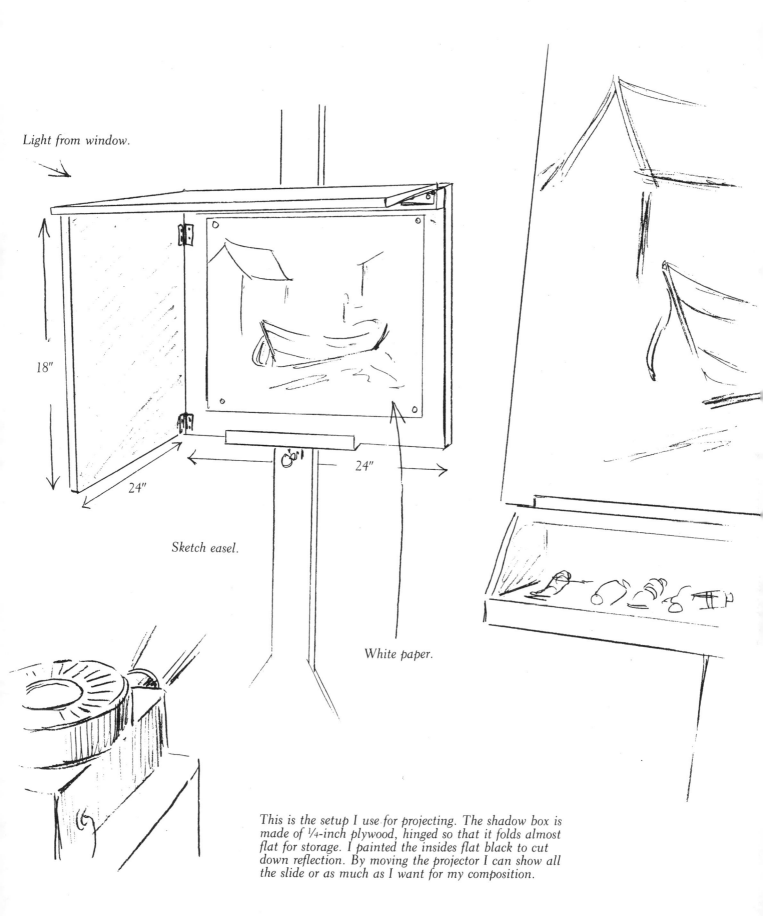

Light from window.

18"

24"

24"

Sketch easel.

White paper.

This is the setup I use for projecting. The shadow box is made of ¼-inch plywood, hinged so that it folds almost flat for storage. I painted the insides flat black to cut down reflection. By moving the projector I can show all the slide or as much as I want for my composition.

where it would be impossible to pause to sketch—a busy wharf, for instance, with workers elbowing past and forklifts making lingering hazardous.

I once had the opportunity to spend some twenty-four hours on a tugboat working the Delaware along the Philadelphia waterfront. Sketching the rapidly passing shoreline and vessels was out of the question. Several rolls of color film provided a number of interesting compositions, however, and with further editing and changes I finally came up with some two dozen paintings. Some artists make a great outcry about the use of photographs, while others will not admit they use them or do so reluctantly. Used properly, however, they can be a great help, as many well-known artists have proved, including Gauguin and some of the Impressionists.

A final word about picture planning from a purely personal viewpoint. Try to make your pictures do more than just record a scene or make a pleasing design. I see so many paintings at exhibitions or galleries that are well designed and professionally handled and yet don't do a thing to me. I call them "So what?" pictures. The artist is a competent draughtsman, his color and composition are good, and the viewer notes all this and wonders what the painting was all about. The artist has done everything except make an exciting painting. Unfortunately, the art world, as well as the theater, is full of forgettable performances.

Just as a Richard Burton may make the reading of the New York telephone directory a moving experience, so an artist should be capable of making a dramatic event out of the most ordinary material. Maybe it's the way the paint is put on, perhaps the lighting or the essential feeling of the subject matter, but there should be *something* that reaches out to the viewer and says "Hey! Stop and look at me" or appeals more subtly to the emotions. A gray, blurred impression of a dock in the rain, with a lonely gull winging by, may prove far more effective than the same subject painted in detail in bright sunlight.

The rewarding thing about painting is that the final word is always yours. Each blank canvas or piece of paper means a whole new ballgame. And with a subject as varied as marine painting you can keep playing until you can no longer hold a brush.

Index

Proper names of ships, paintings, and people appear in italics,
illustrations in capital letters.
If a subject is mentioned in text, the entry repeated in upper and lower case.